ART
&
DESIGN
EDUCATION
IN TIMES
OF
CHANGE

edition: 'ʌngewʌndtə

Book Series of the University of Applied Arts Vienna
Edited by Gerald Bast, *President*

CONVERSATIONS ACROSS CULTURES

ART
&
DESIGN
EDUCATION
IN TIMES
OF
CHANGE

Edited by
Ruth Mateus-Berr, Luise Reitstätter

DE GRUYTER

SHAPING THE INTERNATIONAL SCIENTIFIC DIALOGUE IN ART EDUCATION

Digital media and the global dimension of changes associated with it are crucial for education. How these developments influence art and design education, and how today's technologies reflect aesthetic perception, and, primarily, can be put to good use for humankind, need to be further discussed. Global challenges such as migration will influence future education; art education shows its strenghts and competencies in negotiating cultural and aesthetic concerns.

The comprehensive reform of teacher training aims to enhance the quality of teaching by improving both the academic and practical training of future teachers. The University of Applied Arts Vienna has already contributed significantly in this process through participation in working groups, building up professional networks and through relevant publications.

The Austrian Center for Didactics of Art, Textile & Design ("D'Art") provides therefore a joint platform for Austrian universities as well as international partners in the field of art and design education and subject didactics. Organizing the InSEA Regional Conference Vienna 2016 with participants from more than 40 nations, D'Art gathered an impressive amount of expertise and from it emerged inspired and inspiring results.

As Minister of Science and Research I am grateful for the fruitful cooperation and the good partnership between all of the stakeholders in the field. Their work not only strengthens Austria's position as a key player in art education but also helps shape our international scientific dialogue.

Reinhold Mitterlehner
Austrian Minister of Science, Research and Economy

ART EDUCATION IS INDISPENSABLE FOR THE TWENTY-FIRST CENTURY'S KEY QUALIFICATION: CREATIVE LITERACY

We live in an age that is to an increasing degree characterized by complexity, change and uncertainty. Digitization and automation require a redefinition of work and education. Even more, in conjunction with the development of artificial intelligence and biotechnology, the future role of humankind on our planet is under discussion.

The complexity of our societies and the challenges that they face demand a culture of questions and connections rather than one of answers and quantification. The recognition of the most interesting and important questions, and the selective evaluation of interdependencies and approaches to solutions is far more meaningful than quick, simple and ostensibly valid answers. Nonetheless, a culture of the correct and the incorrect is becoming increasingly dominant, even in the university sector. Students, teachers, universities and indeed entire education systems are being more and more evaluated, compared, judged and rated on the basis of quantifiable answers to multiple choice tests, bibliometrical reports and other statistical data. Only what can be quantified seems to be relevant today.

Almost a century after Heisenberg formulated the uncertainty principle and his theory of quantum mechanics broke the paradigms of physics and even philosophy, we are still accustomed to acting and arguing largely along linear patterns of causality within insulated boxes of fragmented knowledge.

At the end of the 20th century, those fundamental cultural techniques – reading, writing, calculating – that expanded broadly during the industrial era, were supplemented by the ability to communicate digitally. Those who lacked this skill were regarded as "digital illiterates," and they saw social exclusion and a shortage of employment opportunities as a consequence.

Now this canon of cultural techniques has to be expanded once more: creative literacy will be *the* most important skill for mastering life in twenty-first century societies. It will mean:

- Dealing with ambiguity and uncertainty
- Possessing imaginative and associative abilities
- Thinking in terms of alternatives
- Questioning existing structures and appearances
- Establishing unconventional contexts
- Questioning the status quo
- Anticipating and developing future scenarios
- Looking for new perspectives
- Recognizing that there are forms of communication other than the verbal

All of this is the domain of the arts. People who are used to dealing with the arts – whether they are artists or art's audience and participants – possess *creative literacy.*

Art education is more important than ever.

In almost every age of human civilization, the arts have been a part of the explanation and development of the world. The history of art demonstrates how systematically the arts dedicated themselves to this task, proceeding from a variety of approaches and positions.

The more we understand the mechanisms and consequences of the contemporary, ongoing technological revolution that is taking over large fields of formerly human levels of activity, the more it becomes evident that our educational systems increasingly have to support and embrace creative literacy.

Because at its core, civilization was and is a *cultural* process.

Gerald Bast
President, University of Applied Arts Vienna

THERE'S A
BATTLE OUTSIDE
AND IT IS RAGIN'

IT'LL SOON
SHAKE YOUR
WINDOWS AND
RATTLE YOUR
WALLS

FOR THE TIMES
THEY ARE
A-CHANGIN'

Bob Dylan 1964

THE TIMES THEY ARE A-CHANGIN'

Art & Design Education Making Futures

It is no coincidence that the song, "The Times They Are A-Changin'," written by the 2016 winner of the Nobel Prize for Literature, Bob Dylan, was chosen for this preface. Today, we face such unexpected and radically new living and working conditions that we are forced to think anew how art and design education can respond.

The symposium Art & Design Education in Times of Change, organized as a Regional Conference of the International Society for Education through Art (InSEA) at the University of Applied Arts Vienna in September 2016, along with this subsequent publication, aim to support and discuss various national and international art and design educational approaches in conversations across cultures. In response to intertwined phenomena such as the global economic crisis, migration movements and the pervasiveness of new technologies in everyday life, the demand for sharp analysis and conscious critique as well as artistic, participatory and political practices in governance, education and culture is growing rapidly.

The latest leap in industrialization will cause a severe loss of work and its takeover by robots and Artificial Intelligence. Logos and Ergon will play against one another, rather than in an imagined harmony of form and content (Wiercinski 2011, 518). Economic relations are more and more determined by emotions, while emotions form their own economy of "affective capital" (Illouz 2015). As early as 1795, Friedrich Schiller, in *On the Aesthetic Education of Man*, wrote in an empirical key of the established metaphysical questions, the mind-body duality, and the moral purpose of man; his approach is more than ever necessary today in these changing times of high-tech. Aesthetic experience requires conscious participation; its engagement demands the assumption of multiple perspectives. Such expertise allows us to overcome any mind-body dualism. Design has a long history of being involved in shaping the societies we live in, as Pelle Ehn, Elisabet M. Nilsson and Richard Topgaard extensively describe in their book *Making Futures. Marginal Notes on Innovation, Design and Democracy* (2014). Empowering co-articulations and participation by artistic means not only offer solutions to problems, they become interventions.

How diversely art and design education can act will be shown in the following papers. These were selected in a double blind peer review. Part One, Actions, starts with the role and practice of artists and educators in the civil domain; in Part Two, Changes, the museum becomes analyzed as a site of radical ruptures in relation to its publics; Part Three, Patterns, offers insights into the structures of aesthetic experiences from primary school to teacher training and artistic research; and finally, Part Four, Identities, shares a common lens in analyses of different working conditions, from historical design laboratories to transnational mobile subjects and non-western school contexts.

By way of art and design educational connections, cultural knowledge and intercultural understanding can be promoted across the mere borders of nations. With this book we hope to offer inspiration for further theoretical reflections and an ongoing critical and engaged practice.

Ruth Mateus-Berr, Luise Reitstätter
Editors

References

Schiller, Friedrich. 2004. *On the Aesthetic Education of Man*. Mineoloa: Dover Publications.

Wiercinski, Andrzej, ed. 2011. '*Gadamer's Hermeneutics and the Art of Conversation in International Studies in Hermeneutics and Phenomenology.*' Münster: LIT.

Illouz, Eva. 2015. 5th ed. *Gefühle in Zeiten des Kapitalismus*. Frankfurt am Main: Suhrkamp.

Ehn, Pelle Elisabeth M. Nilsson and Richard Topgaard, eds. 2014. *Making Futures. Marginal Notes on Innovation, Design and Democracy*. Cambridge/London: The MIT Press.

INTRODUCTION

INSEA: ADVOCACY AND NETWORKING FOR EDUCATION THROUGH ART

Teresa TORRES DE EÇA
President, InSEA

The International Society for Education through Art (InSEA) is a non-governmental organization affiliated with the United Nations Educational, Scientific, and Cultural Organization (UNESCO). InSEA was founded in 1954 and is a legally incorporated non-profit organization whose purpose is to advocate for education through visual arts. InSEA membership includes visual arts education professional organizations, academic institutions and researchers in art education; art teachers from various levels and types of education; museum and community educators, artists, designers and others dedicated to advocacy, networking and partnerships that advance visual arts education. InSEA members share their practices and ideas during congresses and through InSEA publications. It is a strong community where new ideas, peer reviews and collaborations are made possible. Very often the members plan and conduct joint international projects taking advantage of the worldwide scale of the organization.

Visions of the future

From its beginnings InSEA members adopted the belief in art education as a tool to transform society. The preamble to the Constitution reveals the idealism of the founding members of InSEA and their belief that:

> *Education through art is a natural means of learning at all periods of the development of the individual, fostering values and disciplines essential for full intellectual, emotional and social development of human beings in a community. (InSEA Constitution, 1954)*

Since its founding, InSEA members have actively advocated for the arts in and through education, playing an important role in UNESCO discussions, especially at the beginning of the twenty-first century with the "UNESCO Road Map for Arts Education" (2006), and the "Seoul Agenda: Goals for the Development of Arts Education" (2010). In each world or regional InSEA congress many papers show evidence that the arts play a vital role in encouraging students to learn in physically embodied ways by inviting them to collaborate with their peers and by developing their cognitive and emotional capacities as they are educated in, through and about the arts. Nevertheless more data about the role of visual arts in education is needed in all countries of the world in order to reinforce and maintain the presence of arts education for all. More and more, policies require such evidence, and it is important that the experts in the field and the key agents – art teachers and art educators – make visible the results of their work both in research and in practice. According to the report produced by Ellen Winner, Thalia Goldstein and Stéphan Vincent-Lancrin for the OECD (Winner et al. 2013), the arts are unique in bringing about specific outcomes for students in societies where cultural goods are traded; they foster economic growth, not only by training future artists, but also cultural producers and consumers. But too, we need more data to prove this.

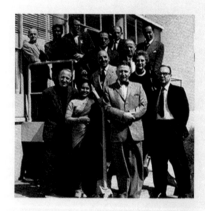

Figure 1 InSEA founders, 1956. *Upper group, left to right:* Emil Betzler, Germany; M. P. Alladin, Trinidad, British West Indies; Rikard Sneum, Denmark; Dr. M. Y. Bassiouny, Egypt; A. Kroonenber, the Netherlands; G. J. van Koppenhagen, the Netherlands; Osamu Muro, Japan. *Lower group, left to right:* Ap Boerma, the Netherlands; Mme. Kamala Coelho-Veloso, Portugal; Dr. Carlo Leoni, InSEA Secretariat, Italy; Dr. C. D. Gaitskell, Canada; Mlle. Henriette Noyer, Secretary, France; Dr. Edwin Ziegfeld, InSEA President, USA. Photograph: InSEA Archives

People's lives are infused with the arts as they listen to music on their iPods, read fiction, attend museums, watch TV dramas, dance, etc. We believe that the well-being and happiness of individuals will be higher in countries where the arts are given a prominent role in our schools, because of the inherent pleasure gained from the arts. (Winner et al. 2013, 21).

However, this perspective can be extremely reductionist. Visual media education and visual arts education are important not only for building audiences and molding cultural consumerism. The twenty-first century has ushered in a post-technological world order and the arts should be employed wisely to prepare students to succeed in this changing global community where the great majority of information is transmitted by visual media. Visual literacy is a key and necessary competence for the production and transformation of communication.

The world is dominated by a knowledge-based global economy that is driven by consumerism, technology, diversity and polarization, as well as violent disagreements and great disparities between and among people and communities. It seems that our old models of education are unprepared to educate students to succeed in the future. Some look at education from an economic point of view and see it resulting only in competitiveness and innovation. Others point towards more humanistic and sustainable values. The consensus among education experts seems to be that education should foster critical thinking and problem-solving skills, communication and collaboration skills, creativity and innovation skills, and information, media literacy and intertextual learning skills. Marketplace projections point towards a need for both creativity and entrepreneurial thinking – a skill set highly associated with job creation (Pink 2005, Robinson 2006, Sternberg 1996). The ability to think unconventionally, to question the herd and imagine new scenarios is now highly valued by society. Another set of skills that are considered important in this technologically interconnected global economy is life skills, including leadership, ethics, accountability, adaptability, personal productivity, personal responsibility, people skills, self-direction, and social responsibility. Below is a more detailed list of skills from the Partnership for 21st Century Skills.

Although artistic thinking processes, visual communication and visual literacy are not explicitly included in this list, the arts have been widely recognized as a unique dimension of human knowledge through the centuries and in every society:

The arts have been in existence since the earliest humans, are parts of all cultures, and are a major domain of human experience, just like science, technology, mathematics, and humanities. In that respect, they are important in their own rights for education. Students who gain mastery in an art form may discover their life's work or their life's passion. But for all children, the arts allow a different way of understanding than the sciences and other academic subjects. Because they are an arena without right and

Critical thinking, problem solving, reasoning, analysis, interpretation, synthesizing information

Research skills and practices, interrogative questioning

Creativity, artistry, curiosity, imagination, innovation, personal expression

Perseverance, self-direction, planning, self-discipline, adaptability, initiative

Oral and written communication, public speaking and presenting, listening

Leadership, teamwork, collaboration, cooperation, virtual workspaces

Information and communication technology (ITC) literacy, media and internet literacy, visual interpretation, data interpretation and analysis, computer programming

Civic, ethical, and social-justice literacy

Economic and financial literacy, entrepreneurialism

Global awareness, multicultural literacy, humanitarianism

Scientific literacy and reasoning, the scientific method

Environmental and conservation literacy, ecosystems understanding

Health and wellness literacy, including nutrition, diet, exercise, and public health and safety

Source: Great Schools Partnership, the GLOSSARY OF EDUCATION REFORM
available at http://edglossary.org/21st-century-skills/

wrong answers, they free students to explore and experiment. They are also a place to introspect and find personal meaning. (Winner et al. 2013, 21.)

More than ever we need to approach a more sustainable vision of education for the future of humanity and the planet. In Edgar Morin's vision, ethics and awareness of our human condition within a society, a species and a planet is an essential part of education (Morin 1999). It is our belief as InSEA members that education through art may still play a crucial role in the future because through the arts we explore the senses and the mind, we experiment with tools and develop personal, ethical and social skills. At the core of art education are creativity, curiosity, imagination, innovation and self-expression. By making art students acquire methods of enquiry and analysis, they interpret and synthesize information, practice critical thinking, problem solving and reasoning. Learning about and practicing contemporary art in education promotes perseverance, self-discipline, adaptability and self-initiative, enabling students to achieve global awareness, multicultural literacy and a deep sense of humanitarianism.

Advocacy and networking

Over the last few decades we have observed in many countries that the presence of the arts – and especially the visual arts – has been substantially reduced in the school curriculum. There is always a need for advocacy in arts education at all levels, from macro organizations such as UNESCO and InSEA to those on the national, local and community levels. We need to advocate for the arts and visual literacy in the curriculum not only to reinforce economist values such as entrepreneurialism or media consumerism, but also and mainly to include ethical and aesthetic values, including critical thinking in reading images – by which public opinion can be manipulated – so as to ensure freedom of expression in visual media. Researchers and art educators who can provide reliable data and project results need to be aware that their findings may be of interest to all, and to make them available in open platforms. Arts education organizations and individuals interested in arts education can work together to create common platforms to disseminate their findings and make them available to others. In a networked environment it is not so much individualism and self-expression that count but, increasingly, new ways of creating, sharing and disseminating digital information. Through collective action the field progresses as a whole. Sharing and collaborating means learning from each other so as to generate a common body of knowledge.

In the face of societal changes arts education movements have been reframing approaches, rationales and advocacy strategies. New media have brought about fast, interactive and global functionalities for a variety of groups. Each one of us is a part of various networks and inhabits multidimensional spaces in the way of blogs, second-life environments and social networks (Facebook, Diaspora, Instagram, Twitter; Linkedin, etc.); each is a member of interlinked professional networks, including research and teacher databases and portals. Although seemingly chaotic, the excess of local groups is not disorganized. Rhizomatic structures are growing in every direction, and global networks are constructed without losing the individual and local aspects of the nodes that sustain the main networks. The key factor to maintaining networks is synergy. Against division, competition and fragmentation, new movements are proposing cohesion and syncretism.

When we face threats to art education in schools, we also face the benefits of such local and global structures. Arts education organizations and individuals interested in arts education can work together to create local structures in virtual or semi-virtual environments, and display information, share practices, questions and outcomes on a global scale. The InSEA Web portal and its Wordpress and Facebook blogs are providing a valuable space to receive and transmit information of interest for art educators around the world. In the last few years InSEA has encouraged and endorsed cooperation between members to engage in joint projects that have now become strong reference points for praxis and research in visual arts education. InSEA provided a database for finding partners for international projects such as the Art Lunch Project, "Image and Identity: Improving Citizenship Education through Digital Art," Hexagon and ENViL. The Art Lunch Project was part of a comparative study of cultural differences reflected in interpretations of a common lesson theme among teachers in different countries. Art educators, art specialists and classroom teachers from eight countries participated in this project during 2006/7. The research project was developed in Japan by Kinichi Fukumoto, professor of the Department of Arts Education, Hyogo University of Teacher Education. The common lesson theme, "Creating an Imaginative Lunch for a Foreign Friend," was implemented by art teachers/InSEA members in primary and middle schools in the following countries: Finland, Germany, Slovenia, Denmark, Japan, the Philippines, Portugal and Turkey. The informal European Network for Visual Literacy (ENViL) was founded in 2010 and consists of more than sixty members from eleven European countries. All members conduct research in the field of art education. The steering group comes from the Netherlands, Austria, Hungary and Germany. The network works closely together with InSEA. In two European projects, the InSEA Europe Regional Council (ERC) was an active partner. For the project Enhancing Creative Education in Russia, we helped strengthen links between nine Russian universities and provided students with the opportunity to study the Double Degree EU-RU Master Program in Digital Arts both in Russian and EU universities. In the project InSEA also had the role of non-academic EU partner connecting EU and Russian universities with business, as well

as increasing the effectiveness of disseminating the project's results in Russia and other countries in Europe via InSEA resources. InSEA was also an active partner in the design and evaluation of CREARTE, the Creative School Partnerships with Visual Artists (2016–2017). CREARTE is a project for experimental pedagogies based on contemporary art practices in primary schools. The project has been co-funded with support from the European Commission and integrates the following partners: Faculty of Fine Arts, University of Porto, Portugal; Cyprus Pedagogical Institute, Cyprus; the Ministry of Education and Culture, Cyprus; University of Jaen, Spain; Stichting, the European Regional Council of InSEA (International Society for Education Through Art); Goldsmiths' College, UK, and the BUFF Film Festival, Sweden.

InSEA congresses are spaces for presenting reports and starting joint projects; through its virtual spaces InSEA also provides spaces for the exchange of information and makes it possible for individuals from different parts of the world to explore new visual art education strategies, providing practices, feeding research, and furthering advocacy for visual art education at both the macro and micro levels.

REFERENCES

Morin, E. 1999. *Les sept savoirs nécessaires à l'éducation du futur*. Paris: UNESCO.

Pink, Daniel H. 2005. *A Whole New Mind: Why Right-Brainers Will Rule the Future*. New York: Riverhead Hardcover.

The Partnership for 21st Century Skills. 2008. *21st Century Skills, Education and Competitiveness. A Resource and Policy Guide*. Accessed March 3, 2017. http://www.p21.org/storage/documents/21st_century_skills_education_and_competitiveness_guide.pdf.

UNESCO. 2006. *Road Map of Arts Education*. Accessed March 3, 2017. http://www.unesco.org/new/fileadmin/MULTIMEDIA/HQ/CLT/CLT/pdf/Arts_Edu_RoadMap_en.pdf.

UNESCO. 2010. *Seoul Agenda: Goals for the Development of Arts Education*. Accessed March 3, 2017. www.unesco.org/new/en/culture/themes/creativity/arts-education/official-texts/development-goals/.

Winner, Ellen Thalia R. Goldstein and Stephan Vincent-Lancrin. 2013. *Art for Art's Sake? Overview*. OECD Publishing.

**Art & Design Education
In Times of Change:
A Look inside**

#1 ACTIONS
What can we learn from
artists/educators/activists
and their social practices
within communities and
their engagement in the civil
sphere?

#2 CHANGES
How can museums confront
changing social, political and
technological circumstances
actively and in dialogue with
their audiences?

#3 PATTERNS
What are the prevailing
concepts of art and patterns
of aesthetic experiences
in different cultural contexts
of teaching/learning, and
what does this mean for
future art education?

#4 IDENTITIES
How do non-Western and
shifting working contexts
change design education
perspectives, professional
identities and embodied
practices?

#1 ACTIONS

Pascal Gielen **25**
Contemporary Soviets of Art: On the Role of
Art and Education in the Civil Domain
Keywords: civil sphere, democracy, education,
Paris Commune, Soviets

Susannah Haslam,
Jonny Mundey **31**
Alternative Action(s) as a Mode of Address
Knowledge Mobility and the *IF* project
Keywords: knowledge, symbolic/structural
institution, systems of value, political actions,
the alternative

Dipti Dessai,
Jessica Hamlin **37**
Sites of Learning: Artists and Educators
as Change Agents
Keywords: contemporary art, social activism,
critical pedagogy, public sphere

Christine Liao **43**
Service Learning through a Community Art
Participatory Project
Keywords: community art, service learning,
community mural

Glen Coutts,
Timo Jokela **49**
Art and Design on the Edge: Challenge,
Change and Opportunity in the Arctic
Keywords: Arctic, art and design, community art,
applied visual arts

#2 CHANGES

Jocelyn Dodd 57
Addressing Contemporary Social Issues
through Culture: A Framework for Action
Keywords: values, difference, impact,
activist practice

Martina Riedler 63
The Role of Museums in Creating Social
Change through Community Collaborations
Keywords: critical pedagogy, museum education,
Paulo Freire, dialogic approach, community
collaborations

Pia Razenberger 69
Tabādul-Exchange: An Approach to Art
Education Projects Supporting Equal Exchange
Keywords: intercultural dialogue, equal exchange,
Islamic art

Jane Sillis,
Jo Plimmer,
Lisa Jacques, 75
Hannah Pillai,
Gina Mollett
Creating Lasting Change for Young People
through a Touring Exhibition
Keywords: exhibition, education, young people,
touring

Petra Šobánová,
Jana Jiroutová, 81
Jolana Lažová
New Ways in Education through Art: Research
into Mobile Applications in Museums and
Galleries in the Czech Republic and Abroad
Keywords: museum mobile application, museum
e-learning, interactivity in museums, digital
teaching tools in museums

Luise Reitstätter 87
Making Museum Apps Matter?
Keywords: museum education, media use,
multimedia guide, app, relevance

#3 PATTERNS

Michael Hann **97**
Stripes and Checks
Keywords: stripes, checks, regular, balanced, sett

Peter Gregory **103**
Laying Good Foundations?
The Value of Art in Primary School
Keywords: primary education, art experience,
breadth of curriculum, developmental opportunities

Annika Hossain, **109**
Helena Schmidt
Art History as Indicator of Swiss Secondary
School Art Education History: A Case Study of
the Canton of Bern from 1994 to Today
Keywords: Swiss art education history,
gymnasium, art history, theory and practice

Ernst Wagner **115**
A Tool for Art Educators: The
Common European Framework of
Reference for Visual Literacy
Keywords: visual literacy, competencies,
curricula, assignments, assessment

Ulla Kiviniemi **121**
Playful Hands-on Crafting for Personal
Growth and Communal Well-being
Keywords: craft education, community art,
playful learning, collaborative learning

Ruth Mateus-Berr **127**
Teaching Empathy for Dementia
by Arts-based Methods
Keywords: dementia, arts education,
arts-based research, transferable skills, empathy

Birgit Engel **133**
Potential of Aesthetic Experiences in
the Field of Teacher Education
Keywords: teacher education didactics, lived
experience, epoché, sensible awareness,
aesthetically-based reflexivity

#4 IDENTITIES

Lesley-Ann Noel 141
Imperatives for Design Education in Places
Other Than Europe or North America!
Keywords: design education, developing countries,
design curriculum, Usain Bolt

Gert Hasenhütl 147
The Design Laboratory. A
Paradigm for Design Education?
Keywords: design research, design education,
history of science, studio studies

Razia I. Sadik 153
The Joys and Obstacles of a Change Agent:
Teaching in Pakistan's Only Postgraduate
Program in Art Education
Keywords: higher education, teacher education,
pedagogy, curriculum, Pakistan

Verónica Sahagún Sánchez 159
Mestiza Pedagogies: Subversive Cartography
Applied to Arts and Crafts Making
Keywords: cultural identity, place, art/craft,
mapping

Mila Moschik, 165
Virginia Lui
War on Cash
Keywords: war on cash, money design, actuality vs.
virtual reality, physical money, culture

Budhaditya Chattopadhyay 171
Hyper-listening: Praxis
Keywords: sound art, listening, environment,
community art practice, mindfulness

CONTEMPORARY SOVIETS OF ART ON THE ROLE OF ART AND EDUCATION IN THE CIVIL DOMAIN

Pascal GIELEN
University of Antwerp, Antwerp Research Institute for the Arts (ARIA),
Culture Commons Quest Office, Belgium

ABSTRACT

In this article the relationship between art, education and civil society is analyzed within the context of the contemporary western political condition. The recent presidential elections in the USA showed that the classical model of liberal representative democracy is shaking on its foundations. The question thus is: how can art and education respond to this political condition? In the article, I argue that art possesses a special quality by which to address political, and especially democratic issues. It can strengthen education in its lessons in democracy and citizenship. Art has the special quality of taking an alternative path of democracy, namely that of the civil domain. In the civil sphere artistic qualities and skills in design and imagination can play a crucial role. And this is why the artist has to take her and his responsibility in these times of dramatic change, by stepping on to the historical path of the soviets.

KEYWORDS

civil sphere, democracy, education, Paris Commune, Soviets

Today we see many projects that undauntingly explore the boundaries between art and education. This sort of activity primarily occurs when art attempts to inform the civil debate. But can art enhance the role of education, maybe even compensate for it? In short, what is the educational value of art to the civil domain?

Civil space

It is in the gaping gulf between legality and illegality, between creativity and criminality that civil space sees the light of day. In the grey area between what is allowed and not allowed, civilians – citizens – initiate that which a government or state has not yet thought (or does not want to think of), and for which there are no interested markets. For the record: civil action does not coincide with criminal behavior. Civil actions simply concern non-regulated domains, areas not yet covered by law. A civil action may denounce the fact that something is not sufficiently regulated by law; or it may develop a practice for which there simply is no regulation. Whether the actions involved are lawful or not remains to be seen. Within a democracy, at the end of the day it is the legislative and judicial powers that decide whether to categorize an issue at hand as legal or illegal. At the moment of the actual civil action itself this is still undecided: will this practice be tolerated, embraced, or even passed into law, or not? Civilians who take a stand are uncertain about where they will end up, how they will be judged. They simply do not know if the rights they claim will be granted them. This is why a civil action is always a risky undertaking.

Because of this undecided nature of the space in which a civil action takes place, it seems wise to distinguish between the terms "civil" and "civic." Although both concepts are often used interchangeably in everyday usage, civic mainly refers to the government, which has "civic tasks" to perform, or delegates them to institutions. In other words, the civic place is already regulated whereas the civil space still lies open. A civil space on the contrary is taken into the hands of (would be) citizens. Or, to paraphrase Michel de Certeau's distinction between place and space: the civic place is established or has taken root in policies, education programs, regulations or laws. By contrast, the civil space remains fluid, a site where positions still have to be taken up or created (Certeau 1980).

Authorities who wish to regulate civil space by, for example, guaranteeing a public space or by implementing lessons in democracy and public spirit in school curriculums, are pushing the civil space into a civic place. Likewise, the civil movement that demands a better legal framework for a certain issue, is, paradoxically, promoting the elimination of its own reason for existence. It is no coincidence that civil movements often evaporate once their goal has been reached.

This curious position of the civil space also has a historical reason, as Hannah Arendt demonstrates in *No Revolution* (1990). She writes of a "treasure" that was lost in the American, French and Russian revolutions. Arendt refers here to the rural communities of the new continent, the Paris Commune, and the self-organization of Russian workers into soviets. Remarkably, "the men of the revolution," as Arendt calls them, didn't know what to do with the murmuring of this multitude. Nevertheless it was perhaps the same multitude that took the revolutionary idea most to heart. As we know, the troops of Versailles rather brutally swept the communes aside, while Lenin, although paying lip service in founding the Soviet Union, did in fact opt for the secure path of a one-party system. Arendt's analysis therefore shows that revolutions could in fact have followed two diverging historical routes. One, that of party politics (sometimes via a stop-over at despotism), which for various modern forms of politics ended up as liberal representative democracy; or, two, that of bottom-up initiatives of many forms of self-governance. Although for that latter path the way was also paved for democracy – perhaps a more radical democracy than we know today – history has mainly ignored this option. That is why Arendt speaks of "a lost treasure." However, following her insights further, we could say that civil initiatives have actually filled this void. They move in the other direction that history might have taken by picking up where the Paris Commune and the soviets left off. And, they take the same risks as their predecessors. They are still in danger of being shoved aside or being criminalized, violently or otherwise.

Lessons in democracy

One of the most remarkable conclusions drawn by Gert Biesta in his publication *Learning Democracy in School and Society* (2011), is that we cannot be taught democracy. No matter how many lectures in democracy and active citizenship a student attends, if the educational institute itself is not organized in a democratic way, the student will have great difficulty internalizing and realizing whatever fine ideals and insights about democratic governance he or she has learned by heart.

> *"The desire for democracy does not operate at the level of cognition and therefore is not something that can simply be taught. The desire for democracy can, in a sense, only be fuelled. This is the reason why the most significant forms of civil learning are likely to take place through the processes and practices that make up the everyday lives of children, young people and adults, and why the conditions that shape these processes and practices deserve our fullest attention if we really are concerned about the future of democratic citizenship and about the opportunities for democratic learning in school and society." (Biesta 2011: 97–98).*

The same can be assumed to apply to civil behavior. Theoretical lectures on civil spirit, *Bildung*, civil responsibility, et cetera, can only make themselves felt if the civil space is actually experienced, if it is learned while actively engaging with it.

The point is that nowadays schools and universities have great difficulty in organizing civil space democratically. Pressure to perform, competencies to check off and strict contact hours leave little room for democratic organization and decision-making. The latter especially can require much patience as it can take up a lot of time in debate – which can be annoying – because everyone needs to have his and her say. It is, particularly, the unpredictable duration of such processes that the present-day (post-Bologna) educational structure is having trouble with. Within a regime of strict schedules and fixed-end qualifications time is measured precisely. Within school hours there is hardly any "flexible" time, although democratic consultation and organization desperately need the space provided by as yet unspecified time, or "holes" in time. The same can be said to apply to civil space. The fear of claims, panic over potential insurance costs, copyrights and, last but not least, a hired external security company, leave very little room for a gray area between legality and illegality inside the walls of educational institutions. Almost everything has to be regulated and insured nowadays. The traditional school director has had to make way for professional (micro) management that knows how to squeeze every last bit of profit from contact hours and classroom use, i.e., calculating and quantifying everything. That is why our contemporary school regime has also been referred to as a "catering regime": just as with school meals, education and educational space are now neatly apportioned (Gielen and De Bruyne 2012). The fear of negative audits and withdrawal of accreditations do the rest.

A spontaneous field trip because it's a sunny day or there just happens to be an exhibition this month that will have ended by the time all the paperwork is done; a building that remains accessible to students outside school hours; an unspecified class or having a beer with a colleague: all of these sorts of activities are becoming increasingly impossible to do. Still, it is precisely in this informal or non-regulated time and space that exercises in civil behavior can occur. Exactly at those moments when things are not compulsory, but perhaps also, strictly speaking, not allowed, that civil space can occur. It is only then that spontaneous initiatives can originate and independent decisions to take responsibility and to take control can be made. Any government that wishes to encourage civil spirit and civil initiative should actually break open its own schools. Compulsory lessons in democracy and citizenship can at best inspire students, but true democratic behavior and social responsibility can only occur in the gap that a governing body leaves open: that is to say, in the open spaces where governments … do not govern.

Art and civil education

For the time being it doesn't look like governments are going to allow schools more civil breathing space. In Europe anyway, current education policies suggest just this. Still, it seems that civil initiatives have found an escape route to extracurricular domains. Civil praxis now seems to have found a new home in the art world. Those who have been scouring biennales over the past decade have been treated to a veritable feast of political discussions. Sometimes art is hardly the topic anymore, but rather globalism, neoliberalism, precarity or "commonism," to name but a few.

But there is more than just lessons, or room for debate. The space itself is being experimented with. For example, discussions may take place in a setting that looks like the British Parliament, and we only need to think of the artistic projects of Jonas Staal to see how more and more thought goes into the shape of architecture for civil actions. While this literally physical space within education is being heavily formalized – and "formatized" by strict schedules and budgets – the artistic domain offers an opportunity to experiment with the form of public debate. Admittedly, sometimes it is just about building aesthetic façades or backdrops, but more and more artists are also deliberately experimenting with the setting of the public space. This not only allows for lessons *about* democracy and citizenship, but also for lessons *in* democracy and citizenship, because through such formats or experiments participants can personally experience what it feels like to be democratically positioned or not. And, as we have learned from Biesta, it is only in this experience that the desire for democracy "can be fuelled." Precisely because the artistic does not focus exclusively on content but also on form, it co-defines the conditions of a

civil process. But that is not all there is to say about the potential of art for civil education.

After proclaiming "the end of history" (Fukuyama 1992), advocating the end of ideology and de facto the end of democratic differences, the idea of utopia was also buried. An academic taboo on utopian thinking erodes nowadays the humus soil of the civil space, especially that of the social imagination. The current dominance of "realism" and pragmatism in politics deprives it of any chance to develop a long-term vision. Nowadays, any visionary project with an eye on an ideal society invariably runs aground on the Realpolitik of budget policies. This corners the imagination, or, rather, sends it into exile to the exclusive domain of fiction. Only within the cinema, the theater or the art gallery there is still room to speculate about a possible future society.

Perhaps then the boom in fantasy and science fiction movies in popular culture need not surprise us. The first genre is a rosy escape from reality, while in the second utopia becomes dystopia. What both genres have in common is their creation of an image of a truly post-political society at the end of history. Whereas in fantasy movies all power relations have been depoliticized – as they are dissolved in the supernatural and the magical – the world of science fiction tends to present us with societies that are at the mercy of terror, totalitarian regimes, or natural disasters of apocalyptic proportions. Convincing stories about possibly different, utopian worlds are however few and far between. The contrast with the boom in social commitment in that other segment of the imaginary domain of fiction could hardly be sharper: the activist architecture of Recetas Urbanas, the political art of Staal and Oliver Ressler and the postcolonial interventions by Renzo Martens, the utopian but also highly concrete gestures of Thomas Hirschhorn – these are all concerned with imagining a different world. It can hardly be denied that in their quests they are hoping for a possibly different, indeed, better world. It is precisely this imaginary potency that gives them the possibility of going further than traditional education.

As mentioned earlier, the civil space is an undecided zone. This space provides the necessary opening to set a civil intention into motion. Here especially something has to happen, either because no one has seen this civil space yet or no one cares about it. And this brings us to the importance of art. In order to see what no one else has yet seen, artists deploy their powers of imagination. Now that the result of the latest elections in the USA has officially declared the bankruptcy of liberal representative democracy, the need for a civil domain has become clearer than ever. It only adds to the pressure on artists to bet on the gap between creativity and criminality.

REFERENCES

Arendt, Hannah. 1990. *On Revolution*. New York: Penguin.

Biesta, Gert. 2011. *Learning Democracy in School and Society. Education, Lifelong Learning, and the Politics of Citizenship*. Rotterdam, Boston & Taipei: SensePublishers.

De Certeau, Michel. 1980. *The Practice of Everyday Life*. California: University of California Press.

Fukuyama, Francis. 1992. *The End of History and The Last Man*. New York: Free Press

Gielen, Pascal and Paul De Bruyne, eds. 2012. *Teaching Art in the Neoliberal Realm. Realism versus Cynicism*. Amsterdam: Valiz.

ALTERNATIVE ACTION(S) AS A MODE OF ADDRESS
KNOWLEDGE MOBILITY AND THE *IF* PROJECT

Susannah HASLAM Royal College of Art, UK
Jonny MUNDEY, The *IF* Project, UK

ABSTRACT

As part of Susannah Haslam's PhD research on knowledge, dialogue and organization in the expanded field of art, she has been in conversation with Jonny Mundey, co-founder of the *IF* Project, an alternative, experimental and free university organization based in London. These conversations have cumulatively formed the basis of an ongoing dialogue that serves as both a reflective and productive space considering the combined roles of knowledge, the symbolic and the structural institutions of arts education, systems of value, the honorable execution of the political act and the nature and practice of an alternative and possible future arts education(s). These conversations have produced the dialogical essay, *In dialogue – knowledge: its movement, value and organisation or, its criticality, values and struggle* (Haslam and Mundey 2016). Developing this dialogue, new questions have emerged, less concerned with "the what" of the effects of the "intertwined phenomena of global financial crisis, mass migration and the perversion of new technologies," but focussed more on addressing "the how" – that is, how best to move forward and work appropriately within these conditions. As a proposition alone, "Art and Design Education in Times of Change" requires a degree of reflexivity that must acknowledge the possibility of change as an active and pragmatic capacity. Questioning the efficacy of known politics, value systems, knowledges and epistemologies, infrastructures and notions of an alternative in relation to the institution of arts education, this dialogue proposes new forms of addressability when considering what the future of art and design education is in times of immense and precarious change.

KEYWORDS

knowledge, symbolic/structural institution, systems of value, political actions, the alternative

By way of context ...

The *IF* Project is a "free university" that runs free, degree-level arts and humanities short courses, taught by a network of academics who volunteer their time and expertise. *IF* has run two four-week humanities summer schools, and a charity-funded ten-week course that focused on critical thinking techniques deriving from the humanities. It is an initiative in no-fee, alternative higher education – a community where knowledge is exchanged, taught and debated at no cost to students.

Dialogue between the *IF* Project and research into knowledge mobility following art's "educational turn" (focussing on the period 2008–2016) has addressed the wider cultural, political, social and economic implications of conceiving of and establishing a free and alternative education program today in the UK. It has additionally considered the realities, limitations and virtues of enacting the politics of the alternative while simultaneously advocating some aspects of both the symbolic and structural manifestations of the institution of arts education. Together these conversations have constituted the *IF* Project as a mode of address; *IF* takes on, deals with and speaks to the current education climate in the UK. What is particularly interesting is that it exists and can only exist within this so-called crisis of arts education. That is, its existence is completely conditioned upon an arguably failing education system. The acknowledgement of this through action, i.e., through advocating a free humanities education for all and providing access to such an education for a number of students, is testament to the fact that investment in the project is not only made in political and critical terms, but towards the defense of the arts and humanities for the greater good.

A principle undercurrent to this dialogue is art's educational turn, particularly in the now abundant and go-to configurations of the alternative art school, modelled between self-instituted replications of the symbolic institutions of education and more radical and critical manifestations. Some examples are: Open School East, School of the Damned, Alt MFA, Islington Mill Art Academy, the Syllabus program at Wysing Arts Centre, TOMA (The Other MA), among numerous others including constellatory programs such as the reinvigorated Antiuniversity Now festival, each presenting degrees of alignment to the formal institutional structures of the art school and less formal, more radical and critical tendencies of horizontal and peer-led education. All of these contribute to contemporary art's recent undertaking of the task of organization-building. In addition to an increasingly prevalent discourse on the persistence of alter-institutional and para-institutional organizations (Lütticken 2015, 7), this was congruously marked in late 2016 by Pioneer Works' Alternative Art School Fair in New York as the "[recognition] that the act of school building is an effort to create institutional structures that are more responsive to cultural evolution" (Pioneer Works 2016). Noting the abundance of the alternative, our dialogue

intends to make a critical distinction between the kinds of artist-led practices that have emerged from the educational turn and types of extra-institutional programing and instituting such as *IF*. Both attempt to affect the status quo by offering a set of (supplementary) alternatives to an (arguably) otherwise unresolvable arts education climate that generally exists across Europe. Hence the idea of the alternative as a mode of address or strategy towards coping as artist, educator, facilitator, organizer or what Angela McRobbie has called the "creative entrepreneur" (McRobbie 2016, 61) or "artist-précariat" (McRobbie 2016, 84), a collective, oscillating and mobile body whose creativity is often held at the expense of "labor reform" subsumed by the aegis of a "talent-led" (McRobbie 2016, 62) and portfolio economy.

Reflecting on this dialogue, it has emerged that a central and crucial concern moving forward is extended consideration into what it means to simultaneously execute a political act and honor the subject when the future of arts education is concerned. This resonates with Janna Graham, Valeria Graziano and Susan Kelly's call to re-orient the educational turn via "radically altering our reading practices [...] composing transversal processes as continuous movements between critical reflection and intervention in the conditions of production [and] excavat[ing] and learn[ing] from other histories that have informed radical pedagogy and art education" (Graham, Graziano and Kelly 2016, 33). Perhaps what this means explicitly is asking two things: (1) how might we consider what is appropriate action in terms of existing productively and sustainably and for the greater good within the conditions, described by Pascal Gielen, of repressive liberalism and its effects on art and design education? (Gielen 2016); and (2), when thinking of the capacities of addressability towards a changing future for art and design education, what does this appropriateness actually address?

In dialogue ...

The following paraphrases a conversation between the authors that was presented at InSEA's "Art and Design Education in Times of Change" conference in September 2016, and which builds from the original essay.

In our contemporary moment, art, design and humanities education is encountering a problem of value. This is to say that just at the moment when we need the criticality bestowed by the humanities' methodologies the most, the prevailing discourse is one that denigrates the value of this approach. Marketized visions of higher education present it as a transaction, guaranteeing a salary return to the individual student that will allow them to pay back the debt accrued in undertaking their education. We find ourselves a long way away from arts and design education as a way of passing on and inculcating criticality. There is a problem of value therefore, in that the intrinsic value of an arts and

humanities education is in need of defense. One of the central planks of the *IF* Project's approach is simply to defend the worth of such an education.

In this context, how might an alternative such as the *IF* Project enact the notion of defense? The worth of defending the intrinsic value of arts and humanities education towards the idea of a greater good is ultimately and always overshadowed by the monetary cost of such an education. So, how does an alternative action work in this context? *IF* is defined by its alternative status. It is an alternative higher education community, enacting degree-level education that sits outside and extra to established university institutions. A paradox at the heart of the project is that while it is outside, it relies on the expertise and pedagogical brilliance of academics who work day-to-day within the institution. *IF* uses this productive tension to its advantage, while simultaneously acknowledging that it is the same tension that cements the project's fundamentally alternative status (Haslam and Mundey 2016). On the ground *IF* provides short courses in arts and humanities subjects for registered classes of students. These courses are taught face to face. In doing this – offering a completely free higher education space – *IF* enacts an opposition to marketized higher education, and by doing so vocalizes necessary dissent in the UK context.

This is one approach, but there is a very broad range of possible actions within what could be described as alternative arts education. This plurality of the alternative is clear across the educational turn in art, which has produced a multitude of practices that on one hand are instances of institution and organization-building, and on the other are very much bound in a kind

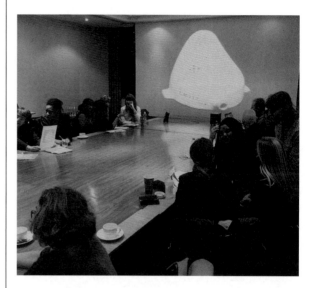

Figure 2. Discussion at an *IF* seminar; part of the course "Thinking: A Free Introduction 2016." Photograph: The *IF* Project

of radical, critical and political action. The tension between these two impulses is writ into all action that is determinedly alternative, and it is useful to consider these alternative actions as occurring somewhere on a scale or axes: vertical (institutional, hierarchical), and horizontal (flat, exploratory).

The *IF* Project identifies itself as straddling this axis by being alternative yet also being aware of its own limitations. In practical terms it is described and defined as a free university, which places the project in a radical tradition; but it is also a registered charity, for the purposes of good governance and to provide a measure of stability to the organization. This is indicative of the tensions that arise when one confronts the reality that radical, alternative and oppositional projects also need to be equipped in order to survive. The project effectively says, "we do not want to exist but we do, because of and despite this crisis in education." The current scenario demands that *IF* exists in order to embody an alternative to prevailing norms. Precisely because the project is in reaction to something, it simultaneously produces its own politics and its own epistemological frame, very much in the manner of Michael Schwab's articulation of expositionality in the domain of artistic research (Schwab 2015, 10), that is to say, the idea of the production of a thing creating its own epistemological framework.

Across the plurality of the alternative, *IF*'s particular action and defense is perhaps best described by the idea of the supplement. *IF* has never claimed, in light of tuition fees, to be a solution to the inequality of access to humanities higher education in the UK; it cannot claim that ground and those involved would never attempt do so. *IF* strongly argues for the worth of an alternative action which is not a solution, and the idea

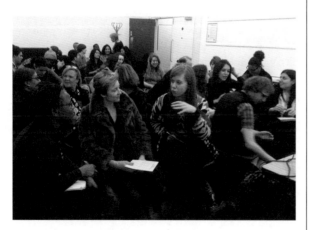

Figure 1. Discussion after an *IF* lecture, January 2016. Photograph: The *IF* Project

of a supplement is useful because it describes something which just by existing signals the incompleteness of the main body to which it is extra. The supplement, in this case *IF*, is designed to say something about that which it is supplementing.

Following the dialogue captured in our long-form essay (Haslam and Mundey 2016), we find ourselves asking further questions about how to inhabit and equip the alternative within present conditions, and look further ahead. How do we honor the limitations of the alternative forum? Do we dig deep and inscribe a foundation, or demand the transformation of the political status quo? Do we think, read, write and act according to an entirely new register, where precarity is the norm and struggle is embodied in the continuous production of alternative forms? In this new norm, how are we to act and how are we to translate and maintain all that is great and good within the broader domain of the arts and humanities? What do we take from the formal and symbolic, structural and institutional project? How do we inhabit the plural and move forward? While these questions belong to a complex discourse, they begin to take form as modes of addressability. Projects like *IF* inhabiting this discourse permits us to strike a productive balance between doing and thinking.

Address through action, address in action

We write at a time of immense political change. The hegemony of neoliberalism – as a language and set of structures within which we speak, act and educate – stutters, and yet retains its status as the primary language and infrastructure of our times and lives. And while right and left subject untrammelled globalized capitalism to varying kinds of critique, the increasingly aggressive marketization of higher education continues apace. As such, the intrinsic value of an arts and humanities education – as a resource for critical thought and action worth passing on to as many as possible; and as a public rather than consumer good – is under attack. It is under attack from legislation (the higher education bill currently under scrutiny in the UK will only deepen the hold of market values on arts education), and by the slow creep of meme, habit and quotidian cliché. While this unwelcome redefinition of what an arts education actually is continues, it will be necessary to be vocal in defense of such an education as a critical social space. It will be necessary to be in constant dialogue with a way of thinking that would erase criticality as an end in itself and arts education as a valuable pursuit in and of itself. It will be necessary to enact as many alternative positions to this as are possible within the limits of the alternative. It will be necessary to speak.

Pioneer Works. 2016. "Alternative Art School Fair." Accessed January 6, 2017. pioneerworks.org/alternative-art-school-fair/.

Gielen, Pascal. 2016. "Artistic Praxis and the Neoliberalization of the Educational Space" Keynote paper presented at the InSEA Regional Conference, Art and Design Education in Time of Change, University of Applied Arts Vienna, September 22–24.

Graham, Janna Valerie Graziano and Susan Kelly. 2016. "The Educational Turn in Art: Rewriting the Hidden Curriculum." Performance Research Vol. 21 No. 6:29–35.

Haslam, Susannah and Jonny Mundey. "In dialogue – Knowledge: its movement, value and organisation or, its criticality, values and struggle." Accessed January 6, 2017. https://drive.google.com/file/d/0B5DIssaZYQFVbUNMm9SNTdXdik/view?usp=sharing.

Lütticken, Sven. 2015. "Social Media: Practices of (In)Visibility in Contemporary Art." Afterall. A Journal of Art, Context and Enquiry 40:4–19.

McRobbie, Angela. 2016. Be Creative Making a Living in the New Culture Industries. London: Polity Press.

Haslam, Susannah and Peter Le Couteur, eds. 2015. Why Would I Lie? London: Royal College of Art.

SITES OF LEARNING: ARTISTS AND EDUCATORS AS CHANGE AGENTS

Dipti DESAI and Jessica HAMLIN
Department of Art and Art Professions, Art + Education Programs, New York University, USA

ABSTRACT

The question we address in this paper – What are the connections between contemporary art, education, and activism? – opens a space to investigate artistic activism as a site of pedagogical possibility. Artist activists ask critical questions, critique and comment on the pressing social, political and economic issues of our times; they also design aesthetic interventions to enact social change. Working within institutions as well as in the public realm, many artists seek to disrupt unequal power structures either through the representation of politics or through direct political action. We align these creative practices with the ways critical educators (in collaboration with students) seek to transform the world through a critical inquiry into pressing contemporary issues. This narrative outlines strategies used by artist activists that have inspired our teaching and, by extension, the socially engaged work of our students.

KEYWORDS

contemporary art, social activism, critical pedagogy, public sphere

Introduction

What are the connections between contemporary art, activism, and pedagogy? As artist-educators committed to radically changing the landscape of visual art education in schools, museums, community-based programs, and in the public realm in the United States, we find ourselves returning to this question time and time again. How can we enact radical approaches in our classrooms, and how can the work of artists doing political activism in public spaces inform this work?

Artistic activists understand that their role as cultural producers is inherently pedagogical (Helguera 2001, x-xiii). The 2012 performative work, *Chalk,* presented in Lima, Peru by Jennifer Allora and Guillermo Calzadilla included the placement of five-foot-long pieces of chalk – much like the chalk used in classrooms – in a civic plaza surrounded by state and city governmental buildings. The chalk provided an opportunity for residents and citizens to write and draw their thoughts and opinions, and to reclaim public space as a democratic site for debate and discussion. As a pedagogical tool and a common protest method, chalk provides an accessible means of political expression as well as the social exchange of ideas. A form of citizens instructing other citizens, Allora and Calzadilla's installation sits at the intersection of political activism and public education.

Public pedagogy refers to the ways that we consume public messages and learn from public forms of culture and media produced to communicate dominant values and messages (Giroux 2004, 497–496). We learn not only in the formal settings of schools and other pedagogical institutions, but perhaps more significantly, we learn from the increasingly visual nature of advertising, popular culture, the Internet, and the design and use of public and civic spaces. If public pedagogy refers to the constant informal learning we all participate in, critical public pedagogy (Sandler et al. 2010, 1–4) speaks to the ways that we must challenge neoliberal educational forms of media and popular culture that actively shape knowledge about ourselves, our communities, and our world.

Through new socially engaged practices, artists are moving to public and community spaces to experiment with pedagogical forms and methods that speak to the pressing concerns and social issues we face today. As a form of critical public pedagogy their artworks seek to question, challenge, and intervene in the maintenance of the status quo; as artists, their work engages a broader public in discourse and actively disrupts unequal power structures.

There are many approaches to socially engaged artwork. More than twenty years ago, cultural critic Lucy Lippard articulated the difference between political art and activist art: "'political art' tends to be socially concerned and 'activist art' tends to be socially involved ... the former's work is a commentary or analysis while the latter's work functions within its context, with its audience to change the situation, in other words it does the political work" (Lippard, 1984, 349). Building from this distinction, we think of the work of socially engaged artists on a spectrum of practices that moves from representation to social action, and we attempt to present these different approaches in our own teaching to inspire future socially engaged artists as well as a new generation of artist-teachers working in schools, cultural institutions, and communities. Through specific course work our goal is to combine theory with practice as a way of modeling and enacting specific activist tactics and longer-term strategies for social transformation.

In what follows we share specific strategies by artist-activists and related student projects that are part of the culminating capstone or final project undertaken in the last semester of their graduate coursework; these strategies provide examples of transformative education in action. The following categories of artistic activism are neither comprehensive nor exclusive but instead overlap and intersect. We find these approaches useful as we look at a broader picture of artistic activism and seek opportunities to inspire new forms of art making and art teaching with our students.

Dreamers

Dreaming can suggest a passive state, but in the context of artistic practice we propose that it can be an active tense of visionary possibility. In the case of artistic activism, dreaming provides a vision of alternative futures combining both realistic and fictional elements. Art can provoke, stimulate and touch us deeply because artists often harness the power of dreaming to propose and enact social change. The Cuban artist Tania Bruguera says, "I want to get into people's minds, into people's political imagination ... the impossible is only possible if someone makes it possible" (Bruguera). Her project, *The Francis Effect*, 2014, asked people to sign a petition to Pope Francis to give Vatican citizenship to illegal immigrants and refugees, regardless of their religion, race or culture. A gesture of artistic imagination, her project is also a conceptual strategy that plants the seed of an idea and mobilizes others to think the impossible.

In 2013, one of our students, Andrea de Pascual created *The Rhizomatic Museum* for her final Masters project. Tapping into the potential of dreaming as an activist strategy, she approached people waiting to enter the Museum of Modern Art in New York and asked them to describe what they would change about the museum. As cultural institutions struggle to be inclusive spaces, her goal was to better understand the nature of exclusion and determine modes of action for re-creating the museum as a space for participation and action.

Tricksters

Artist activists around the world use humor, parody, satire, and irony to challenge institutional power and interrupt the flow of information by government and corporations, as well as the media and advertising industries. The trickster is a key figure in many creation stories from around the world, a figure who provides solutions to problems or explanations for why things are the way they are, but in ways that contradict or defy social norms or conventions. The trickster as suggested by the anthropologist Victor Turner is "a liminal actor ... someone who appears in unstable situations and has the potential to impact on those situations" (Weaver and Mora 2015, 480). Using the tactic of subversion, the trickster is a border-crosser. Working as tricksters, artists enact a playful tactic of defense against authority and often point to the absurdity of those in power. The collective, Enmedio (Spanish for "among") has created dozens of DIY protests against anti-austerity measures in Spain, utilizing accessible aesthetic and performative methods to activate the public. In 2012 they created *Close Bankia* to protest bank bailouts by throwing a spontaneous party every time someone closed their bank account; and *Reflectantes*, which used large reflective balloons to disarm police during protest confrontations. These transformative actions insert unpredictable and spectacular events into contested sites, rendering traditional power structures ineffective and calling attention to broken systems and structural inequities through humor.

As part of her final graduate project, artist and educator Nicole Shulman chose to use the tactics of the trickster to protest the closing of a bus route used by herself and her working class neighbors in Brooklyn, and the increasing privatization of public spaces such as bus stops. During her research and final project seminar, Shulman was introduced to various strategies used by urban-intervention artists that include humor and satire. She leveraged these ideas to create an urban intervention that referenced the work of Rene Magritte as a means of mocking the Metropolitan Transportation Authority. On a defunct bus shelter, Shulman added a sign stating "This is not a bus stop." She also installed a book in the shelter with a link to a website that collected feedback from the public about the bus route that was being closed.

Infiltrators & thieves

Another tactic used by artist-activists includes co-opting or appropriating the visual and media strategies of commercial, corporate, and governmental messaging. Through advertising and the news, capitalist and neoliberal forces that sell ideas or products infiltrate subconscious and unconscious feelings, emotions, desires, and aspirations. Artist and scholar Steven Duncombe explains that activists have learned from advertising that "desire can be power" (Duncombe 2001, 1). Recognizing the ways that corporate interests tap into personal and emotional desires to sell a better life, artists have identified opportunities to infiltrate these systems in the interest of critique as well as to deliver their own counter messages and information. In 2009, at the height of the Iraq War and the protest movement aimed at dismantling public support for it, the artists Andy Bichlbaum and Steve Lambert produced the project, *Iraq War Ends* by mimicking the design of the *New York Times* newspaper, while subverting its content. Creating their own realistic version of the newspaper by substituting the front headlines and news articles, they proclaimed the end of the war in Iraq and distributed 80,000 copies on the streets of New York City.

In a related act of artistic subversion, artist-educator Annie Kyle developed the project, *Portraits of Power*, with New York City African American and Latino high-school students in Harlem as part of her student teaching coursework. After analyzing the history and visual symbolism of many "master" works from the Western canon of art history, students re-staged selected portraits using personal symbol systems and photographing themselves as contemporary protagonists now embedded in these historical representations of power. The portraits were then exhibited at El Museo del Barrio in New York City, infiltrating the museum as a form of counter-narrative and an assertion of a reimagined, more inclusive canon.

Collaborators and coalition builders

Working in a collaborative manner is a critical component of artist-activist approaches. Often, artists work within existing infrastructures as a means of building capacity and enhancing collective power. Beyond amplifying a message or desired outcome, working within a community supports a stronger integration with local issues. In his book, *Community,* Gerard Delanty traces a history of community as originally defined by the Greeks as the "polis," and inferring a shared physical space. More recently, he says, "contemporary communities are communities that are more willfully constructed; they are products of practices rather than products of static structures" (Delanty 2003, 102). Many socially engaged artists understand that actively involving those who share a common concern or need is a form of community construction and can be supported through artistic means and methods. In the case of the artist Pedro Reyes working in the city of Culiacan, Mexico, the artist rallied the community around the issue of pervasive gun violence. His project, *Palas por Pistolas* (2008), solicited donated guns and other weapons by offering a TV or domestic appliance in exchange, and then melted them down to create shovels. Working with city residents through art institutions, schools, and service organizations, the shovels were used to plant trees and transformed an agent of death into a means of regeneration. Reyes brought

people together to form a temporary community that used trade and barter as a means of participation and solidarity.

As a student teacher in an urban high school that is committed to social justice and student activism, graduate student Ariana Mygatt created the project *Making Community Visible* to address the rapid gentrification and disenfranchisement happening around the immediate neighborhood of the school. After introducing contemporary photographers and the history of social documentary, Ariana asked students to think about how their photography could serve as a form of visibility and activism within the neighborhood. The students created a collaborative photo mural and a collective Instagram account to counter the glossy real estate advertisements that were transforming their community.

Closing thoughts

As educators in higher education, preparing artist-educators to work as activists in schools, communities, and cultural institutions opens up spaces of possibility and presents challenges. The examples of artist projects and student work included in this article represent what we feel are successful examples of translating activist strategies into educational contexts; but there are also institutional limitations to this kind of work: course requirements, time limitations, changing student bodies, student diversity, and connections to local communities when students move from other cities and countries all impact the breadth, width and ethics of this kind of activist work. What is the nature of truly collaborative art practices? How do we navigate the power of voice and authority in education and community sites? How do we know when strategies are effective and whom they are affecting? We continue to grapple with these questions and see this work as a long-term commitment towards enacting social change through the arts, not only in the current moment with our students, but through future generations of activist artists and educators.

REFERENCES

Bozzil-Morozow, Helena. 2015 The Trickster and the System: *Identity and Agency in Contemporary Society*. New York: Routledge.

Bruguera, Tania. *The Francis Effect*, Art21 Exclusive Video. Accessed November 12, 2016. https://www.youtube.com/watch?v=8dMFIIPhmPA.

Delanty, Gerard. 2003. *Community*. New York: Routledge.

Duncombe, Steven. 2005 "Think Different: Lessons for the Left from Madison Avenue." *The Journal of Aesthetics and Protest*, 4. Accessed November 12, 2016. http://joaap.org/4/duncombe.html.

Giroux, Henry. 2004. "Public Pedagogy and the Politics of Neo-Liberalism: Making the Political More Pedagogical." *Policy Futures in Education*, Vol. 2, No. 3:495–503.

Helguera, Pablo. 2011. *Education for Socially Engaged Art*. New York: Jorge Pinto Books.

Lippard, Lucy. 1984. "Trojan Horses: Activist Art and Power," In *Art after Modernism: Rethinking Representation*, edited by Brian Wallis, 341–58. New York: New Museum.

Sandlin, Jennifer A. Brian D. Schultz and Jake Burdick. 2010. Handbook of Public Pedagogy: *Education and Learning beyond Schooling*. New York and London: Routledge.

Weaver, Simon and Raul A Mora. 2015 "Introduction: Tricksters, Humor and Activism," *International Journal of Cultural Studies*, Vol. 1, No. 7:479–485.

SERVICE LEARNING THROUGH A COMMUNITY ART PARTICIPATORY PROJECT

Christine LIAO
University of North Carolina Wilmington, Department of Early Childhood, Elementary, Middle, Literacy, and Special Education, USA

ABSTRACT

Participating in community art-making constitutes service learning with the potential to effect positive change in a community. This project taught under-graduate students to use art in a hands-on way to meet community needs. Students participated in a mural project in a low-income urban area to see first-hand how such projects can bring community members together. The mural was created on a 73-meter-long wall belonging to a rundown facility in a low-income area used by an after-school art program. The mural's theme was "Forest of Dreams" and included creatures borne of community members' imaginations. The students also designed a creature for the wall, which gave them some ownership over the project. Specific times were designated for community members and students to participate in the painting. The project proved to be a rewarding learning experience for the students, most of whom had never visited the neighborhood before because of its poor reputation. They saw how different groups of people can work together, and how a community art project can play a positive role in a neighborhood. The article discusses the process whereby the project was executed, and the students' educational outcomes.

KEYWORDS

community art, service learning, community mural

Community art and service learning

Community art – that is, art created by community members working together for the purpose of transforming their community, of engaging community members, and of encouraging collaboration – has the potential to create positive change (Golden 2014, 15–19). However, a finished artwork does not necessarily tell the whole story of its effect on a community. As community art involves the participation of community members, the process is at least as important as the finished artwork. The socially interactive nature of community art is what makes it transformative (Lowe 2001, 457–58). According to Hutzel's (2007) study, focused on the impact of community art, participants realize that they can effect changes in their community. Further, engaging at-risk children with community art can lead to constructive behavior on their part (Sickler-Voigt 2006, 156). On the basis of such observations, it is reasonable to conclude that participating in community art constitutes the best way to experience its transformative power.

The purpose of service learning is for students to learn through working with a community. Although similar to community service, service learning is connected to a curriculum in which students are expected to meet educational goals and the community is expected to benefit (Kraft 1996, 136). Taylor (2002) argues that service learning is postmodern art pedagogy that is creative in its process and provides real life learning opportunities. In addition, service learning emphasizes participants' reflection on their work (Taylor 2002, 128). Combining community art and service learning "brings together the power of the arts with the essential components of service-learning in a mutually empowering way" (Krensky and Steffen 2008, 15). It is exactly at this intersection that the community art participatory project described in this article is located.

Process of the project

The community art participatory project described herein was part of an elementary education course that teaches students how to integrate the arts into their classroom practice. The project idea started with a discussion with Dr. Janet Robertson, a colleague who was interested in working with "Dreams of Wilmington," a local non-profit after-school arts program, to create a mural on the outside wall of their facility. Located in a low-income, high-crime downtown area that has been neglected for many years, the organization provides free arts programs for local K-12 students from low-income families. Its facility is a deteriorating city property in need of renovation. As it is currently used to provide arts programs, the facility could provide a different landscape in an area characterized by abandoned houses and rundown public spaces. In fact, the Dreams of Wilmington staff envisioned creating a different kind of public space in the neighborhood. Before the mural was created, the 73-meter-long gray wall was an eyesore with multiple cracks and a chain fence running along the top (Figure 1). It was no one's idea of an arts program space. Dr. Robertson planned to create a mural on the wall with the theme "Forest of Dreams," and to engage community members in both designing and painting the creatures that would populate this landscape.

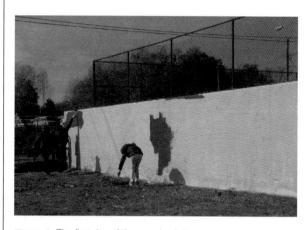

Figure 1. The first day of the mural painting. Photograph: Christine Liao

Although most of my undergraduate students had not visited the area where Dreams of Wilmington is located because of the area's bad reputation, they were, in the future, likely to be teaching children from elementary schools in the area. In order for them to learn more about these children and to engage with the community, I asked them to participate in the community mural art project. True to the goals of service learning, the students participated in the project and fulfilled their own direct educational goals and benefitted the community in the process. The goal was to show the students how such work can bring a community together and even lead to positive changes there.

We started by learning in class about community art. As most of the students had yet to participate in a community art project, their first step was to research examples of it and learn about the changes such projects had brought to other communities' lives. They also researched the after-school arts program to learn more about its impact on students. For example, they were excited to discover that 100% of students in the program graduate from high school and 99% go on to college or join the military ("DREAMS of Wilmington" 2016).

An important aspect of the mural idea was that it would include fantastic creatures to represent the community and community organizations. After their initial research, the next step for the students was to work in groups to design creatures to include in the mural and that would represent the community and the college. Many local schools, organizations, groups, and businesses participated in designing a dream creature. Some organizations also volunteered by making donations to support the project.

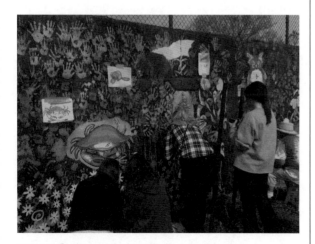

Figure 2. Students worked together to paint the mural.
Photograph: Christine Liao

The open mural painting was scheduled every Saturday over a two-month period. The students contributed to the project in a multitude of ways: not only did they participate in the painting (Figure 2), they also helped organize the painting event by such activities as working at the sign-in booth, preparing the paint, and cleaning up the site. Through guided activities, they also worked with young children in order to help them participate in the painting at the site.

The power of participating in community art

A number of key questions guided this project: How does participating in a community art project help students understand the impact of community art? And, what changes did they see associated with the project? Each student submitted a critical reflection discussing their experience with the project and what they learned from it. Their reflections were analyzed and categorized for research purposes.

Seeing is believing

After participating in the project, most of the students commented that they were amazed by the participation of the community members. They did not expect to see what turned out to be a very diverse group of community members come together to work on the mural. Seeing first-hand how creating the mural brought people together strengthened the students' understanding of the possibilities of community art. In fact, a number of the students felt that the community had become a family through the project. This comment exemplifies this view as expressed by multiple students:

> This project made the community feel like a family. Many people who lived around the area helped to paint the creatures, and I think that is great. There were people who have been going each Saturday and it was neat how they became really close. (Student SA. 2016. Reflection, May 2.)

Art can go beyond boundaries to become a shared interest. Another student saw that the mural had become the center of the community, thereby demonstrating that art is a shared language:

> It was incredible to see children coming from around the area to see the progress that the mural had made. I love the fact that art was the center of the community, and that it brought together people that may not usually be together on a Saturday morning. (Student MS. 2016. Reflection, April 25.)

Overall, the students got to know community members and gained a better, general sense of the community. Many students came to know community members

quite well through working together on the project; and they were particularly pleased to see how excited many of the children were about having a hand in the art-making:

> These kids were so excited to help and be a part of something that is close to their home. I was able to talk to the families and find out about their lives and what they are learning in school. (Student BC. 2016. Reflection, April 4.)

Through this project, the students gained an understanding of the need to teach children from the community, and they saw the importance of the process of creating art as a way of bringing people together to work on something meaningful to them.

Transforming the community

The students were able to see that the mural project brought changes to the community. One obvious difference pertained to the environment. The mural brought a different visual landscape to an area known for poverty and crime. One student reflected on this visible difference as follows:

> Driving down to the mural, I had to go through some areas downtown [where] I knew there was a lot of crime and it was very different than the areas around campus. After I turned and the mural was proudly displayed down the street, the sense of community and the environment completely changed. (Student JL. 2016. Reflection, May 1.)

Many of the students and community members were concerned that the mural would be damaged and covered with graffiti soon after it was completed. However, so far, this has not turned out to be the case. Neighbors keep a lookout on the mural, as they think of it as belonging to them.

Students also observed how a community can form:

> I was able to see that community art projects actually form a community. Relationships are built, memories are made, and Wilmington as a whole came together in order to make that street a little bit brighter and bring hope to the students that attend that after-school program. (Student DK. 2016. Reflection, April 7.)

The power of art for transformation was seen from every angle. Not only did it create a sense of community and produce some excitement, but "art can really brighten someone's everyday life and make them feel a little happier" (Student MW. 2016. Reflection, May 1).

Community art integration

Many of the students did not expect to have a positive experience working on the project. Some reflected that initially they did not want to participate. Service learning is often associated with volunteer community service. However, Taylor (2002, 129) makes a compelling case against this idea: "[W]hen service-learning is a required aspect of a university course, the students are not volunteering. ... The word volunteerism does not necessarily carry with it the enduring sense of civic responsibility that is the primary purpose of service-learning programs."

The value of service learning is the learning experience. Although students were initially hesitant to participate, they all later reported having a positive experience and saw the power of community art through this project. When working on the project, some felt more comfortable working with children, while others enjoyed the opportunity to paint or interact with community members. Finding where they can best use their abilities and contribute to the community is an important key to any successful project.

In contrast to their initial misgivings, the students also made a connection with the curriculum and expressed the view that everyone should learn about the value of community art:

> When first approached with this project, I felt like it was a misplaced assignment that was tacked on to our already overwhelming course load. However, I have learned that community art is a fundamental integration into a curriculum. I think that community art should be included in every grade to teach students the value and worth behind creating and beautifying something that was rejected. (Student BD. 2016. Reflection, April 30)

Some students offered a further explanation of the benefits of community art in one's curriculum. As one student said, "I think by including community arts in the curriculum, students will begin to develop a sense of involvement and personal responsibility for the environment in which they live" (Student DD. 2016. Reflection, April 22).

Conclusion

This community art participatory project showed the value of service learning. Although a project like this comes with risks throughout the process – for example, I had to change the project's timeline because of the city permit issue for the mural site – I learned the most from the challenges I had to face. When I planned to include it in the course, it was impossible to know how the community mural project would turn out and how the community itself would react. There had never been a project like this there before. However, I believed that art can bring change. Through this service learning project, the students played a role in creating change through the power of community art. They also learned to solve real life problems through art. I encourage teachers to find opportunities to engage students through service learning, to expose them to different perspectives and to enable them to rise to new challenges.

REFERENCES

"DREAMS of Wilmington." 2016. *Dreams of Wilmington*. http://dreamswilmington.org/.

Golden, Jane. 2014. "Growing Up, Growing Out, Putting down Roots." In *Mural Arts @ 30*, edited by Jane Golden and David Updike, 15–19. Philadelphia, PA: Temple University Press.

Hutzel, Karen. 2007. "Reconstructing a Community, Reclaiming a Playground: A Participatory Action Research Study." *Studies in Art Education* 48 (3): 299–315.

Kraft, Richard J. 1996. "Service Learning: An Introduction to Its Theory, Practice, and Effects." *Education and Urban Society* 28 (2): 131–59.

Krensky, Beth, and Seana Lowe Steffen. 2008. "Arts-Based Service-Learning: A State of the Field." *Art Education* 61 (4): 13–18.

Lowe, Seana S. 2001. "The Art of Community Transformation." *Education and Urban Society* 33 (4): 457–71.

Sickler-Voigt, Debrah. 2004. "From out of Sight to 'Outta Sight!' Collaborative Art Projects that Empower Children with at-Risk Tendencies." *The Journal of Social Theory in Art Education* 24: 156–76.

Taylor, Pamela G. 2002. "Service-Learning as Postmodern Art and Pedagogy." *Studies in Art Education* 43 (2): 124–40.

ART AND DESIGN ON THE EDGE: CHALLENGE, CHANGE AND OPPORTUNITY IN THE ARCTIC

Glen COUTTS and Timo JOKELA
University of Lapland, Faculty of Art & Design, Department of Art Education, Finland

ABSTRACT

This article is in three parts. The first part addresses the central theme of the title, "Challenges for the Arctic," as viewed through the lenses of contemporary art and design practice as agents for change. We discuss developments at the University of Lapland and the *Thematic Network, Arctic Sustainable Arts and Design* (ASAD), which focuses on innovative ways of using contemporary art to address socio-cultural issues in diverse cultural contexts. In the second section, the theme of change is addressed. We reflect on developments in art education in the North, and a new study initiative located at the intersection of art and design practice that draws on the key strengths of both the art and design disciplines. Referred to as *Applied Visual Arts*, the studies require students to work on issues related to the Arctic and the circumpolar north, thus creating a challenging environment for students to create innovative solutions with community groups. The third part considers some of the opportunities that the unique socio-cultural and ecological conditions which exist in the Arctic afford. We discuss the roles of art and design and the potential benefits when they operate in collaboration with local partners. How might the techniques and methods of art and design be used for the benefit of local people and business?

KEYWORDS

Arctic, art and design, community art, applied visual arts

Challenge

As the economic, political and social landscape changes in Europe and the rest of the world, perhaps we need to reconsider the nature and purpose of art and design education and training. In addition, in our region, the special challenges facing the Arctic need to be foregrounded in the redevelopment of art education: for example, extreme weather conditions, sparsely populated areas, long distances between communities and the migration of people.

The creative industries, often characterized by small, flexible and interdisciplinary companies, are an increasingly important sector of future economies in many parts of the world, and this is increasingly the case across the Arctic. The Circumpolar North contains a vast set of knowledge and skills, built over generations by indigenous peoples and other northerners and manifested in the region's modern institutions of knowledge; these are the heritage of the North's various communities for the future of the arts, design and visual culture.

Arctic Sustainable Arts and Design (ASAD) is a *Thematic Network* of the University of the Arctic (ASAD 2016). Established in 2011, it aims to identify and share contemporary and innovative practices in teaching, learning, research and knowledge exchange in the fields of arts, design and visual culture education. In addition, ASAD seeks to be an agent of change by bringing together academia and the creative industries for specific events or projects. Between 2011 and 2016, five symposia and exhibitions have taken place in five different countries across the North. The network consists of art and design art education universities and similar institutions in the circumpolar area. Combining traditional knowledge with modern academic knowledge and cultures at northern academic institutions, ASAD represents an opportunity unique to the Arctic.

ASAD has been developed on collaborative, partnership and collegiate principles to encourage researchers, artists, designers and educators to serve as visual designers or consultants in various everyday environments. They may, for example, be developers of adventure and cultural environments, art-related services or organizers of place-specific events. Thus, artistic work is carried out in cooperation with cultural institutions, the education and social sectors, and industry. Typically, the artistic activities share spaces with the social, technical, and cultural sectors.

ASAD's collaborative events are based on experiential, project-based learning, and community and place-specific methods of contemporary art. Education implemented in this practical "project-form" has points of reference in, among other things, the latest participatory trends in contemporary art, for example, community and environmental art. In addition, design thinking informs the work of the ASAD network in the shape of environmental service design and co-creation methods. A central aim of the ASAD group is to bring together art and design professionals to apply their expertise and art techniques for purposes external to the art world. It is a prime aim of ASAD to integrate artistic skills with practice-based scientific knowledge so as to create ecologically and ethically sound environmental experiences, services, and art productions that are based on the cultural heritage and traditions of an area and its people. The ASAD network facilitates project-based collaborations with cultural institutions, and public, social sector and tourism companies in the Arctic and northern regions. For example, partner universities collaborate with the public and private sectors to develop products and services that meet specific social and economic needs. From the outset of the ASAD initiative, a principal goal has been to develop new and innovative forms of cooperation, environments, and products that can, in a sustainable manner, contribute to the vitality and well-being of the Arctic. A central tenet of the network is knowledge exchange, and this is achieved in a variety of ways including staff and student exchange, partner-to-partner research projects, exhibitions and publications (Coutts and Jokela 2016, 2015, 2014).

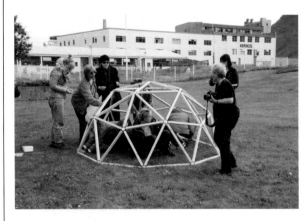

Figure 1. ASAD collaborative event, Iceland, 2016
Photograph: Elina Harkonen

Change

Social circumstances, as well as industry and commerce are changing rapidly in the Arctic as they are around the world; concurrent with these changes, the demand for an adaptable, highly skilled and creative workforce has increased. In most countries in northern Europe, particularly in Finland and the UK, higher education institutions have traditionally produced graduates with a good "skills mix" of creativity, Information Communication Technology (ICT) knowledge, and sound practical competences. Art schools with their emphasis on independent and studio-based learning have been excellent at allowing students to pursue their own ideas, whilst providing training in practical and craft skills. Education in art and design has always been about creativity, problem solving and encouraging alternative ways of seeing and making sense of the world. Although there are notable exceptions, what has been missing in many such programs has been practice-based learning rooted in the "real world" (Coutts, 2013).

Figure 2. Collaborative working
Photograph: Merja Brinon

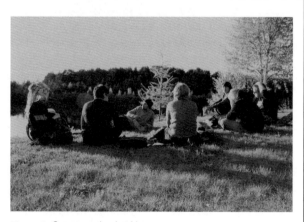

Figure 3. Summer school at Li
Photograph: Glen Coutts

The model of art education in Finnish universities and academies of art is largely based on the early 1930s German Bauhaus program. Art education at the University of Lapland was one of the first education programs in Finland, where, in the spirit of postmodernism, new kinds of contemporary artistic forms of education have been developed, particularly in community-based and environmental art. (Coutts and Jokela, 2008; Jokela and Huhmarniemi, 2008).

Instead of educating fine artists who exhibit and try to sell their art, the new programs have been based on the increasing trend for artists to be employed as specialist consultants and project-workers. In this model, artists act as facilitators for a community group, public service or business, using their skills and experience. For example, visual arts and cultural productions have become an integral part of the tourism-related "experience industry" in the North.

What is now known as the Applied Visual Arts (AVA) program differs significantly from the traditional so-called "free" art (fine art) education, which typically focused on the artist's personal expression via various media. AVA is situated at the intersection of visual arts, design, visual culture, and society, from which it draws its themes, operating environment, and network. Compared to the fine arts, it is about a different approach and expertise, as AVA is always based on communities and socio-cultural environments, as well as places that define it and its means of activity and expression. Training in social engagement in its many forms is an integral part of the program; students are required to design and deliver "innovative productions" (Jokela 2012, 7) on location and with community groups.

In practice, AVA projects involve artists working with, or for, people in a public context. AVA is a context-driven model of art practice characterized by notions of participation, collaboration and inclusion. It should also be recognized that, while the focus of AVA is on visual arts, projects frequently embrace work across art disciplines. Projects might include, for example, performance, sound or movement. Working in this field, artists need to draw on many different disciplines, including anthropology, cultural geography and place-making, sociology, history and town planning. Inevitably, there are many points of interaction between different professional disciplines, and it is impossible for the artist to be an expert in all of them. However, it is essential that the artist has skills in what Lester and Piore have called "interpretive innovation" (2004, 97), and this has implications for the way we conduct art education. Education providers need to consider whether the programs on offer are those most conducive to developing the skills-base required to deal with the complexities of the world of work in the twenty-first century.

Opportunity

The unique conditions of the Arctic and the focus on arts-based research in the North are factors that have presented an opportunity to look at new ways of educating arts professionals. The AVA program seeks to produce multi-skilled arts professionals with the ability to work with a wide range of individuals and groups. In addition, they should be able to participate seamlessly in diverse development initiatives. AVA should not be thought of as synonymous with, but rather complementary to, already established professions such as graphic design, architecture and interior design. The interaction between science and art, environmental engineering, tourism, and the public social and health care sectors are central to AVA practice. In essence, AVA practice is multi- and inter-disciplinary. Successful examples of AVA draw on many different disciplines and traffic back and forth across the traditional boundaries of fine art and design. Methodologies inherent in design processes can be clearly traced in many of the AVA projects (Jokela, Coutts, Huhmarniemi and Harkonen, 2013). The artists who work in this field require skills that are not often taught in art academies; while they are, to be sure, artists, they also need skills in research, documentation, analysis, community engagement, interpretive innovation (Lester & Piore 2004) and design thinking (MacDonald 2012). To engage communities and companies with the practice of art requires practical skills, leadership, innovation, entrepreneurship and diplomacy.

The development of AVA is also an opportunity to improve the status of the North in the highly competitive area of arts and cultural funding. The AVA program's main objective is to educate art professionals for the specific needs of the northern environment and its communities, professionals who will have the capacity to work in close cooperation with the various stakeholders and fully utilize their own expertise. Thus, AVA has aimed to meet the needs of Lapland's leading industries, including the tourism and adventure businesses that have been related to the development of the outdoor environments and services, and to achieve a sustainable way of promoting the well-being of the region. Therefore, it has been essential to cooperate with business and industry in the form of joint projects. The goal has been to develop operational models, build networks, and respond to partners' growing needs with a common language for artists, designers, businesses, and local stakeholders.

The notions of participation and co-creation are increasingly at the forefront of current educational thinking. The balance between theory and practice and "hands on" thinking-through-making permeates research and teaching in AVA. The AVA program sets out to train people in a broad range of competences: "Tomorrow's creative economy will require an even richer fusion than today's of knowledge and skills from individuals who are comfortable working across the boundaries of established disciplines." (Bakhshi et al. 2013, 105).

It is not a coincidence that AVA was launched at the University of Lapland. The university's strategy has been to profile itself as a place of northern and Arctic research, in addition to research in tourism. It has therefore created an opportunity to examine the role of art in strengthening the university's northern expertise. In addition to art, the socially-oriented disciplines of the university have begun to re-evaluate their views of the north in the light of changing socio-cultural and ecological circumstances. Based on the positive results and knowledge gained from the AVA program, as well as the faculty's collaborative international intensive courses and research projects, a new international Master of Arctic Arts and Design program was launched in 2015. In this new program the engaging nature of applied visual arts and the participatory essence of service design merge together through art-based action research.

This is all happening at a time when fruitful cooperation in research across academic disciplines is being developed. In this new situation, environmental and community-based art offers the tools to research the encounter of contemporary art with northern living conditions, as well as the practicality of contextual art education.

Figure 4: Screenshot: The ASAD website

REFERENCES

ASAD. 2016. Accessed January 12, 2017. www.asadnetwork.org

Bakhshi, Hasan, Ian Hargreaves and Juan Mateos-Garcia. 2013. *A Manifesto for the Creative Economy*. London: NESTA. Accessed January 12, 2017. www.netsa.org.uk.

Coutts, Glen. 2013. "Applied Visual Arts: Learning for the Real World?" In *COOL: Applied Visual Arts in the North*, edited by Timo Jokela, Glen Coutts, Maria Huhmarniemi and Elina Harkonen, 22–31. Rovaniemi: Publications of the Faculty of Art and Design, University of Lapland. Series C. Overviews and Discussions 41.

Coutts, Glen and Timo Jokela, eds. 2008. *Art, Community and Environment: Educational Perspectives*. Bristol, UK, Chicago, USA: Intellect.

Coutts, Glen and Timo Jokela. 2016. "Art, Community and Context: Educational Perspectives." In *Cultural Sensitivity in a Global World: A Handbook for Teachers*, edited by Enid Zimmerman, Steve Willis, and Marjorie Cohee Manifold, 136–146. Reston, VA: National Art Education Association.

Jokela, Timo, Coutts, Glen, Huhmarniemi, Maria and Elina Harkonen, eds. 2013. *COOL: Applied Visual Arts in the North*. Rovaniemi: Publications of the Faculty of Art and Design, University of Lapland. Series C. Overviews and Discussions 41.

Jokela, Timo and Glen Coutts, eds. 2014. *Relate North 2014: Engagement, Art and Representation*. Rovaniemi: Lapland University Press.

Jokela, Timo and Glen Coutts, eds. 2015. *Relate North: Art, Heritage & Identity*. Rovaniemi: Lapland University Press.

Jokela, Timo. 2012. *Arts, Cultural Collaborations and New Networks: The Institute for Northern Culture*. Kemi Tornio University of Applied Sciences.

Jokela, Timo and Maria Huhmarniemi. 2008. "Environmental Art and Community Art Learning in Northern Places." In *Intercultural Dialogues about Visual Culture, Education and Art*, edited by Rachel Mason and Teresa Eca, 197-210. Bristol, UK, Chicago, USA: Intellect.

Lester, Richard K. and Michael J. Piore. 2004. *Innovation – The Missing Dimension*. Cambridge MA: Harvard University Press.

Macdonald, Stuart. W., 2012. "Tools for Community: Ivan Illich's Legacy." *International Journal of Education through Art*, 8(2): 121–133.

#2
CHANGES

ADDRESSING CONTEMPORARY SOCIAL ISSUES THROUGH CULTURE: A FRAME-WORK FOR ACTION

Jocelyn DODD
University of Leicester, Research Centre for Museums and Galleries (RCMG), School of Museum Studies, United Kingdom

ABSTRACT

Arguably, the arts and culture have never been more important than they are today. At a time of such rapid change and instability, we more than ever need to be reflective, empathetic, resilient and engaged citizens. Participation in the arts and culture enables us to develop those skills critical to a world undergoing drastic change. This paper will draw on research undertaken by the Research Centre for Museums and Galleries (RCMG) at the University of Leicester, UK. It will consider what elements are required for us to address contemporary social issues. What values underpin this work? How do these pervade every element of what we do? How can we develop activist practices? What ethical issues do we need to consider? With a range of skills, expertise and approaches, how can we work collaboratively so as to ensure that some people's views are not privileged over others? How do we make sure that this work has contemporary relevance? What impact can such work have? How do we express the experiences of participants? Why is this impact so important?

Central to all of these questions is how we value difference: by making it part of our strength, diversity is critical to our ability to thrive. Combining a variety of processes and case studies, this paper proposes a framework for action that will be adaptable to diverse contexts but also provide a rigorous underpinning to support cultural work that is concerned with contemporary social issues.

KEYWORDS

values, difference, impact, activist practice

In a time of rapid social change, we need, more than ever, reflective, empathetic, resilient and engaged citizens. Art and culture can help us to develop these skills and navigate through complex issues. Yet why are cultural institutions still reluctant to tackle contemporary social issues? Drawing on research by the Research Centre for Museums and Galleries (RCMG), University of Leicester, UK, this paper proposes a framework for action to support cultural institutions to engage the public with contemporary social issues, a framework that is adaptable to diverse contexts and provides a rigorous underpinning to support cultural work connected with activist practice.

The value of art and culture

In a world undergoing drastic social, demographic, environmental, political and economic change we should not underestimate how effective art and culture are for developing active and engaged citizens. Crossick and Kaszynska (2016) highlight how art and culture not only provoke us to reflect on our own lives, but can also lead to enhanced empathy enabling us to appreciate the diversity of human experience. This would certainly be hugely significant in a world with increased numbers of displaced people from very different backgrounds and experiences from their host communities. As forums for debate, art and culture can create conditions for change by disrupting established patterns of thinking and helping us imagine alternative futures. Participation in art and culture can (1) develop engaged citizens who are involved in other civic behaviors such as voting and volunteering, which are critical to the effectiveness of our democratic political and social systems; and (2) support positive outcomes of well-being, in particular resilience, an attribute that allows us to cope with the challenges that are part of everyday life.

The importance of values

What values are critical to shaping this work? Socially-engaged museums like those of National Museums Liverpool (NML) are driven by social justice, equality, human rights and the desire to make a difference in people's lives. These values are embedded across the organization and expressed through their statements and strategies. Liverpool is a deprived city and NML sees it as their responsibility to "'help mitigate the social consequences of adverse economic conditions" (Fleming 2012: 74). As a result, NML's visitor profile reflects the city's diversity, with 26% of visitors in 2010–2011 from lower socio-economic groups, compared to only 13% for London-based national museums (NML n.d.). The issues NML tackles are challenging; these include domestic abuse, the legacy of slavery, immigration, transgender and dementia. It faces them through connecting with people's everyday lives, and as a consequence, is extremely popular. It is important for cultural organizations to articulate their values clearly as too often they hide behind a smoke-screen of authority that allows them to avoid taking responsibility for aspects of their policy and strategy.

Figure 1. Mat Fraser performs "Cabinet of Curiosities," Photograph: RCMG

Examples of practice: Refugees and asylum seekers

How can museums impact upon our understanding of contemporary social issues? Three projects show how working with refugees and asylum seekers can help integration and challenge negative perceptions among existing communities. Salford, Greater Manchester, was one of the largest dispersal areas for refugees and asylum seekers under the 1999 Asylum and Immigration Act. Originally from Afghanistan, Nadeem was one of ten refugees and asylum seekers involved in a volunteer program at Salford Museum. The museum provided a safe and respectful space away from the abuse Nadeem experienced in the community. Her experience of volunteering and the sight of tattered, children's clothes in an exhibition had a profound effect on her, enabling her to talk about and confront her painful past. Although it brought back experiences of conflict, including seeing her home devastated by a bomb, it helped her to focus on the future: "'Now I can see that time as a past time. I don't feel really bad talking about these things" (Hooper-Greenhill et al. 2007: 10).

While Woking, Surrey, was not a dispersal area where communities do not come into contact with refugees and asylum seekers, there is perhaps a greater imperative to engage these places too in a sustained and focused way. As part of a national program to explore the impact and legacy of twentieth-century conflict. The Lightbox worked with 15–16 year old students to produce a film that captured the experiences of refugees and asylum seekers in the UK. Through carrying out filmed interviews the student's eyes were opened, as their head teacher, David Smith explained, "It's been a very emotive experience ... They've had to do things which take them out of their comfort zone ... And I think that has shocked and enriched them at the same time" (Dodd et al. 2011). Given the recent rise of far-right political parties in Europe, and the connection to fears over immigration, could cultural organizations do more to explore and tackle these issues?

The need to integrate refugees and asylum seekers in Glasgow and a desire to be relevant and accessible to a wide audience prompted the Gallery of Modern Art (GoMA) to radically rethink its role. In collaboration with Amnesty International, *Sanctuary* (2003) put internationally renowned artists center-stage alongside community engagement programs working with the most vulnerable people in the city. The title *Sanctuary* was significant, in that it highlighted an issue that the whole city should consider and process in a trusted public space. The success of *Sanctuary* led to a biannual social justice program, which used the powerful mix of high quality contemporary art, community engagement and partnerships to give voice to marginalized groups and present issues in a cutting-edge way.

Examples of practice: Challenging society's views of disability and difference

Although almost one in five people are disabled, we live in a society which struggles to accept difference. The roots of RCMG's work to address societal attitudes towards difference can be traced back to the establishment of a disability consultancy group to advise on the redevelopment of Nottingham Castle Museum. The group were concerned that even if they had access to the museum, would they see themselves represented inside it? *Buried in the Footnotes* (Dodd et al. 2004) investigated the evidence of disabled people within collections, revealing that while there was significant material related to their lives and experiences it was either rarely displayed or it reflected stereotypical representations, with many curators anxious about getting it wrong. *Rethinking Disability Representation in Museums and Galleries* (RDR) (Dodd et al. 2008) was a collaborative action-research project that developed new and experimental approaches to representing disability, as well as shaping and framing the conversations that visitors have about difference. Nine museum interventions were framed by the social model of disability, which locates the issue and need for action within society and points out the barriers which restrict and oppress disabled people. A think tank of disabled activists, artists and cultural practitioners played a key role in guiding and supporting the museums. Although challenging, *RDR* moved practice forward and generated rich and complex responses from visitors.

Medical museums represent a significant challenge for addressing issues around difference. While their collections contain thousands of objects that are relevant to disabled people and hold the potential to engage the public in debates around disability rights and equality, this potential remains largely untapped. Modes of display and interpretation privilege perspectives of clinicians and medical historians or are built upon assumptions that non-normative bodies are inherently defective and in need of a cure. Artist Mat Fraser worked closely with RCMG, curators and medical historians to develop a live performance, *Cabinet of Curiosities: How Disability was Kept in a Box* (2014), which presented a searing critique of the medicalized understanding of disability.

Exceptional & Extraordinary (2016) continued this approach, working with four artists, eight medical museums and experts in medical history, disability and museums to produce a series of thought-provoking artworks that stimulate debate around the implications of a society that values some lives more than others. The performances were visceral, complex and challenging; Julie McNamara's play *Hold the Hearse* explored the ways in which people with different minds and bodies have been incarcerated, while Deaf Men Dancing's *Let Us Tell You A Story* used dance to convey the frustration of being denied the right to language and culture. Both projects used the model of the "trading zone,"

a space in which individuals from diverse backgrounds and with different expertise can come together to resolve an issue in a collaborative and equitable way and where no one voice is privileged over another (Dodd, Sandell and Jones, forthcoming).

The ethics of activist practice

Activist practice raises many ethical issues, but ethics itself is also changing. Rather than a code applied indiscriminately, ethics can be seen as a set of ideas that are used to navigate challenging issues and encourage cultural organizations to put social responsibility at their core (Marstine, Dodd and Jones 2015). A significant issue is how vulnerable groups are involved in a museum's decision-making processes. Human stories and experiences bring collections to life, but working with vulnerable groups can expose them to public scrutiny; accordingly, museums need to be sensitive to their needs and context. How museums manage visitor responses to issues that are not part of their everyday lives is also critical; approaches include staff training, careful use of language, and providing spaces for quiet reflection. Taking a political stance can be challenging for museums as it may leave them open to "accusations of bias or of inappropriately taking up the role of advocate for a specific cause" (Sandell and Dodd 2010: 15). However, activist practice is not about offering prescriptive or didactic ways of thinking but supporting visitors to reflect on challenging issues in new ways.

Capturing impact

Unless cultural organizations know the impact of their work, how can they understand the depth of their significance to individuals and the wider society? Those museums which understand the value of impact studies integrate it into their practice; but there are still huge gaps in our understanding, including a lack of credible qualitative and longitudinal evidence (Crossick and Kaszynska 2016). While collective evidence can show us what is happening, the most compelling and powerful examples of cultural impact are often personal stories. Cultural organizations need to capture both, and even the simplest of research tools, such as response cards, can generate rich and complex responses from visitors. This response card (Figure 3) completed by a disabled visitor to an *RDR* museum intervention reflects everything that the project set out to achieve by putting disabled people's experiences at the center of the mainstream.

Figure 2. Deaf Men Dancing perform "Let Us Tell You A Story" Photograph: Sarah Lee

Figure 3. Response card from Birmingham Museum and Art Gallery Source: RCMG

A framework for action

When addressing contemporary social issues, cultural institutions need to do more than merely offer access to marginalized groups, but also include them within decision-making processes and use their voices and expertise to engage audiences with difficult questions. A framework for action takes the form of a set of tools that can be applied across a range of organizations: a set of values that are shared throughout the organization; a proactive and dynamic organizational structure in which difference is valued; the ambition to have contemporary relevance, and not be placed apart from the everyday world. Such a framework will help organizations become places where their impact is captured and valued, and work is collaborative and in partnership with other organizations using models like trading zones. Most of all, work needs to be underpinned by a passion for change, a belief that culture, art and design education can contribute to making a fairer, better, more socially just world.

REFERENCES

Crossick, Geoffrey, and Patrycja Kuszynska. 2016. *Understanding the Value of Arts and Culture: The AHRC Cultural Value Project*. Swindon: Arts and Humanities Research Council.

Dodd, Jocelyn Richard Sandell, Anni Delin, and Jackie Gay. 2004. *Buried in the Footnotes: The Representation of Disabled People in Museums and Galleries*. Leicester: RCMG.

Dodd, Jocelyn Richard Sandell, Debbie Jolly, and Ceri Jones, eds. 2008. *Rethinking Disability Representation in Museums and Galleries*. Leicester: RCMG.

Dodd, Jocelyn Ceri Jones, Sheila Watson, Viv Golding, and Elee Kirk. 2011. *An Evaluation of the MLA Their Past Your Future 2 Programme, 2008–2010*. London and Birmingham: MLA.

Dodd, Jocelyn Ceri Jones, and Richard Sandell. "Trading Zones: Collaborative Ventures in Disability History." In Paula Hamilton and James B. Gardner, eds. *The Oxford Handbook of Public History*, forthcoming 2017.

Fleming, David. 2012. "Museums for Social Justice: Managing Organizational Change." In Richard Sandell and Eithne Nightingale, eds. *Museums, Equality and Social Justice*, 72–83. London and New York: Routledge.

Hooper-Greenhill, Eilean Jocelyn Dodd, Claire Creaser, Richard Sandell, Ceri Jones, and Anna Woodham. 2007. *Inspiration, Identity, Learning: The Value of Museums Second Study. An Evaluation of the DCMS / DCSF National / Regional Museum Partnership Programme in 2006–2007*. London: DCMS.

Marstine, Janet Jocelyn Dodd, and Ceri Jones. 2015. "Reconceptualizing Museum Ethics for the Twenty-First Century: A View from the Field." In *The International Handbook of Museum Studies: Museum Practice*, edited by Conal McCarthy, 69–96. Malden, Oxford and Chichester: John Wiley & Sons.

National Museums Liverpool Changing Lives: *Economic Impact and Social Responsibility at National Museums Liverpool*. Accessed February 2, 2017. http://www.liverpoolmuseums.org.uk/about/corporate/ reports/NML-Changing-Lives-social-eco-impact-report.pdf.

Sandell, Richard, and Jocelyn Dodd. 2010. "Activist Practice." In *Re-presenting Disability: Activism and Agency*, edited by Richard Sandell, Jocelyn Dodd and Rosemarie Garland-Thomson, 3–22. London and New York: Routledge.

THE ROLE OF MUSEUMS IN CREATING SOCIAL CHANGE THROUGH COMMUNITY COLLABORATIONS

Martina RIEDLER
Çanakkale Onsekiz Mart University, Faculty of Education, Department of Art Education, Turkey

ABSTRACT

This paper examines various ways art museums can engage with diverse communities and broaden their audiences in the 21st century by foregrounding Paulo Freire's concept of dialogical pedagogy. Drawing on the theoretical framework of critical pedagogy, it maps these ways onto current museum practice in relation to notions of identity, power, collaboration, conflict and risk. The author further explores how museums can transform institutional culture to engage social change initiatives through building innovative and long-term relationships with diverse community partners. Ultimately, this paper emphasizes the immense potential and challenges for sustainable collaborations with community groups if undertaken in a way that grants participatory practice, as well as shared authority to everyone involved.

KEYWORDS

critical pedagogy, museum education, Paulo Freire, dialogic approach, community collaborations

Introduction:
A historical, systematic exclusion in traditional museum programming

Public museums as we know them today are a product of the Enlightenment. Great edifices functioned as repositories and conservatories of priceless objects originally accumulated, classified, and cataloged in private collections that were later opened for the benefit of the public. That is, in their early conception museums were understood to be educational establishments whose primary function was to enable individuals to educate and thereby improve themselves. This traditional principle of museum education has its roots in the nineteenth century belief in art and museums as cultural instruments of moral amelioration available to a government committed to social reform: parks, libraries, concert halls and schools were all used to serve the ostensibly laudable aims of cultural governance (Bennett 1995, 21; Boswell and Evans 1999; Kaplan 1994). In Europe in particular, the upper classes slowly came to believe that the culture contained in museums would serve to educate the lower classes, and thus once-private collections were gradually opened to the public. Since then, the concept of learning in the museum has implied more than simply transmitting knowledge and enlightening visitors. The practice of teaching in the museum has been informed by a number of developments in theory and creative practice: most prominently, a shift toward a constructivist understanding of teaching and learning (Hein 1998; Hooper-Greenhill 1999).

There is widespread recognition of the possible diversity of museum visitors – and, indeed non-visitors – and the wide range of meanings they generate, an awareness that has complicated the task of museum administrators and educators to an enormous degree (Falk and Dierking, 2013, Marstine 2011; Roberts 1997; Sandell 2003). Yet, despite its notion of democratic openness, the public museum also carries and conveys ideas of inequality and hegemony. As a result, museums and their programming are now being looked at as cultural and political arenas in which identity can be both asserted and contested. Most particularly, theorists in the field of museum studies have called for a critical and reflexive questioning of how museums continue elitist, Eurocentric notions at the expense of particular marginalized groups. This "radical re-examination of the role of museums" has triggered a growing critical analysis of the nature of museums and their function in "social and cultural theorizing" (Karp, Kreamer, and Lavine 1992; Vergo 1989, 3).

Nevertheless, a curator/educator-directed and subject-centered pedagogical approach – evidenced in the "exhibition-as-teacher" – remains prevalent, and many museum programs still require an objective notion of what should be learned, and focus on whether this idea is being communicated to the visitor/learner. In such a context, the exhibited artifacts, practiced pedagogy and accompanying activities within the museum setting rarely dispute underlying power relations and paternalistic models of museum interactions. Along the same line as other public educational institutions such as schools, museums must be "understood as political and contested terrain" (McLaren 2007, 16). This is especially relevant from a historical perspective, given the methods with which museums have "appropriated cultural artifacts from colonized, oppressed and enslaved populations" (Ames 1995, 23). Therefore, museums are still shaking loose their colonial and imperial roots.

In Paulo Freire's view (1970), this top-down transfer of information becomes a symbol and "instrument of oppression that inhibits inquiry, creativity, and dialogue" (Eryaman 2007, 90). This paper attempts to briefly describe how museums can serve as sites for the practices of critical pedagogy and transform institutional culture so as to engage social change initiatives by building long-term relationships with diverse community partners. Significant for my purpose here is the idea that a Freirean approach to education and collaborative learning is highly relevant for several sites of learning, and within this framework, I suggest that museums are an important and productive site for practicing critical pedagogy.

Dialogical pedagogy and critically engaged museum programming

With the goal of better attending to the pluralistic constituencies that museums should serve, museum educators followed the progressive thought of other humanistic disciplines by critiquing omissions and representations in traditional museum displays in regard to issues of meaning, authority and authenticity (e.g., Bishop 2006; Finkelpearl 2013; Helguera 2011; Kester 2004; Lacy 1995; Simon 2010).

Conceptualizing museum programming in critical-theory terms means challenging the privileged and dominant knowledge construct and questioning the museum's authority so that the museum, first, begins to communicate more liberal values within its own administration (both on the board and staff levels). Is the museum a diverse workplace? How can the museum reduce bias in the people it hires, or address the dearth of diversity among those who write about art (such as critics and journalists)? What can we realistically expect from museums as social agents if they close their doors to people who cannot afford to work as unpaid interns? Opening museums up to socially engaged museum practices entails an awareness of and reflection on the museums' mission and institutional dynamics, as well as a conceptual shift to participative practice: who works in and with museums ultimately impacts the diversity of voices in museum programming. Consequently, to what extent can social justice advocacy and sustainable collaborations with community members change institutional culture?

Emphasizing a critical-reflexive approach and the notion of dialogical knowledge production, Paulo Freire's work has for years urged us to recognize that, in order to initiate transformative and community-based actions, individuals are more strongly empowered by sharing their wisdom and experiences with each other. As Lois Silverman reiterates, critically informed collaboration in a museum setting means more than granting access to the museum to certain community members (2010). Silverman affirms the concept of a relationship-centered, socially-focused museum, and encourages museum professionals to find out their communities' needs, since museums only have a long-term impact by genuinely addressing these needs.

This standpoint contradicts museum and community collaborations of a more exploitative manner, wherein an institution will strive to target new audience groups in order to fulfill funding purposes or higher attendance number requirements. Such utilitarian types of initiatives might eventually provide an exciting experience to various audience groups, but they are not meant to create long-lasting relationships, social justice or self-reflective practices. Dealing with such "product-oriented processes," Lehan Ramsay (2006,1) confirms that there is "less interest in learning from each other," and any real interest in the voices of community collaborators is lacking; rather, these processes "function with preconceived outcomes" created only by the museum. In other words, according to a critical theory perspective, those excluded from the center by merit of their race, gender, class, ability, sexuality, religion or politics are kept on the periphery of power and thereby marginalized in institutional practices, including museums. Thus, progressive, critical theories of teaching and learning in museums identify transformation and change as the condition of being other than the norm in which power and authority is centered (Hein 2015; Riedler 2015).

Acknowledging the supportive role of the Tenement Museum in New York City in representing local communities and community engagement, Stephen Long challenges us to cultivate and reach out "to people who haven't acknowledged they hold a stake in the museum" and to inquire "what needs these groups have that could be potentially addressed by the museum" (Long 2013, 146). Indeed, how do we learn about the needs of a community? New York-based artist Miguel Luciano whose work involves socially engaged projects in the public arena, suggests asking audiences and artists directly what changes they would like to see in art institutions. How accessible – or closed off – are our facilities, and how much do we allow ourselves "to step outside the box" and get to know people whom we usually do not expect to get to know? Leaving our field of specialization or working from the margins, and thereby trusting the expertise of people whom we would not usually expect to have it, can broaden our own experience and knowledge and effect change for everyone involved. This then is a plea for openness to different kinds of collaborations that can complement and enhance our work, transforming it into entirely new shapes.

In the light of rapidly changing demographics, national polarization, and increasing inequality, ensuring that museums remain relevant to the support of an equitable and democratic society requires addressing pressing, real-life social issues, and also means understanding learners' needs, developing more supportive, engaging scenarios and creating more inclusive opportunities. Inclusion is based, among other things, on constructing authentic partnerships. A genuine partnership model builds on trust and transparency, and emphasizes the co-creation of knowledge, shared authority, imagination, reciprocity, and the ability to change on both the institutional as well as the individual levels.

Conclusion

Overall, an approach informed by critical theory can offer an invaluable perspective for museum staff and community members alike who are interested in reflective teaching and learning, attending to underrepresented and underserved communities, sharing knowledge production, and conversely, addressing the overrepresentation of other groups. To situate critical models for program development and institutional change in museums, this paper briefly described commonly accepted values and strategies shared by educators and democratic theory advocates: (1) acknowledging a historical, systematic exclusion on the part of the museum; (2) becoming open toward democratizing institutional change; (3) challenging assumptions about the general public; and (4) equitably collaborating in cross-domain partnerships. Naturally, such goals require case-by-case negotiations among staff, visitors, colleagues from other fields, and cultural groups participating in and co-creating any planned programs. However, the intense requirements of time, resources, creative thinking, patience, vulnerability, and sharing authority equally, is often what has hindered the progress of reconstructing mainstream museum education practices through genuine collaborative work. Yet it is clear that to meet social needs and to be relevant for future practices, museums must adopt a more holistic and encompassing approach.

REFERENCES

Ames, Michael. 1992. *Cannibal Tours and Glass Boxes: The Anthropology of Museums.* Vancouver: University of British Columbia Press.

Bennett, Tony. 1995. *The Birth of the Museum.* London: Routledge.

Bishop, Claire. 2006. "The Social Turn: Collaborations and its Discontent." *ArtForum International* 44 (6): 178–183.

Boswell, David, and Jessica Evans, eds. 1999. *Representing the Nation: A Reader. Histories, Heritage and Museums.* London: Routledge.

Eryaman, Mustafa Yunus. 2007. "From Reflective Practice to Practical Wisdom: Toward a Post-Foundational Teacher Education." *International Journal of Progressive Education* 3 (1): 87–107.

Falk, John H., and Lynn D. Dierking. 2013. *The Museum Experience Revisited.* London: Routledge.

Finkelpearl, Tom. 2013. *What We Made: Conversations on Art and Social Cooperation.* Durham: Duke University Press.

Freire, Paulo. 1970. *Pedagogy of the Oppressed.* New York: Continuum.

Hein, George E. 1998. *Learning in the Museum.* London: Routledge.

Hein, George E. 2015. "Progressive Museum Education: Examples from the 1960s." In *International Handbook of Progressive Education,* edited by Mustafa Yunus Eryaman and Bertram Chip Bruce, 107–120. New York: Peter Lang.

Helguera, Pablo. 2011. *Education for Socially Engaged Art.* New York: Jorge Pinto Books.

Hooper-Greenhill, Eilean 1999. *The Educational Role of the Museum.* London: Routledge.

Kaplan, Flora Edouwaye S, ed. 1994. *Museums and the Making of "Ourselves": The Role of Objects in National Identity.* London: Leicester University.

Karp, Ivan, Christin Mullen Kreamer and Steven Lavine, eds. 1992. *Museums and Communities: The Politics of Public Culture.* Washington, DC: Smithsonian Institution.

Kester, Grant. 2004. *Conversation Pieces: Community and Communication in Modern Art.* Berkeley: University of California Press.

Lacy, Suzanne. 1995. *Mapping the Terrain: New Genre Public Art.* Seattle: Bay Press.

Long, Stephen. 2013. "Practicing Civic Engagement: Making your Museum into a Community Living Room." *Journal of Museum Education* 38 (2): 141–153.

Marstine, Janet, ed. 2011. *The Routledge Companion to Museum Ethics: Redefining Ethics for the Twenty-first Century Museum.* Oxon: Routledge.

McLaren, Peter. 2007. *Life in Schools: An Introduction to Critical Pedagogy in the Foundations of Education.* Boston: Pearson/Allyn and Bacon.

Ronnessy, Lenore. 2006. *Collaboration: Moving up to the Future.* Monash University Melbourne/Art Basket and Future University Hakodate.

Sindlar, Martha. 2009. "Overarching Issues in Progressive Education." In *International Handbook of Progressive Education,* edited by Mustafa Yunus Eryaman and Bertram Chip Bruce, 210. New York: Peter Lang.

Roberts, Lisa. 1997. *From Knowledge to Narrative: Educators and the Changing Museum.* Washington, DC: Smithsonian Institution.

Sandell, Richard. 2003. "Social Inclusion, the Museum, and the Dynamics of Sectoral Change." *Museums & Society* 1 (1): 45–65.

Serota, Nicholas. 2000. *Experience or Interpretation: The Dilemma of Museums of Modern Art.* New York: Thames and Hudson.

Silverman, Lois H. 2010. *The Social Work of Museums.* London: Routledge.

Simon, Nina 2010. *The Participatory Museum.* Santa Cruz: Museum 2.0.

Vergo, Peter. 1989. *The New Museology.* London: Reaktion Books.

TABĀDUL–EXCHANGE AN APPROACH TO ART EDUCATION PROJECTS SUPPORTING EQUAL EXCHANGE

Pia RAZENBERGER
Center for European-Arab and Islamic-Christian Studies, Austria

ABSTRACT

Many projects for refugees are currently being organized and undertaken. The project "Tabādul" (Arabic for exchange) is one of them. Its aim is to enable an exchange of opinions on an equal level, one which is not affected by any discussion concerning legal status or citizenship. Young men from Arabic countries who have lived in Austria for two years now, present, in German, Islamic artworks to Art History students. Though the artworks are of Arab/Persian/Sicilian-Islamic origin, they were used in Vienna within a Christian context. By analyzing the works and their context it was possible to draw a link between the medieval object and contemporary Austrian culture. The ensuing discussion focused on the current social situation in Austria. On the one hand, the project encouraged a linguistic and cultural exchange between students and the young men on the basis of a shared interest in Art History. On the other hand, the project aimed to raise people's awareness of the distinction between the terms "Arabic" and "Islamic." The Arabic native speakers allowed the whole group to gain a better understanding of the objects by reading aloud the Arabic inscriptions on the objects. These artworks are not quite regarded as part of "Austrian culture," even though they were used for centuries in an Austrian context. The successful outcome of the project shows that we can reflect our understanding of culture by looking at these examples of medieval art. "Tabādul" can serve as an example for further projects dealing with the idea of an equal exchange between people from various backgrounds.

KEYWORDS **intercultural dialogue, equal exchange, Islamic art**

"Refugees Welcome!" In 2015, as is well known, large numbers of people fled to Europe in their attempt to build a new life there. In reaction to this event and within a very short time, many initiatives were created in the field of art education. Various institutions organized projects aimed specifically at refugees, but sometimes they overlooked the problems existing among different groups of refugees, ignoring the fact that differences exist among all people. One potential art education provides is the chance of creating a space for dialogue and exchange in which to bring together a broad audience. The project Tabādul is such an attempt to realize this potential.

From the beginning, even the term "refugee" must be debated. The designation of a person as a "refugee" implies a kind of homogeneity among all the many people who have only a single thing in common: flight. The experiences people have on their way to Europe can neither be forgotten nor denied; but these people are bracketed within a single homogenous group solely on the basis of their fate, a bracketing that results in a diminution of individuality. Their heterogeneity, and individual needs, as well as their abilities, are cast aside.

The status of these individuals is required by state institutions, and is hence linked to subsidized projects in art education. But apart from the bureaucratic use of the term, art education can forgo it and employ other or more descriptive designations like "people who want to improve their German," or "people who are interested in art." Why should a person's legal status matter in art education?

"Tabādul: Objects, Changing their Context, and Questions Concerning Interculturalism" enabled people who were interested in studying at university to do research with art historical methods on objects used interculturally in Austrian-Christian and Arab/Persian/Sicilian-Islamic societies. The research outcome was presented by the project's participants and served as the starting point for discussing current issues in Austrian society.

Tabādul was developed and organized by Pia Razenberger. The final event was a one-time workshop, offered as a part of a small "Kunstgeschichte (Art History) Festival," organized by art history students. The institutional partners in Vienna consisted of the Museum of the Cathedral of Saint Stephan, Vienna (Dom Museum Wien), the Imperial Treasury, Vienna (Kaiserliche Schatzkammer), and the Department of Art History at the University of Vienna.

Tabādul: Procedure

"Tabādul" is an Arab word which means "exchange." The concept's goal was to enable a space for equal exchange between people. The project lasted from January until May 2016 and can be divided into three phases:

Phase I
The project searched for participants who were interested in Islamic Art, wanted to improve their German and were able to read and speak Arabic. The resulting team members were four young men who had come to Austria due to the socio-political conditions of their Arabian home countries.

Phase II
The participants' task was for each to prepare a presentation focusing on one art work to be introduced to the group in the final workshop. The team visited together the partner museums to get acquainted with the objects and to read their inscriptions in Arabic. Afterwards everyone was expected to do research on his chosen object, elaborate a text and practice the oral presentation in German.

Phase III
The last part consisted of the final event, which took place in the museums. The presentations were held in front of a German-speaking audience. In the museum's seminar room, all the workshop's participants collaborated in how to approach the objects and their intercultural use. They had to attribute the art works to a culture and how the two correlated. The exercises raised questions about the meaning of each object's origin and about the importance of the idea of origin itself within society's current understanding of culture and identity.

The discussion that followed was initiated by the story of a woman who grew up in Syria and moved by choice to Austria some years ago. As she had not been forced to leave her home country, her story led to a debate about integration, the challenges of becoming a part of another society, and adapting or avoiding customs and traditions in a new country. The discussion covered the difficulty of living in a new country regardless of legal status. Through this approach people connected with each other, because most of them could easily empathize with a "newcomer situation."

Aim

One aim of Tabādul was to avoid looking at one's legal status as the defining feature of an individual. It was important to give the young men the possibility to act as art educators and discuss their personal experiences and impressions with the audience. The focus lay on their future life in Austria. Furthermore it was a goal to create a space where Arabic and Islam would be appreciated.

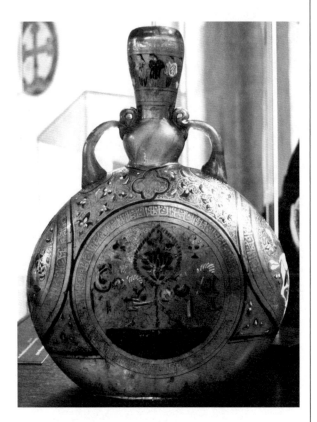

Figure 1 Glass bottle, thirteenth-fourteenth century, probably made in Syria, Dom Museum Wien
Photograph: Pia Razenberger

Method: The matter of consistent content on the meta-level

How is it possible to relate a medieval object to current social debates?

The four objects – from the Imperial Treasury, the coronation mantel of Roger II, and the Alba of William II; from the Dom Museum, two glass bottles, and the Textile of Abū Saʿīd/the Shroud of Rudolf IV – were chosen from collections of Islamic Art and share some common characteristics. All of them exhibit Arabic inscriptions and were produced between the twelfth and the fourteenth centuries. They came to Austria through trade or as gifts and had nothing to do with theft or controversial excavations. This was a crucial criterion of selection, because if the provenance had been problematic, the entire discussion would then have been determined by this topic, which was not at all a part of the desired goal. Furthermore, all objects showed a changing context: they had been used in different religious and cultural situations. This was a key factor as it allowed a connection to be made between the medieval object and current social circumstances, as will be explained through the following example.

A Syrian Glass Bottle: An example to demonstrate the purpose of this approach on the meta-level

The Dom Museum owns a painted glass bottle, which was probably manufactured in Syria (Figure 1). Its "journey" to Vienna is not documented by historical sources, but it is very likely that it was a gift to Rudolph IV, who lived in Austria during the fourteenth century (Karl 2011, 40). In one scene, the bottle shows people playing different musical instruments in a garden. The depiction is framed by an Arabic inscription, which says "as-sultan" which means "the sultan/the ruler." The oldest inventory of St. Stephan's Cathedral states that the bottle was filled with Christian relics (Saliger 1987, XX). This implies that it served Christian liturgical purposes.

The bottle's function as a reliquary is for many people contradictory, and usually leads to the question: "How is it possible to use an object of Islamic Art in a Christian context?"

To unravel this mystery it is necessary to differentiate terms. On one hand it needs to be decided if it is appropriate to designate the bottle as "Islamic." If the bottle is from Syria, it can be identified as "Arabic," but need not also automatically be called "Islamic." The painted scene shows a secular theme and bears as well a profane inscription. In Islam, it is not allowed to depict living beings in a religious context. This allows us to presume that the bottle was not originally used in an Islamic religious space. Thus, it can certainly be designated as "Arabic" but not therefore "Islamic."

Besides, it is likely that the bottle was not regarded as an "Islamic" object when it came to Austria. Certainly

it was appreciated for its material value, but it is possible that it was given some Christian value. Due to its Syrian provenance it could be that it was seen as a treasure from the Holy Land. That would explain its unproblematic use for Christian relics and liturgical purposes. This thesis coincides with the findings of Markus Ritter concerning the understanding of the Arabic inscription in the case of the shroud of Rudolph IV. Ritter concludes that Arabic script could have been interpreted as ancient Christian or Hebraic script (Ritter 2015, 66). That indicates a completely different understanding of culture in medieval times compared to this day and age. Today the glass bottle is seen as Arabic-Islamic. Who would have identified it as Christian? Moreover, during the workshop the majority of the audience identified the bottle and the other object's culture as being Arabic/Syrian or Islamic, while some people saw them as combinations, such as Arabic-Austrian, or simply Austrian. No one designated the objects as being parts of Christian culture, although it was clear that they had been used in that context for centuries (Figure 2).

The exercise demonstrates that in many people's view culture is connected to origin. The understanding of culture is linked to a geographically limited area – a nation – and in this context, is often connected with a single religion, ethnicity or language. This current understanding of culture leads to a different reading of the glass bottle. Through this comparison of the Middle Ages and the present each person's way of thinking and the construction of his or her own identity becomes apparent.

Critique

In addition to the persuasive meta-level content, role-reversal during the final workshop was a conscious strategy. Tabādul created a transmitter-receiver situation where Arabic native speakers became art educators, offering specialized information to the audience. Even though museums offer free guided tours and other activities to its non-native-speaking visitors, for the most part these visitors are confined to their role of recipients and do not get the chance to contribute to society and participate in it.

In the end, one question arises: Why are institutions, including museums, still referring to this particular audience group as "refugees"? The majority of people designated as such would like to avoid this term (as many told me). Lastly, having attended many different conferences regarding such issues as culture, art education, the refugee crisis and so on, it seems that institutions want to maintain this particular label, because supporting this group via various projects and initiatives allows them to appeal to the Austrian general public. There seems to be a greater interest in impetuously starting up initiatives rather than ones that create spaces to enable dialogue, which is also connected

To which culture would you attribute the glass bottles of the Dom Museum Vienna?

7%
7%
13%
46%
27%

■ Arabic-Islamic
■ Syrian
■ Mixed cultures
■ Eastern
■ Austrian

Figure 2. Statistics regarding attribution of culture, 18 workshop attendants, May 2016, Dom Museum Vienna
Source: Pia Razenberger

to the demands of political subventions. Some projects seem to be solely based on the target group's entertainment. Should not art education be much more?

In 2016, the Museum for Islamic Art in Berlin (Museum für Islamische Kunst) launched a project called "Multaka." Within this project, people from Middle Eastern countries, who had recently come to Germany, receive training and work as museum guides. In the beginning, they offered guided tours in Arabic through the different museums located on the Museumsinsel. One could argue that the initial approach of the museum pursued the concept "refugees for refugees." This can be seen as problematic since it once again separates an alleged homogenous group from the rest of society. Now, however, the Museum also provides workshops to a German- and Arabic-speaking audience. These are necessary to bring people with different backgrounds together and enable them to get in contact with each other. Austrian Museums could follow the example of Berlin by training people who have recently arrived in Austria and hire them as guides to present a heterogeneous team of art educators resulting in a greater variety of views and opinions.

It is necessary that museums and art educators provide a framework in which people can get together, criticize, and discuss on an equal level – and surely share an enjoyable experience with one another. After all, is it not the role of art education to play with roles, to widen world views and to dispel prejudices?

In order to develop situations of equality it should be a mission of art education to create spaces to enable dialogue and develop projects where everyone's opinion can be heard and appreciated. Long-term projects and exchanges between heterogeneous groups can establish confidence and help build positive relations. It is worth exploiting the potential of art education to reach this aim. One way to do so is to reflect – through an art historical object and its relation to the current sociocultural debate – upon one's own way of thought and identity.

REFERENCES

Karl, Barbara. 2001. *Treasury – Kunstkammer – Museum: Objects from the Islamic World in the Museum Collections of Vienna*. Vienna: Österreichische Akademie der Wissenschaften.

Museum für Islamische Kunst. 2016. "Project Multaka Berlin." Accessed January 10, 2017. http://www.smb.museum/museen-und-einrichtungen/museum-fuer-islamische-kunst/sammeln-forschen/forschung-kooperation/multaka-treffpunkt-museum-gefluechtete-als-guides-in-berliner-museen.html.

Ritter, Markus. 2015. "Stoff für die Ewigkeit. Luxusgewebe mit arabischen Inschriften in spätmittelalterlichen Fürstengräbern Europas und die Grabhülle Rudolfs IV." In *Wien 1365: Eine Universität entsteht*, edited by Heidrun Rosenberg and Michael V. Schwarz, 54–71. Vienna: Böhlau.

Saliger, Arthur. 1987. *Dom- und Diözesanmuseum Wien*. Vienna: Dom- und Diözesanmuseum.

CREATING LASTING CHANGE FOR YOUNG PEOPLE THROUGH A TOURING EXHIBITION

Jane SILLIS, Engage, and Jo PLIMMER, coordinator, Generation ART
LISA JACQUES, Arts and Museums, Leicester, UK
HANNAH PILLAI AND GINA MOLLETT, Untitled Play, Leicester, UK

ABSTRACT

Given economic austerity, combined with a sea change in political and educational policy, museums, galleries and young people are confronting complex and challenging times for visual arts education in England. This paper introduces *Generation ART: Young Artists on Tour,* conceived by Engage, the leading advocacy and training network for gallery education in the UK, in consultation with national arts and education partners. The project aimed to raise awareness of the abilities of young people as artists, individually and collectively, at a time when art, craft and design are under threat, particularly within state schools, and to introduce young people to professional roles in the cultural sector. The touring exhibition of art by children and young people, accompanied by artist commissions and participatory programs, asked the research question: "How can a touring exhibition of art, devised with children and young people as artists and potential next generation art professionals, have an impact on visual arts engagement and methodologies?" This question is explored here from three different perspectives from the *Generation ART* program: (I) The Strategic Framework, with the Engage Director and the *Generation ART* Coordinator; (2) Participatory Research, with children and young people in a *Generation ART* venue; and (3) Young People as Leaders: young artist educators involved in the *Generation ART* workshop delivery.

KEYWORDS

exhibition, education, young people, touring

Introduction

Given economic austerity, combined with a sea change in political and educational policy, museums, galleries and young people are confronting complex and challenging times for visual arts education in England.

In this context, Engage, the lead advocacy and training network for gallery education in the UK and internationally, in consultation with national arts and education partners, conceived *Generation ART: Young Artists on Tour,* a touring exhibition of art by children and young people (CYP) accompanied by artist commissions and participatory programs. The project's mission was to raise awareness of the abilities of young people as artists, individually and collectively, and to introduce them to professional roles in the cultural sector. This paper addresses the research question "How can a touring exhibition of art, devised with CYP as artists and potential next generation arts professionals, have an impact on visual arts engagement and methodologies?" The question arises from concerns that CYP not only have less access to art and artists, but that state schools are failing to recognise the value of art and design, and consequently the talent and potential of young artists.

This question is explored here from three different perspectives of the *Generation ART* program:

- Strategic Framework; with Jane Sillis, Engage Director, and Jo Plimmer, *Generation ART* coordinator
- CYP Participatory Research in a *Generation ART* venue; with Lisa Jacques, Learning Officer for Arts and Museums, Leicester
- Young People as Leaders; Gina Mollett and Hannah Pillai, young artist educators, Untitled Play

The contributors explore how *Generation ART* was conceived nationally, and realized with one of its host venues, the New Walk Museum and Art Gallery (NWMAG), Leicester.

Figure 1. Generation ART exhibitors at Turner Contemporary, Margate. Photograph: Engage/Jane Moorhouse

Strategic Framework
Jane Sillis, Engage Director

Engage initiated *Generation ART* due to specific concerns about art, design and craft education in England. Research by the National Association for Education in Art and Design (NSEAD) reveals that children and young people in England are spending less time studying art and design, fewer young people are taking the subjects at exam level (GCSE and A level), and fewer schools are visiting galleries and working with artists. Teachers and teacher trainers consulted by NSEAD also expressed the concern that children and young people not only have less access to art and artists, but that state schools are failing to recognise the value of art and design and consequently, the talent and potential of young artists. In response to these challenges, Engage, NSEAD and the Expert Subject Advisory Group for Art and Design in English schools, developed the idea of a touring exhibition of CYP's art with the following aims:

- To showcase high quality artwork by CYP alongside professional artists' work
- For CYP to be fully involved in every stage of creating and promoting exhibitions and programs, with a wide range of learning outcomes
- To raise awareness of the potential for CYP to produce high quality artwork, particularly among teachers
- For CYP to collaborate with and benefit from working directly with artists and arts professionals
- To encourage CYP, schools and families to visit the exhibitions and build sustainable relationships with galleries and visual arts venues
- For venues to engage with new audiences through the exhibitions and programs
- To build capacity in the venues for curating, hosting and evaluating touring exhibitions and working with new audiences
- For the legacies to be shared by Engage and the venues with peers in visual arts and education.

Funding was secured from the Arts Council England strategic touring program, the Garfield Weston Foundation and the Helen Jean Cope Charity. Tour partners selected were: Turner Contemporary, Margate, New Walk Museum and Art Gallery (NWMAG), Soft Touch Arts, and the Spark Arts for Children, Leicester and Quay Arts, Isle of Wight. These venues operate in areas facing challenges to cultural engagement, through geography or social deprivation, or both. Engage also worked with strategic arts and education organizations to develop and share learning from the program: the Contemporary Visual Arts Network, and two Bridge Organisations, Mighty Creatives and Artswork.

The resulting exhibition of forty artworks by five-to-eighteen-year olds was selected by open submission from throughout England and included works made

individually and collectively, in and beyond school, and in museums and galleries.

To encourage new audiences, particularly CYP and families, each venue initiated an engagement program for the target audience, many programed by young people and artists. Engage commissioned a qualitative evaluation of *Generation ART* and an analysis of quantitative visitor data from the Audience Agency. The exhibition received over 203,000 visitors; more than double the number anticipated, with a significant 42% new to the venues. The exhibition also inspired at least 1,300 CYP to make art in associated creative activities. Audiences responded positively, the talent of young artists was recognised and, perhaps most importantly, young people who took part in the program grew in confidence, skills and knowledge.

Figure 2. Kate Owens' curated studio space alongside *Generation ART* exhibition. Photograph: Lisa Jacques

Figure 3. Kate Owens' workshop at New Walk Museum and Art Gallery. Photograph: Engage/Jane Moorhouse

Empowering young people (Jo Plimmer, *Generation ART* Coordinator)

Generation ART set out to demonstrate the positive impact on cultural organizations when young people take the lead, by involving them in every aspect of delivering a national tour: as artists, curators, commissioners, communicators, evaluators and educators. Although the duration of the exhibition at each venue was relatively short – two to three months – we wanted this involvement to be as deep as possible, and for young people to learn skills, be inspired, and influence how the tour was delivered. The evaluation strategy also put young people at the core; evaluator Kamina Walton trained young Evaluation Champions at each setting. *Generation ART* gave them a remit and support to be involved in a project of local and national importance. Young people influenced how *Generation ART* was displayed and experienced in their own venues, worked alongside professional installation and curatorial teams, and visited and compared its curation at other venues. When *Generation ART* launched at Turner Contemporary in June 2015, young Evaluation Champion Lydia Laitung observed that visitors wanted to make and show their own art in response. This had a major impact on the presentation in Leicester.

CYP participatory research in a *Generation ART* venue (Lisa Jacques, Museum Learning Officer)

As Learning Officer I design education and learning activities integral to our exhibitions program. The population of Leicester is growing faster than most UK cities, becoming younger and more diverse; the average age is 31. Consequently, for NWMAG the primary audience and focus of audience development work is families, a common denominator which transcends cultural differences in the city.

When planning *Generation ART* for Leicester with our partners, a key question was how CYP's artwork relates to our organizational vision and aims, to the context of our venues, and to our current and new audiences. We examined previous work with CYP, from passive to participatory visitor, to work produced by CYP externally in schools, at home and other settings. When we looked at work by CYP we identified key visual factors that linked it to a place or person, not necessarily in personal style but in production method. Schools sometimes develop strategies to enable pupils to progress through their course successfully, a secure approach to achieve the required grades. Consequently we could identify from which school a work had originated. We observed the production of work created at NWMAG. Parents who attended workshops with their children often over-influenced the product. They would suggest the direction of their child's artwork even if it went against the workshop direction or the

Figure 4. Untitled Play workshop at New Walk Museum and Art Gallery. Photograph: Untitled Play

Non-facilitated workshops
a staff member was present and offered an invitation to participate, but gave no direction as to what to produce. Again we saw a high return of visitors.

Artist-facilitated workshops
artists Kate Owens and *Untitled Play* provided direction with participant numbers limited to ensure contact time. We chose artists interested in analysing CYP engagement, but in different ways than usual: they brought fresh ideas and imaginative ways of working. The artist-facilitated approach taken by *Untitled Play* is summarized below.

The *Generation ART* studio space allowed visitors different ways to produce artworks without pressure or judgement. The response was overwhelming as people felt at ease to create. It also allowed the Learning Team to observe different audiences engaging with different methodologies. We are using our research framework to compare these and inform our ongoing CYP learning programs.

Figure 5. Untitled Play studio space alongside *Generation ART* exhibition. Photograph: Untitled Play

child's aims. This kind of work becomes the parent's, played out by the child. The same can be seen (though to a lesser extent) when facilitators guide and artists tease out and suggest. Where is the boundary between being influenced and being taken-over? We were interested in how this affected individual CYP's creativity. The *Generation ART* participatory program provided an opportunity to ask the question: "Who and what influences the production and authorship of artwork by CYP?"

We used an intuitive, anecdotal and observational model of research to see how children's artwork is influenced by others, comparing different participatory methodologies and the resulting art products, learning and experiences. The observations of the young Evaluation Champion at Turner Contemporary inspired two *Generation ART* studio spaces in Leicester. A previous project at NWMAG had concluded that CYP preferred a "personal space in a public space" to encourage the transition from passive to participating visitor; a moment where visitors are inspired and feel comfortable to create, without pressure or guidance.

The gallery and studio spaces were complementary and of equal significance; the two were curated together and thus designed to flow and connect. We wanted participants to be able to exhibit their artworks in the space, and we wanted to observe this process. A wide choice of art materials was provided and a visible means of displaying work, but with no formal outcome requirements. This space became our primary research tool for studying the following methodologies:

A supported space
an open studio, monitored by staff who had no dialogue with visitors. The passive visitor became a participant without expecting to or anticipating this before his or her initial visit. A high number returned specifically to produce artwork.

Young People as Leaders
(Hannah Pillai and Gina Mollett, artists)

From our mid-teens, our art learning and practice has grown through involvement with galleries, leading us to pursue art at a degree level, and now to set up our own participatory arts research project. As a key aim of *Generation ART* was to involve young people in all aspects of the project, we were delighted to work on the program as artist educators. The national tour also enabled us to visit other venues, design gallery activity sheets based on our experience, and contribute, share and participate in events and conferences at national and international levels. We produced six family sessions for *Generation ART* in Leicester, which involved an exhibition tour; and each week we created an art installation in the studio space using cardboard, paper and tape and invited children to collaborate with us.

Participating children became the driving force in our joint work. They enjoyed making their own decisions about how to use the materials and were inspired by their peers. Our initial ideas for the workshop didn't work out as planned; we felt that imposing our ideas on the children risked squashing the imaginations that came bursting through our doors. Instead we observed, reflected and adapted our sessions to the behavior of the participants and how they chose to use the space. We thought critically about how we could empower children as fellow artists and peers. Freedom to explore the materials in their own way allowed the children to show us possibilities that we hadn't considered.

The installation became a space for play, creativity and sharing stories. Over the weeks it became clear that we were not teaching art in the sense of new techniques and using materials. The children were developing life skills such as decision making and working together. We encouraged them to share their thoughts and ideas and allowed them to step into the role of teacher by giving us instructions in how to create art. Through this the children gained confidence, were empowered to express their opinions, and learned that their views were important, creatively and socially.

Figure 6. Untitled Play workshop session at InSEA Conference, Vienna. Photograph: Untitled Play

Conclusions

The evaluation and reports here point to how *Generation ART* has introduced new audiences to the visual arts, demonstrated the high quality of CYP art, had an impact on participating CYP, and is influencing venue development and visual arts engagement methodologies. *Generation ART* received more than double the anticipated audience, including an impressive 42% new to the venues. It elicited a positive response to young people's art and provoked discussion about the future of art education at a time when it is under extreme pressure. Exhibiting work in a national exhibition, working with artists and curators, and taking part in the participatory programs has given CYP confidence and increased life skills such as leadership and negotiation. It has equipped young people with knowledge and experience about professional roles within the cultural sector, and given them influence in the staging of a national tour.

In Leicester *Generation ART* provided an opportunity for NWMAG to analyse and develop its methodologies for CYP engagement. Giving young people a voice was the catalyst for creating a studio space integral to the exhibition as a potential engagement model for the future. *Untitled Play* supported young artist educators to deliver accompanying workshops resulting in playful, informative practice, and to be unafraid to take risks and be responsive. It led Gina Mollett to become more strategically involved with gallery education: she has been elected to the Engage national council as a representative for the East Midlands.

Learning from *Generation ART* is having an enduring effect on work with CYP in all of the participating venues. Experience of the program and how to involve young people in roles of influence within a complex project has changed the thinking of Engage and the partner venues. Sharing what has been learned with colleagues in England and internationally is raising the status of visual arts engagement for CYP and encouraging similar projects elsewhere. Engage aims to secure resources to collaborate with young people on a future iteration of *Generation ART* as part of an ongoing campaign defending the importance of art, design and craft education for the next generation.

REFERENCES

National Association for Education in Art and Design (NSEAD Survey Report 2015-16. Accessed January 12, 2017. http://www.nsead.org/downloads/survey.pdf.

NEW WAYS IN EDUCATION THROUGH ART: RESEARCH INTO MOBILE APPLICATIONS IN MUSEUMS AND GALLERIES IN THE CZECH REPUBLIC AND ABROAD

Petra ŠOBÁNOVÁ, Jana JIROUTOVÁ, Jolana LAŽOVÁ,
Palacky University Olomouc, Department of Art Education, Czech Republic

ABSTRACT

The paper introduces our research into mobile applications ("apps") used in museums and galleries that bring new elements to contemporary education through art. A team of researchers based at Palacký University Olomouc (CZ) has focused on the educational aspects and quality of the didactic transformation of content in selected apps. A parallel subject of the research was to analyse the way in which the content of a given application is linked to a particular museum, its mission and collections. We were interested in how these new types of museum products effectivity extend existing possibilities, and in the typology and application of museum communicators in relation to their application in art education and other educational disciplines. The paper presents the current results and significant findings of our research, and is one of the outcomes of the IGA project titled "Research into Museum Presentation and Its Educational Context" (IGA_PdF_2016_025 supported by the Faculty of Education, Palacký University Olomouc, CZ).

KEYWORDS

museum mobile application, museum e-learning, interactivity in museums, digital teaching tools in museums

Introduction

Education through art has always been linked to a school's environment as well as to museums and galleries. Throughout their existence, exhibition activities have helped museums create specific educational environments that offer visitors contact with original artworks. Gallery presentations arrived in their current state after more than 200 years of development, but have many limitations. These are mainly the result of a formalist approach to presentations that does not allow for the showing of an artefact in a meaningful context that would facilitate visitors' perception of artworks and their meanings. To a lay visitor, traditional gallery presentations are insufficiently communicative, difficult to follow, and they often further the distance between the public and the arts. However, this issue has been rather successfully addressed by the educational activities of volunteers in museums, or by various educational tools. Currently, the traditional repertoire of museum didactic tools has been widely extended by digital technologies and the use of the Internet. One of the new and significantly innovative ways by which to mediate artefacts is mobile applications for smartphones and tablets. Mobile applications have found their way into museums and galleries across the world in an extremely short period of time. The objective of our paper is to introduce research into mobile applications that bring new elements and initiatives to contemporary education through art.

Defining key terms

Mobile applications ("apps") are bound together with mobile devices, particularly with smartphones and tablets. Apart from its hardware, such devices also contain system and application software. The arrival of mobile devices and the facilitation of developmental tools, as well as the specific functions of mobile phones and tablets, such as GPS, camera and video tools, has led to a boom in application software.

A mobile application is software which a user selects according to her or his needs and preferences from a software repository, and then downloads it to their mobile device which runs on the particular operation system for which a given application is designed. It is a program that offers certain functions and executes tasks which are useful and interesting for the mobile device user. Compared to computer programs, mobile operation systems enable specific functions, such as the working of applications or functions that depend on the mobility of a device or its hardware capabilities (built-in camera, video camera, motion sensor, etc.).

Research into museum mobile applications: objectives and methodology

Museum mobile applications have become a new and rapidly growing phenomenon, which we believe needs to be subjected to a thorough analysis. We have focused on museum and gallery mobile applications, or, mobile applications based on museum content. We have analysed software available to the public from specific repositories. The subjects of our research, which was realized in 2014–2015, were products from both the Czech Republic and abroad.

When analysing mobile applications, we were interested in the way these applications could be linked to museums – their goals, collections, and activities – so as to extend their possibilities, impact and types of communication. Connected with this is of course the apps' content, or better, its quality, and if digital technologies facilitate the communication of new types of content or whether they alter its structure. We also focused on the functionality of the apps; this does not only depend on state-of-the-art technology but also on other aspects that affect the quality of interaction between a digital product and its user. All of these factors play a key role in establishing a product's success and popularity among users. As early as the 1980s, the term "user experience," referring to the summary of these aspects, was coined. (Norman 1988, and others) In more recent years, another frequently used term connected to the field of digital culture has been "Conversion Centered Design (CCD) (Gardner, 2015), which we also applied when analyzing our selected applications.

Research objectives and questions

The main objectives of our research, analysis and evaluation of museum and gallery mobile applications were:

 - to identify the types of mobile applications offered by museums today
 - to find out what their content is based on, and its link to the museums' missions and collections
 - to describe and evaluate their design
 - to subject them to a functional analysis

In our research, we also examined the more general issue of how museum communications and culture have been transformed and accelerated by digital technologies. When analysing the apps, we focused on their basic technical specifications and classification, their description and content, usability, graphic design and artistic aspects, and the functionality of their technical solutions and their overall design.

Basic research set and sample

Realizing the extent of our basic research set, we decided to analyse representatives of various types which we identified during a pre-research test and which are described in the section below concerning our research results. When establishing the research sample, we

Figure 1. *MoMA Art Lab*. The Museum of Modern Art (New York). The application explains artefacts displayed in exhibitions while offering experimental tasks developing the creativity and expressivity of users. While accomplishing a task, users learn about the formal features of a particular work, its production principles as well as its meaning.
Screenshot: MoMA Art Lab, The Museum of Modern Art, New York

Figure 2. *MoMA Art Lab*. Practical activities combine the reception of particular artworks and children's own art making activity during which they can learn more about an artist's technique. Some activities are designed for manual art making practice, which can later be used in art lessons.
Screenshot: MoMA Art Lab, The Museum of Modern Art, New York

Figure 3. *Strawberry Thief* (Victoria and Albert Museum, London). This application intensifies the experience of William Morris's (1834–1896) artwork. The experience-based concept offers aesthetic experience with a focus on details and colors.
Screenshot: Strawberry Thief, Victoria and Albert Museum, London

considered both typical (museum guides) and marginal cases (alternative solutions in some educational games). Our goal was to produce a sample that would show a true image of the variety of today's museum mobile applications. Accordingly, our research sample was produced by gradual selection and reduction: the number of apps was reduced so that the main types are represented and individual examples are illustrated.

Our research sample includes the following 14 mobile applications (listed alphabetically):

- Aleš, South Bohemian Gallery
- British Museum Visitor Guide, British Museum
- sTips
- Color Uncovered, explOratorium
- Ferdinand, British Museum
- MoMa Art Lab, Museum of Modern Art, New York
- Memory of Nations Sites, Post Bellum
- Na Venkově [In the Country], National Museum CZ
- Sound Uncovered, explOratorium
- Strawberry Thief, Victoria and Albert Museum
- Tate Draw, Tate Gallery
- Titian & Diana, National Galleries of Scotland
- Turner Free
- V technice je budoucnost [The Future is in Technology], National Technical Museum Prague.

Methodology

Our basic research strategy was by case-study; individual cases show the scope of today's approach to the development of these specific museum communicators while offering basic information on the types of current museum applications, their content, and the ways in which they are transformed by software designers. Using an inductive approach typical of qualitative methodology, we generated a typology from the individual cases. Based on the pre-research test, we were able to produce certain categories which we then applied to the research phenomena. Our overall qualitative analysis was the result of analyses based on content, didactic aspects and function. As for data gathering, we relied upon our own observations and testing of products; in the follow-up analysis, we focused mainly on the manifest content of the apps. Product testing was performed by the authors of this text, with a few exceptions where others were involved. The data obtained was analysed and processed, and then subjected to further analysis. We looked out for information that would apply to our given categories, and then produced the descriptions that would give an account of the content, function, and design of the selected mobile applications. While analysing data, we also applied a constant comparative method that enabled us to define a case typology. Another approach was to compare "polar opposite" cases; this applied mainly to information-based applications versus education-based applications.

Figure 4. *Strawberry Thief.* Three different levels describe the production phases of this textile artwork; users thereby further enjoy the beauty of Morris's ornament.
Screenshot: Strawberry Thief, Victoria and Albert Museum, London

Summary of research results

Our research gave rise to detailed case studies which will be published in our upcoming monograph titled *Museums vs. the Digital Era.* In this paper, we present findings that go beyond individual case studies, and offer general statements regarding the characteristics of contemporary museum and gallery application software in the following typology.

Information-based Applications
didactic transformation not present

Museum Mobile Presentations
consist of basic information on the institution and its collections without digital representations of the collection; they are information-based and simply copy the functions of web pages with information on the museum, its mission and activities.

Mobile Guides
contain information on the institution and the objects in its collections as well as digital reproductions of the collection, plus additional information about the individual pieces.

Mobile Databases of a Collection's Objects
present a collection's objects globally or thematically; the database can be either simple or will contain frames of reference and explications of various kinds and extent.

Education-based Applications
greater or lesser didactic
transformation present

Educational Applications as Interactive Textbooks
offer information that is didactically transformed so as to support understanding of content. It is not a simple, information-based, content facilitation, but comes with a certain method or strategy. They support and facilitate the acquisition of new information, abilities, and learning on the user's part.

Games of an Educational or Entertainment Nature
draw the user (as "player") into an activity by way of a game that complies with certain binding rules and limitations (e.g. a time limit, functions of a player's avatar, number of lives, etc.). In this game, the player is to accomplish a given task requiring certain skills. Museum games can be defined as having "edutainment" aspects rather than being purely entertaining. Their purpose is to present museum collections in a fun way.

Software of another Type
can be program-editors for designing and editing of graphic representations, audio, video, etc.

In museums, application software plays the following two basic roles:

- as a marketing tool for promoting the institution, its products, collections, events
- as a tool for fulfilling the function and mission of a public, non-profit organisation (Applications enable access to museum collections by being a new type of institutional presentation: educational applications realize the educational potential of museums).

Mobile applications are examples of an entirely new form of museum communication tool and their brief existence shows that the development of innovative forms is far from over. On the contrary, a completely new era of museum culture is being created. In some cases, museum applications are not new (cf. mobile guides or databases); in others, they are a revolution (especially as games or interactive books). It is not only their multi-mediality and interactivity that makes them innovative, but also their mobility, which means that we can use software with museum content anytime and anywhere. This changes the relationship and impact between visitors and museums, as well as the traditional concept of a museum in that it is no longer defined by its physical space.

As for the content of museum applications, designers are only recently learning more about the plethora of functions offered by mobile devices (navigation, motion sensors, etc.), which is why in many cases the content of applications is still traditional: connecting a text (audio commentary) with an image. However, there are successful applications that more fully exploit the possibilities and thus change the kinds of activities offered to users; they are moving toward a "learning by doing" concept, or experiment- and game-based learning. These are being used by art museums whose exhibitions are often of a conservative, formalist or non-contextual nature. We can conclude that museum applications offer new possibilities for museum content mediation while tackling the ongoing issue of insufficient communicativeness between gallery exhibitions and visitors (including children). They show us how to approach the issue of accessibility to those visitors while also preserving galleries as places for uninterrupted aesthetic experience and contemplation.

Conclusion

Mobile applications constitute a very dynamic sector producing entirely new digital products. Increasingly, these include applications for cultural and educational institutions that have been fast to understand their potential. Research into the content and function of mobile applications shows that multimedia-functioning software offer the possibility of completely new interactions with cultural institutions and their content. These and other institutions – many dealing with various aspects of cultural memory – can thereby widen their impact and offer specific experiences that might be otherwise impossible. Whether they offer information-based applications or software of an "edutainment" nature, mobile apps are an effective way of fulfilling the mission of our cultural institutions. For education through art and for other educational disciplines as well, mobile education-based applications offer new possibilities and original solutions.

Figure 5. *Color Uncovered*. The Exploratorium, San Francisco. The application as a multifunctional game uses interactivity to help develop cognitive processes and to facilitate learning about the vast subject of color.
Screenshot: Color Uncovered, The Exploratorium, San Francisco

Figure 6. *Color Uncovered*. This interactive textbook based uses a problem-solving, illustrative method by which even the most difficult phenomena are explained in a simple and fun way.
Screenshot: Color Uncovered, The Exploratorium, San Francisco

REFERENCES

Gardner, Oli. 2015. *The Ultimate Guide To Conversion Centered Design*. Vancouver: Unbounce. Accessed November 14, 2016. http://unbounce.com/conversion-centered-design-guide/

Norman, Donald. 1988. *The Design of Everyday Things*. New York: Doubleday.

MAKING MUSEUM APPS MATTER?

Luise REITSTÄTTER
University of Applied Arts Vienna, Institute of Art Sciences and Education, Austria

Making Museums Matter (2002) is the title of a seminal book by the American museologist Stephen E. Weil stressing museums' societal relevance as their major evaluation criterion. Within the numerous efforts they make to be relevant to their audience, museums today increasingly make use of various digital channels such as websites, blogs, online collections, virtual tours, social media and apps. Taking into account that more than two-thirds of Austria's population use smartphones to access content online, the thought of combining a digital device with the analog museum visit becomes obvious. However, due to the intense financial investments and special competences required, only a limited number of institutions until now have been able to utilize museum apps. In order to ask how these apps might make museums and their objects more meaningful to an audience, this study draws on a structural comparison of Austrian museum apps and expert interviews with persons involved in their development. This analysis points towards critical issues and potential use values to see how museum apps might matter today or at least in the near future.

museum education, media use, multimedia guide, app, relevance

When Stephen E. Weil published *Making Museum Matters* in 2002 he very much stressed a major institutional change. What he evidenced for the museum at the turn of the century was an "evolution from a collection based organization to a more educationally focused one." He envisioned a museum "that uses its very special competences in dealing with objects to improve the quality of individual human lives and to enhance the well-being of human communities" (Weil 2002, 29). Museums are not sacred, self-fulfilling places but need to consider why and to whom they should matter, and how to accomplish this. In another case of timely diagnosis, the status of communication technology is also drastically changing. Web 2.0, with its emphasis on user-generated content, usability and inter-operability, has apparently changed what could be understood by and done with the Internet. The rise of the mobile Internet adds another important element to the Internet's use today. A luxury only a few years ago, smartphones are now are a daily reality for 92% of Austrian people (Mobile Communications Report 2016). Taking into account that 82% use smartphones to access content online (Statistik Austria 2016), the thought of combining a digital device and the analog museum visit becomes obvious.

Mobile museum applications ("apps") experienced on smartphones or tablets offer an opportunity to render the museum experience independent of time and space (apart from the restrictions of opening hours or distant sites, of course), and to enrich the museum experience via additional or customized content. They also address a diversity of audiences, especially young people, or "digital natives." Theoretically, the positive aspects of museum apps are evident, but are these promises being fulfilled in practice? To empirically question the potential of museum apps, this paper, first, shortly introduces its methodological approach, and then outlines particularities of the Austrian app scene. The interpretative analysis of the selected case studies that follows points towards critical issues when it comes to the implementation and maintenance of the app and specific use cases. Findings relate to typologies of apps and different mobile devices as well as institutional and user attitudes and behavior, all of this making it clear that apps are not at all an easy medium to play with.

On methodology and the Austrian museum app situation

This micro-study takes place within the research and development project personal.curator by Fluxguide and the University of Applied Arts Vienna in cooperation with MAK – Austrian Museum of Applied Arts/Contemporary Art and whatchado, and co-funded by the Vienna Business Agency. personal.curator works with a combination of Applied Design Thinking in the development phase, Thinking Aloud in pre-test periods, and participant observation as well as a visitor survey in the evaluation phase of a specifically developed smartwatch application. Methodologically, this study combines a structural analysis of museum apps in Austria through desktop and smartphone research, as well as seven expert interviews with museum professionals involved in the development of the five selected case studies.

In Austria museum apps are not a broad phenomenon yet. Systematically searching for apps of art museums and galleries, only about two dozen Austrian apps could be found. Some of them are left over from major special exhibitions, some are simply sightseeing guides from commercial providers, and others work within Cloud solutions including various audio tours from different institutions. As this study's interest is in genuine solutions developed and offered by art museums and galleries themselves, the pool is significantly minimized. Five apps from the following institutions were selected for comparison: (1) MAK – Austrian Museum of Applied Arts/Contemporary Art; (2) mumok, the Museum Moderner Kunst Stiftung Ludwig Wien; (3) KHM, the Kunsthistorisches Museum Wien; (4) the Tyrolean State Museum Ferdinandeum; and (5) Kunsthaus Graz. (Figure 1.)

From the audio guide to the app – an evolutionary perspective?

Drawing on the structural analysis of the museum app scene in Austria might give the impression of an evolutionary perspective. While earlier museum apps still very much resemble audio guide versions, newer iterations include various multimedia content, are connected to social media channels, and feature technological tools such as personalized collections or indoor localization. Within the sample, two different apps perfectly represent this shift. The app from the Kunsthaus Graz, developed in 2009, was an early pioneer with a specific use case scenario that explored the characteristic "blob" architecture of the building. (Figure 2.) Focused on audio content, the tour for adults is a walk through the building; the tour for children additionally offers charming insights into art education and curatorial work.

The app of the Tyrolean State Museum Ferdinandeum makes it very clear that today's apps are all about customization as the title #myFERDINANDEUM already suggests. Within the app, a feature allows the user to add individual art works so as to "curate" one's own exhibition (with the nice option of also incorporating treasures from the museum's storage facility). And if that is not enough, the artworks – in their original size – can be assembled afterwards in a so-called "Curating Room," an installation site inside the museum with three walls and powerful projectors. (Figure 3.)

Interestingly, the interviewed experts add that although offering all these extraordinary features, the visitor demand is still much more concentrated on the audio guide files, and the more "fancy stuff" is often left aside. These features are considered too time-consuming or too complex to use (06, 07), thus making simplicity a feature that a lot of developers consider to be crucial (e.g. Handschuh 2013, 2).

Institution	MAK	mumok	KHM	Kunsthaus Graz	Tiroler Landes-museum Ferdinandeum
Name	MAK App / Multimedia Guide	Multimedia Guide	KHM Stories	Audioguide and iPad App	#myFERDINAN-DEUM
Publication year	2014	2012	2016	2009	2016
Device	Tablet download/ rental iPad	Smartphone download/rental iPad mini	Smartphone download/no rental	Smartphone download/rental iPad	Smartphone download/rental iPad mini
User costs	Download for free, 2 Euro rental cost	Download for free, 3 Euro rental cost	First two tours for free, additional tours 0,99 Euro each	Download and rental for free	Download and rental for free
Operating system	iOS and Android	iOS and Android	iOS and Android	iOS and Android	iOS and Android
Special focus/ content	Permanent collections, "Vienna 1900", "Asia," and "Carpets"	Special exhibitions	Thematic tours	Architecture tour for adults and children	Permanent collection
Languages	German, English	German, English	German, English, Turkish, Bosnian/ Croatian/Serbian	German, English, Slovenian (rental only)	German, English, Italian, French
Development company	Nous Wissens-management	Nous Wissens-management	Vienom	Tonwelt	Fluxguide

Figure 1. Museum app comparison Source: Luise Reitstätter

Becoming a visitor online and on-site

Generally speaking, the major advantage of museum apps can be seen in their flexibility of use: on a smartphone or on a tablet, as is the case of the MAK app. Beyond well-appreciated basics (admission information, floor plans, calendar), the MAK app offers in-depth information on art and crafts objects through texts, photographs and a large quantity of videos with curators, custodians and conservators, all of which profit from an adequate screen size.

Despite its content being perfectly suited to a tablet, there are some retrospective doubts about this as tablets are not usually brought to exhibitions and tablet apps are "harder to sell" (01) when compared to those for the omnipresent smartphone. Among the 16 to 24-year-old age group, almost all (97.3%!) prefer smartphones to access the Internet; persons aged 55 to 64 slightly prefer a laptop (63%) to smartphones (58.8%). Tablets, not yet that widespread (35.3% use in total), are most common among the 25 to 44 year-old age group (43,35%) (Statistik Austria 2016). While the smartphone suits fast communications and transmitting short bits of information while "on the move," the tablet is mainly used "on the couch" for more intense information consumption over longer intervals (Handschuh 2013, 1).

Contrary to the other apps, KHM Stories relies on a smartphone app working solely with the so-called "Bring Your Own Device" (BYOD) strategy. At this grand museum, the app adds an alternative offering to the classic audio guide with multimedia theme tours from "Love Kills" to "How to Look for Monsters" for

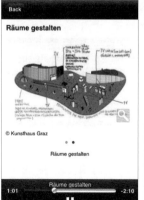

Figure 2. Screenshots: Kunsthaus Graz app

kids, and on to "Magic." With the four most frequent languages spoken in Vienna (German, English, Turkish, Bosnian/Croatian/Serbian) the guide specifically targets locals (05). With "preparatory" and "more" information available, the app also has online visitors in mind (03), though it does nonetheless come with the implicit wish of attracting people to come to the museum. This wish is supported by the ratio of rentals to downloads where, in those institutions where both options are offered, the first – rentals – clearly dominates (01, 02, 06, 07). This comes as a surprise in light of the widespread dissemination of smartphones. Alongside the explanation that old viewing patterns are not easily changed – people having been acquainted with audio guides since the early 1980s – very trivial reasons such as download quotas and battery status also point towards reasons for using rented equipment. With respect to overall visitor numbers, the use rate of guides in museums generally is quite low; the British Museum places its number at only about 3% (Mannion, Sabiescu, Robinson 2015). Reasons in my case studies are less seen in costs (as these are small, from being free up to only three Euros) than with the delivery situation of the guide, which is regarded as "critical" (01). Or as Nina Simon (2016) points out: "underwhelming entry points" and additionally "unlikely reentry points" are the two main problems museum apps suffer from.

On museum authority and negative distinction

Interestingly, the most important point of sale for the digital product is not online but at the museum's cashier desk or info point (01, 02, 04, 05). In a museum, most people become aware of the option to download an app or rent a guide, and optimally receive the guidance needed or wanted. Nonetheless, a visitor statement from a media study at the British Museum says: "I don't feel myself listening to somebody else talking. I think I already know quite a lot." Independent visitors with high authority and trust in their own expertise are very likely to distance themselves from such offers (Mannion, Sabiescu, Robinson 2015). Without an object in one's hand and being only in the pureness of the reception mode is what distinguishes the expert from the "broad public," the general target group of the guide, as can be read at the mumok website with its aim of "making *our* exhibitions and artworks accessible" (my emphasis, accessed November 14, 2016).

Still, the question in the museum is who is authorized to speak and who condemned to listen – although the institutions themselves are breaking with this authoritarian view. Glimpses behind the scenes or voices from within the institution should prove that the museum is not one singular authoritarian identity but speaks with several voices. For instance, the video content of the MAK app was fully produced in-house and features curators, custodians and conservators explaining their work to the public – ideally drawing a more human impression of the institution (01). The KHM

Figure 3. #myFERDINANDEUM with the "Curating Room," © in the headroom.

Figure 4. Screenshot: MAK app

Figure 5. Multimedia guide mumok. Photograph: Lisa Rastl © mumok

Figure 6. Screenshots: KHM Stories

is developing a new thematic tour, presenting the variety of people and tasks involved, entitled "Backstage Museum. The Work behind the Art" (04). The museum narrative thus partly shifts from "The museum is about objects" to "The museum is about people" – or at least about the ones working inside. "The museum is *for* the people," or even cooperatively, "made *with* them," are even more rare narratives. Although sharing options are sometimes included, specific communities outside the museum that might contribute to the guide are rarely addressed. User-generated content is not or is only slightly integrated. Thus, apps, realized as container solutions from single museums and parked within proprietary systems such as the iOS and Android platforms, not only suffer from high development and maintenance costs to be kept up to date, but also from a certain segregation.

A digital take-over from the education department?

For the institution, the challenge of an app interacting with an audience is a path that very often leads not only to the communication department but more often to that of education. Also, the lack of interest from the curatorial side makes the app an interesting playground for the education department. The idea of the current mumok app or multimedia guide as it is called in-house was born after the general museum app from the marketing department (and the only in-house, server-based solution) was withdrawn from the market. Today, the mumok app serves every special exhibition with works chosen and texts written by a team of educators.

In the case of the KHM stories, the art education department acted as the central platform to collect, produce, edit and communicate the storylines they had imagined (03, 04, 05). After some initial skepticism, this led to internal and also external recognition as manifested by their own "five minutes of fame" when they presented the app at the KHM's annual press conference (04).

This proved to be an education department's success story, both for the KHM app and the mumok guide and others that profited from their art educator's practical knowledge (01, 02, 03, 04, 05). Educators rely on their vast contacts with visitors, know objects that are of specific or special interest, and are more likely to use language that communicates to the audience. These skills are crucial in face-to-face situations, but are no less valid for the development of a digital project. Apps can even be used in learning circumstances that combine the personal guided tour with specific mobile content (04).

On matters and relevance

As we have seen, with good practice models and considered details, museum apps can certainly play a part in making museums matter to their audience. Nonetheless, this is not to arrive at a general conclusion regarding the Austrian museum app scene for the simple lack of a significant number of museums offering such opportunities as well as museum visitors making use of them. For museums, the development and maintenance of individual apps is still a major investment of human resources and a substantial financial burden. Museums have to deal with copyright issues, quickly outdated or even new technologies with performance problems, the constant need for content updates and to communicate the app online and on-site. For the visitor, the use of such apps may be limited due to considerations of age, the type of device used and its place of access, costs and one's attitude to even using an app in such a setting. Visitors tend to prefer simple audio guide versions over sophisticated multimedia offerings, rented equipment over sizeable downloads, or they may simply not feel like using or contributing to an app at all. So the question becomes, for museum and visitor alike: is all the effort worth it?

In line with Stephen E. Weil's thoughts, museum apps also mean a change in direction from object-oriented palaces to more subject-oriented arenas. A conceptual shift from the visitor to the user presupposes a distancing from visitor hierarchies that implies a negative distinction between the knowing and the less acquainted or the online and the analog visitor. Also, a "one size fits all" approach no longer applies. Focusing on the diverse use value of apps there is no need to educate visitors in the "right" way to use them, or to transfer what is available online to the "real" museum visitor on-site, as these ideas miss the point of the options offered by the medium. Indeed, the potential of museum apps needs to be experimentally explored and experienced so that they: (1) come to feel less technical (01); (2) work in symbiosis with the exhibition on display (07), in relation to the online collection (02, 04), with personalized tours (04), or even with "gamification" (02, 04); and (3), make the museum more amusing (05), simply through seeing things other than those expected (03). Building up on the limited and not yet always awarding museum app experience, there is still much to be learned so that museums and visitors can playfully use this medium and realize its potential. As there are many more good, old and new museum stories to be told.

Expert interviews

1. Beate Lex, MAK, Austrian Museum of Applied Arts/Contemporary Art, New Concepts for Learning, August 31, 2015.

2. Jörg Wolfert, mumok, Museum Moderner Kunst Stiftung Ludwig Wien, Head of Art Education Adults, November 7, 2016.

3. Larissa Kopp, KHM, Kunsthistorisches Museum Wien, Art Education, November 7, 2016.

4. Rolf Wienkötter, KHM, Kunsthistorisches Museum Wien, Art Education, November 7, 2016.

5. Julia Maria Haußller, KHM, Kunsthistorisches Museum Wien, Art Education, November 8, 2016.

6. Alexandra Hartler, Tyrolean State Museums, Public Relations and Marketing, November 7, 2016.

7. Monika Holzer-Kernbichler, Kunsthaus Graz, Head of Art and Architecture Education, Kunsthaus Graz, Neue Galerie Graz, November 8, 2016.

REFERENCES

Handschuh, Felix. 2013. "Touch your Audience: Geräte-, situations- und zielgruppenspezifische Apps für Tablets und Smartphones." Paper presented at MAI-Tagung 2013, Bonn, May 23–24. Accessed November 14, 2016. http://www.mai-tagung.lvr.de/media/mai_tagung/pdf/2013/Handschuh-DOC-MAI-2013.pdf.

Mannion, Shelley, Amalia Sabiescu, and William Robinson. 2015. "An Audio State of Mind: Understanding Behaviour around Audio Guides and Visitor Media", MW2015: Museums and the Web 2015, Published February 1, 2015. Accessed November 14, 2016. http://mw2015.museumsandtheweb.com/paper/an-audio-state-of-mind-understanding-behviour-around-audio-guides-and-visitor-media/.

Mobile Media Association (MMA). 2016. Mobile Communications Report – MMA 2016. Published August 18, 2016. Accessed November 14, 2016. http://www.mmaaustria.at/html/img/pool/1_Mobile_Communications_Report16.pdf.

Simon, Nina. 2016. "What Does a Great Distributed Digital Museum Experience Look Like?" Accessed November 14, 2016. http://museumtwo.blogspot.co.at/2016/10/what-does-great-distributed-mobile.html.

Statistik Austria. 2016. IKT-Einsatz in Haushalten 2016. Accessed November 14, 2016. https://www.statistik.at/web_de/statistiken/energie_umwelt_innovation_mobilitaet/informationsgesellschaft/ikt-einsatz_in_haushalten/index.html.

Weill, Stephen E. 2012. Making Museums Matter. Washington: Smithsonian Books.

STRIPES AND CHECKS

Michael HANN
University of Leeds, School of Design, UK

ABSTRACT

The concern of this paper is with stripes and checks, probably among the most commonly produced, yet largely ignored, textile designs worldwide. Although perceived in the popular imagination as simplistic designs with little need for any attention or explanation, this paper highlights the potential for design variation, and identifies the range of simple variables which, if adjusted, can lead to significant design change. Differentiation is made between varieties of each design category, and various design types are listed and described.

KEYWORDS

stripes, checks, regular, balanced, sett

Introduction

Stripe and check designs are predominant varieties in all textile-producing cultures, both historically and in modern times. The technical steps required to progress from early forms of weaving, using warp threads and weft threads of a given single color, to the production of striped or checked fabrics in various colors, seem relatively straightforward or even obvious developments. So it is a relatively simple, inventive step to replace bands of warp threads or weft threads, or both, with threads in a different color and thus achieve striped or checked effects. The objectives of this paper are to consider the nature of stripes and checks, and to differentiate between the various types of each. Attention is focused on surface designs rather than the underlying structural manipulations required in achieving these designs.

Preliminary considerations

Most commonly, a stripe design is considered to be a simple entity with no real variation and thus without the necessity for further differentiation or classification. Careful consideration, however, shows that stripes are capable of extensive design variation. A check design is a combination of two sets of parallel bars (or stripes), with one set combined (or interlaced) with the other at ninety degrees. Checks have suffered a fate similar to stripes and, due to their perceived simplicity and lack of potential for variation, have merited little attention from design analysts or historians. Nonetheless, striped and checked varieties of textiles have occasionally received attention in technically oriented publications such as Watson's *Textile Design and Colour* (1912a), and *Advanced Textile Design* (1912b), both dealing with woven fabric structures, and with numerous descriptions and point-paper designs given for varieties of both striped and checked fabrics.

Stripes and their differentiation

Publications dealing exclusively with stripes have been rare. Notable exceptions include: Hampshire and Stephenson (2006), and O' Keeffe (2013). Meanwhile Yoshimoto (1993) produced an interesting catalog of traditional Japanese stripe and lattice designs, while Hann (2015) considered stripes, checks and related phenomena.

It has been observed that "The number of patterns that can be made, even if only two colours are used, is without limit, since the width of the stripe may be varied from the width of a single thread to stripes several inches in breadth ... and again, broad and narrow stripes may be grouped in various ways, each new arrangement of the warp yarns forming a new pattern" (ICS 1906, 85: 2). Readily identifiable textile stripes include woven pinstripes used traditionally as worsted suiting fabric, woven shirting or blouse fabric of various kinds, and striped pullovers and tee shirts (often, in each case, from knitted fabric) with either a vertical or horizon-

Figure 1–7. Variations on a theme: Selection of designs, late nineteenth century.
Source: ULITA – An Archive of International Textiles, University of Leeds

tal striped emphasis. Stripes can also be found in school uniforms (ties, pullovers, scarves and blazers), as well as in sportswear (for both supporters and participants). An important historical example worth mentioning is mattress ticking, typically a heavy canvas-type woven fabric in dominant white or ecru color with blue stripes.

Stripes can fulfill a purely decorative function, though in some cultures they may hold culturally specific symbolism or meaning. In relatively recent times, in many "western" cultural contexts, stripes in bright reds, blues, yellows, greens or oranges have been used to imply joviality at sites such as fairgrounds, circuses and seaside resorts. In years past, and again within a "western" cultural context, stripes were used to add a degree of formality to housing interiors, for example, in the form of "Regency" striped wall coverings and soft furnishings (pillows and the like). According to Hampshire and Stephenson (2006: 35), "tiger" and "Bengal" stripes, associated with the British Raj in south Asia in the nineteenth and early-twentieth centuries, were the precursors of "Regency" stripes.

Stripes are called "regular" when a specific series of parallel components repeats across or along the cloth (or other surface) in an identical order. Regular stripes thus exhibit a clear repeating and parallel sequence. "Irregular" stripes are those which do not show systematic and identical repetition of component parts across the cloth. Irregular stripes (common in nature) may thus have components of variable widths and with no clear repeating sequence, and possibly also differences in the orientation of their component stripes. Further as to classification based simply on "regularity" or "irregularity," stripes may be referred to as "vertical," "horizontal" or "diagonal" (depending, of course, on the point of view). Twill effects on textiles can be considered as diagonal stripes in miniature. Other than twill lines, the width of each component of a stripe can be denoted by simple measurement – numbers and density of threads of a given count or a measurement given simply in centimeters, or some other standard measurement – indicating the width of each stripe component and the distance (if any) between each. In terms of classification, variation in the number of colors used can be noted. For example, variation may be achieved based on an ordering of colored threads which follows a known numerical sequence (such as, for example, part of the Fibonacci series of numbers: 1, 2, 3, 5, 8, 13, 21, 34, 55, and so on), or by allowing numbers to first increase following a selection from a particular sequence and then decrease following the same sequence in reverse (e.g. 1, 2, 3, 5, 8 , 13, 21, 34, 55, 34, 21, 13, 8, 5, 3, 2, 1). In the case of unwoven designs, measurement of stripes can be in centimeters (for example) rather than the numbers of threads placed side by side. Assuming that a stripe design is regular, small changes in the ordering of yarns, their colors, counts, density and textures can lead to noticeable design variations.

Figure 4-5.

Checks and their differentiation

Commonly, checks are considered to be a type of woven textile, though check designs are also found in knitted, printed and "non-woven" textiles. In the weaving context, checks are often comprised of equal color arrangements in both warp and weft directions (thus making a "balanced" design). When this happens, component groups of warp and weft yarns form squares across and down the cloth (ICS 1906, 85:13).

Accordingly, a balanced check design will be based on a regular and identical ordering and coloring of threads within a given unit of measurement (e.g. in centimeters), in both length (or warp-way) and breadth (or weft-way) directions. A balanced check can be considered as two regular (and identical) stripe designs with one superimposed upon (or interlaced with) the other. As is the case with stripes, numerous combinations are possible. For example, colored yarns in both warp and weft directions may be ordered by repeating a sequence such as 2, 4, 6, 8, 10 or 2, 4, 6, 8, 6, 4, 2.

Woven checks can thus be classified simply as "balanced" or "unbalanced." Balanced checks have an equal number of types, colors and varieties of yarn ordered in the same sequence and density in both warp and weft directions, whereas "unbalanced" checks will not show all of these features. With respect to further classification, it seems appropriate simply to number the sequence of yarn types, colors and density (i.e. the number of threads per centimeter) in warp and weft directions, as well as the underlying structure employed during the weaving process; plain weave (the most basic of weave structures where each warp thread crosses over and under successive weft threads), or 2/2 twill structures (where a diagonal "twill" line, caused by the arrangement of warp and weft threads, dominates the face of the textile) are common.

Woven checks can thus show immense variation, through adjusting color, woven structure, numbers of threads as well as their order, count and texture. Various checked textiles have become well known worldwide and a selection of these will now be briefly considered.

Tartans

Tartan checks are probably the best known check designs. Tartans are a checked textile category closely associated with Scotland. There are numerous publications focused on the identification of tartans and on providing a general historical background to relevant families and clans. From the numerous specialist publications dealing with tartans and their history, the most readily accessible are: Stewart (1974), Dunbar (1984), Teall and Smith (1992), Way and Squire (2000), Urquhart (2000 and 2005), Martine (2008), and Zaczek and Phillips (2009). Stewart (1974, 113-117) gives an annotated bibliography of the more important publications between 1831 and 1973.

Grossman and Boykin (1988, 1) explain that a tartan was "... based on the regular interweaving of warp and weft stripes to form repeated pattern blocks or squares ... Thus, the tartan is an inherently regular, balanced weave based on repetition of square pattern blocks." In tartan design, an important consideration is the underlying weave; this is invariably a 2/2 twill which produces a cloth with diagonal lines on the surface (Tubbs and Daniels 1991, 329). The "cloth sett" (or simply "sett") of a tartan is the planned color order and number of warp threads and weft threads per unit length (inch or centimeter). Most tartan fabrics are of square sett (and can thus be regarded as "balanced" checks), with identical ordering and coloring of yarns in both warp and weft directions. Further aspects of the ordering of yarns in tartans are discussed by Hann (2015, 78–81).

Other checks

Other checked textiles that have gained popularity over the years, include: Burberry, Tattersall, houndstooth, gingham and Argyle checks. Burberry checks are a variety of woven textile closely associated with the British fashion company of the same name. Tattersall woven checked fabrics were used traditionally as horse blankets, but increasingly, during the twentieth century, came to be used as men's shirt fabrics. The traditional houndstooth check in woven form is based on a simple twill structure with an interlacing unit in counter-change black-and-white coloring. Gingham check is a plain-woven, light- to middle-weight cotton with equal numbers of white and dyed yarns (often in blue or red), in both warp and weft directions, forming small square checks, and a fabric which is reversible. Argyle checks have diamond-shaped unit cells and, unlike the checks mentioned above, are knitted rather than woven.

Conclusion

Unlike stripes and checks, other forms of textiles which employ recognisable motifs and symbols have received more extensive commentary. Occasionally stripes have attracted the attention of eminent visual artists such as Daniel Buren as well as Bridget Riley, who in the 1960s famously produced striped paintings, often having elements of visual illusion (so-called "Op Art"). Meanwhile, for much of the twentieth century and in the early-twenty-first, textile stripes and checks continue to be produced by manufacturers worldwide, often as part of a "British Country Look," and have also on occasion been adopted by such leading fashion designers as Paul Smith and John Galliano.

Figure 6–7.

REFERENCES

Dunbar, J. T. 1989. *The Costume of Scotland*, London: Batsford.

Grossman, E., and Boykin, M. A. 1988. "Perceiving the Goal: Weaving the Tartan Plaid," *Art Education*, 41(3):14–17.

Hampshire, M., and Stephenson, K. 2006b. *Communicating with Pattern: Stripes*, Mies (Switzerland): Roto Vision SA.

Hampshire, M., and Stephenson, K. 2007. *Squares, Checks and Grids*, Mies (Switzerland): Roto Vision SA.

Honn, M. 2015. *Stripes, Grids and Checks*, London, New Delhi, New York and Sydney: Bloomsbury.

ICS. 1906. *Weaves, Fabrics, Textile Designing*, in ICS Reference Library Series, Scranton, PA (USA): International Textbook Company for International Correspondence School.

Martine, R. 2008. *Scottish Clan and Family Names: Their Arms, Origins and Tartans*, revised edition, Edinburgh: Mainstream Publishing.

O'Keeffe, L. 2012. *Stripes: Design Between the Lines*, London: Thames and Hudson.

Stewart, D. C. 1974. *The Setts of the Scottish Tartans*, London: Shepheard-Walwyn.

Teall, G. and Smith, P. 1992. *District Tartans*, London: Shepheard-Walwyn.

Tubbs, M. C., and Daniels, P. N. 1991. *Textile Terms and Definitions*, ninth edition, Manchester: The Textile Institute.

Urquhart, B. 2000. *Tartans: The Illustrated Identifier to over 140 Designs*, London: Apple Press.

Urquhart, B. 2005. *Tartans of Scotland: An Alphabetical Guide to the History and Traditional Dress of Scotland*, London: Apple Press.

Watson, W. 1912a. *Textile Design and Colour*, London, New York and Toronto: Longman Green and Co.

Watson, W. 1912b. *Advanced Textile Design*, London, New York and Toronto: Longman Green and Co.

Yoshimoto, K. 1993. *Textile Design III: Traditional Stripes and Lattices*, Singapore: Page One Publishing Company.

Zaczek, I., and Phillips, C. 2009. *The Complete Book of Tartan: A Heritage Encyclopaedia of Over 400 Tartans and Stories that Shaped Scottish History*, London: Lorenz Books (with Anness Publishing).

LAYING GOOD FOUNDATIONS?
THE VALUE OF ART IN PRIMARY SCHOOL

Peter GREGORY
Canterbury Christ Church University, UK

ABSTRACT

This paper will consider the present-day value and position of art in primary school in English schools. The way in which children experience the subject is viewed as particularly important. There are several reasons why this ought to be set out. The author trains primary school teachers in art in several different training programs offered by an English university. Discussions with student teachers have not provided confidence that all is well in schools or that they feel adequately prepared to change to the status quo as they begin their careers. For many years, the author has observed the quality of children's art works found in schools, and also tried to support qualified teachers to find better ways of teaching the subject. What follows is therefore a personal view of the situation, and an invitation for others to look at the evidence for the conclusions drawn here. Lastly, it is important to challenge others – especially teachers and teacher trainers – to consider how the future of art education could be improved.

KEYWORDS

primary education, art experience, breadth of curriculum, developmental opportunities

Introduction

This paper will consider the present-day value and position of art in primary school in English schools. The way in which children experience the subject is viewed as particularly important. In order to allow the reader to develop the best understanding of the subject, the terms to be used here will be explained before setting out the sources of evidence and using these to consider what is known and what remains unknown. The ultimate goal is to raise the question of whether we are currently building a good educational foundation or not.

Clarifying terms

England is the largest of the four nations which constitute the United Kingdom (UK). The education system and the evidence described here should be understood as only referring to schools in England.

The term "Primary School" has a broad meaning. Generally, it refers to schools which cater to 4–11 year old children. (The fuller explanation is more complex as some schools have 3–7 year olds, others 7–11 and still others 3–8; in the English education system these are all considered primary schools.)

All constructions require a firm foundation but once the upper parts of a building are built upon them, the foundation is hidden from view. The author takes the view that the same can be said about children's educational experience, especially in art. As with buildings sometimes the strength of the foundation in the ground is only recognised when something goes wrong and a weakness or fault is detected. However, it is understood that the strength of the foundation will determine the shape, size and height of what can be constructed upon it. It follows then that it is worth considering alternative views of why the foundations of learning matter and how they might affect future development (Alexander and Armstrong 2010). For example, primary education could be seen as important in at least three ways:

- to enrich childhood (where all learning experiences are valued and developed)
- to prepare for the "next" stage (of schooling – typically expressed as Secondary School)
- to prepare for adulthood/life (where childhood experiences can be viewed as less important)

Whichever of these views is held then affects the value of art in primary school.

Sources of evidence

Little published literature describes the way that art is taught today in primary school and a picture has to be drawn using a variety of sources. They range from published reports by government inspectors who have visited schools specifically to look at the teaching of the subject (particularly Ofsted, 2009 and 2012), to a variety of small-scale action research projects undertaken by groups of schools (Gregory and March, 2016, Blackmore and Crowe, 2016).

It is possible to build some understanding from research studies at the Master's and Doctoral levels (for example, Corker, 2010, Gregory, 2014a and March, 2016), or books written to assist teachers in their teaching (see Eglington, 2003, Hewlett and Unsworth, 2012; Bowden, Ogier and Gregory, 2013; Tutchell, 2014 and Gregory, 2014b). The survey undertaken by the National Society of Education in Art and Design (NSEAD, 2016) provides a rare insight into the situation reported directly by primary teachers of art themselves.

All of these sources contribute towards the development of understanding the contemporary position referred to here.

What we know from the evidence

As this is account is only a brief outline, a summary of the points will be offered.

The education system, structures and published curriculum documents all contribute to a hierarchy of subjects as a consequence of the considerable importance given to English and mathematics (Herne, 2000; DfE, 2013; NSEAD, 2016). This affects the ways in which primary teachers are trained and actually results in reductions in the amount of time allocated to art in their training (Rogers, 2003; Corker, 2010); many student teachers now have only a few hours of training in the subject. Research into the development of art teachers commissioned by the government (Blundell, Bell, Burley and Smith, 2000) was disregarded and the department concerned later denied any knowledge of it (Gregory, 2014a). Additionally, in 2013 little attention was paid to the recommendations made by an Expert Subject Advisory Group (ESAG, established by the Department of Education). The group itself then published guidance for schools to aid their understanding of the curriculum for art (ESAG, 2014).

In schools, these same pressures often result in art being viewed as less important than other subjects (Bowden, Ogier and Gregory, 2013), as having less value, and art lessons even being allocated to inexperienced teachers in order that the "important" subjects are developed across the school curriculum by staff with considerably higher status (Gregory, 2014a). Less time is being allocated to teaching the subject, and standards upon entry to secondary education appear to be falling (NSEAD, 2016). Frequently, primary school teachers even have insufficient understanding of art (Downing and Johnson, 2003). In fact, the situation regarding the

teachers themselves is summarised clearly by Kristen Ali Eglington:

"Generally, *teachers will teach what they know* ... they carry long-held beliefs about what art is, and what art in education means ... they lack the confidence and skills necessary for teaching art ..." Ali-Eglington (2003, 11–12; emphasis mine).

There is a worrying correspondence here with the inspectors who found that the majority of art lessons that they observed in primary schools were neither acceptable nor enabled children to achieve good work in the subject (Ofsted 2012). Teachers are also reluctant to engage with contemporary art practice (Adams et al. Worwood, Atkinson, Dash, Herne, Page, 2008) or critical enquiry with their pupils (Cox 2000). Although the explanations might be complex, there are clear links with the factors referred to above, and that also have a developmentally accumulative effect on young learners over time (Tutchell 2014).

Additionally, the support previously available as professional development for teachers has been removed (Ofsted, 2012), and the expectations of the current National Curriculum are vague and insufficient to guide most teachers (NSEAD 2014a, 2014b). Children from the age of seven are required to keep a sketchbook but many schools have not met this requirement. In fact, March (2016) has found that teachers do not understand the opportunities offered by children's sketchbooks. The beliefs, knowledge and prior training experienced by teachers have all been demonstrated to impact on the opportunities offered to primary school children – often in ways unnoticed by the teachers themselves (Gregory, 2014a).

Some schools try to focus attention on learning art through cross-curricular projects but do not fully appreciate the depth of subject knowledge that this requires in order to benefit a child's learning (Barnes and Shirley, 2007).

As part of a wider program one school recently undertook an audit which demonstrated a number of factors which they wanted to address (Blackmore and Crowe 2016, 2):

- Younger children might get more art in class
- Teachers have little confidence in teaching art
- Art is taught as a separate subject for about nine hours a year
- Topic based art is "thin"
- Drawing and painting still dominate

The evidence so far is perhaps less than encouraging, but it does point towards the considerable challenges for art and design in such times of change. For those like me, who want to find ways to strengthen the subject and see positive changes brought about, this is an important first step. It contributes much to the planned advocacy work, actions and classroom practice we feel necessary.

What remains unknown

The practices of primary school teachers in art classes are currently largely unknown. Inspectors have ceased subject visits for art and glimpses of pedagogy are only available from very small-scale projects. Some of those that offer some support to teachers outside of the school setting reveal a thirst for such development (Gregory and March, 2016). It seems to the author that some important areas invite exploration and research:

- The varieties of art curriculum planned and actually taught in classes
- Allocation of teaching time to the subject
- Contemporary primary art pedagogies and how they are applied
- Looking for correlations between teachers' personal histories and pupil's experiences of being taught
- Larger scale research (including longitudinal studies)
- Ways of strengthening the training of teachers in art and design
- Measuring pupils' progress and achievement in art
- Use of new media and art practices
- Partnerships with creative practitioners and galleries which empower teachers' teaching

Are we laying good foundations?

Returning to the comparison made at the beginning of the paper between foundations for buildings and those for learning in art, it seems to me that an inescapable conclusion can be drawn. Unless ways are found of supporting and improving understanding, learning from experience, and raising the quality of achievement, there will be continued reductions in the strength of the foundations being laid at the primary school level. The future limitations of the subject – the areas of secondary school, college, university and also employment and the wider impact on society at large – are I hope, avoidable. If they are not, then just like a house shaken by an earth tremor, each of these areas could have catastrophic results as fewer learners acquire the necessary skills and understanding to satisfactorily progress to the next stages in their learning careers.

The author is convinced that at present the only conclusion is that in England we are laying quite poor foundations, and he is determined to do all that he can to find ways of improving upon this situation. Hopefully, by sharing these views, other educators – in England and beyond – will continue to seek one another out, offering support and finding courage in these very challenging times of change.

REFERENCES

Adams, Jeff, Kelly Worwood, Dennis Atkinson, Paul Dash, Steve Herne, and Tara Page. 2008. *Teaching Through Contemporary Art*. London: Tate.

Alexander, Robin, and Michael Armstrong. 2010. *Children, Their World, Their Education: Final Report and Recommendations of the Cambridge Primary Review*. London: Routledge.

Barnes, Jonathan, and Ian Shirley. 2007. "Strangely Familiar: Cross-Curricular and Creative Thinking in Teacher Education." *Improving Schools*, 10(2), 162–179.
DOI: 10.1177/1365480207078580.

Blackmore, Elizabeth, and Michelle Crowe. 2016. *Staff Audit for Sheppey Young Arts Advocates Programme*. Unpublished audit report. Eastchurch: Eastchurch Church of England Primary School.

Blundell, Steve, Ruth Bell, Rod Burley, and Stewart Smith. 2000. *Art and Subject Leadership*. Birmingham: University of Central England in Birmingham.

Bowden, John, Susan Ogier, and Peter Gregory. 2013. *The Art and Design Primary Coordinator's Handbook*. London: Belair.

Corker, Caroline. 2010. *An Investigation into the Provision for Art, Craft and Design in Primary Initial Teacher Education*. Unpublished M.A. Dissertation: University of Roehampton.

Cox, Susan. 2000. "Critical Enquiry in Art in the Primary School." *International Journal for Art and Design Education*, 19(1), 59–63. DOI: 10.1111/1468-5949.00202.

Department for Education. 2013. *The National Curriculum in England. Framework Document September 2013*. London: DfE. Accessed January 6, 2017. https://www.gov.uk/government/publications/national-curriculum-in-england-primary-curriculum.

Downing, Dick, and Fiona Johnson. 2003. *Saving a Place for the Arts? A Survey of the Arts in Primary Schools in England*. Slough: National Foundation for Educational Research (NFER).

Gallagher, Kirsten Ali. 2008. *Art in the Early Years*. London: Routledge-Falmer.

Eagart Subject Advisory Group Guidance and Audit and Subject Audit Tool. Accessed January 6, 2017. www.eagartot.com.

Gregory, Peter. 2012. "Against the Odds? Developing Effective Teachers of Art and Design." Paper presented at European Regional Congress of the International Society for Education through Art (InSEA). Cyprus, June 2012.

Gregory, Peter. 2015. *An Investigation into the Contribution Made by Primary Art Coordinators to the Development of the Teaching of Art: The Evolution of Attitudes, Understanding and Practice*. Unpublished Ed.D. thesis: University of Greenwich.

Gregory, Peter. 2014b. "Art and Design." In *Primary Curriculum*, edited by Robin Alexander, 48–52. Harlow: Pearson.

Gregory, Peter. 2016a. "What is Happening in our Primary Schools?" Keynote ELATE Symposium, London, March 2016.

Gregory, Peter. 2016b. *Laying Good Foundations? The Value of Art in Primary School*. Paper presented at European Regional Congress of the International Society for Education through Art (InSEA), Vienna, September 2016.

Gregory, Peter, and Claire March. 2016. *Art Up on the Downs: New Experiences*. Canterbury: Canterbury Christ Church University.

Herne, Steve. 2000. "Breadth and Balance? The Impact of National Literacy and Numeracy Strategies on Art in the Primary School." In *Journal of Art and Design Education (JADE)*, 19(2), 217–223. DOI: 10.1111/1468-5949.00221.

Hewlett, Claire, and Claire Unsworth. 2012. "An Introduction to Art and Design." In *The Primary Curriculum: A Creative Approach*, edited by Patricia Driscoll, Andrew Lambirth, and Judith Roden, 176–194. London: Sage.

March, Claire. 2016. *How Can the Sketchbook Support the Development of the Child's Thinking Skills?* Unpublished M.A. Dissertation: University of Roehampton.

National Society for Education in Art and Design (NSEAD). 2014a. *The National Curriculum for Art and Design Guidance: EYFS, Primary KS1-2: A Framework for Progression, Planning for Learning, Assessment, Recording and Reporting*. Corsham: NSEAD. Accessed January 6, 2017. www.nsead.org

National Society for Education in Art and Design (NSEAD). 2014b. *Art and Design Programme of Study*. Corsham: NSEAD. Accessed January 6, 2017. www.nsead.org

National Society for Education in Art and Design (NSEAD). 2016. *NSEAD Survey*. Corsham: NSEAD. Accessed January 6, 2017. www.nsead.org

Ofsted. 2009. *Drawing Together: Art, Craft and Design in Schools (2005-8)*. London: Ofsted.

Ofsted. 2012. *Making a Mark: Art, Craft and Design in Schools (2008-11)*. London: Ofsted.

Rogers, Rick. 2003. *Time for the Arts? The Arts in the Initial Training of Primary Teachers: A Survey of Training Providers in England*. West Midlands: Wednesbury Education Action Zone.

Tutchell, Suzy. 2014. *Young Children as Artists*. Abingdon: Routledge.

ART HISTORY AS INDICATOR OF SWISS SECONDARY SCHOOL ART EDUCATION HISTORY:
A CASE STUDY OF THE CANTON OF BERN FROM 1994 TO TODAY

Annika HOSSAIN, Helena SCHMIDT
Bern University of the Arts, Research Department, Switzerland

ABSTRACT

The emphasis on art history in secondary school art education in the Swiss Canton of Bern is exceptional in contrast to the other German-speaking cantons, where art schools do without any academic art history training whatsoever in teachers' education. What historical developments have led to the fact that the proportion of art history is so different in Swiss secondary school art education classes and teacher training? And what implications does the emphasis on art history have for art education teaching practice in Bern gymnasia? Since there exist hardly any fixed regulations for Swiss art education, it is the curricula and the experience of teachers that especially define the role and function of art history within the subject "Bildnerisches Gestalten" (Arts and Crafts). In this article we focus on the role of art history in secondary school art education in the Canton of Bern from 1994 to today. Methodologically, it combines an archival data analysis with oral history. Our study is led by the assumption that the history of Swiss secondary school art education can be approached by an analysis of the part art history plays within it. In addition to the structural implementation of art history in art classes, the research principally strives to reveal prevailing concepts of art mediated in Bern Gymnasia.

KEYWORDS

Swiss art education history, gymnasium, art history, theory and practice

The debate concerning European art and cultural history has played a fundamental role in the development of the school subject of art since its origin at the beginning of the twentieth century. (Preuss 2016, trans. AH.)

Today there exists a highly ambivalent attitude towards the integration of art history in secondary school art classes in Switzerland, where the main responsibility for education and culture traditionally lies with the individual cantons. While in most Swiss curricula the term "art history" is not included, in the Bern curriculum a whole section is exclusively dedicated to it: the Canton of Bern provides a cantonal curriculum for all gymnasia, which was presented by the Bern Ministry of Education (ERZ) in 2005 (ERZ 2005) and will be updated in 2017. For art teachers' training at the Bern University of the Arts, academic art history makes up one-third of the BA program and one-quarter of the MA program. That is considerably more than in the parallel Swiss German-instruction courses, which do not incorporate any academic art history training (FHNW 2017; ZHdK 2015; HSLU 2015).

In this article, the status of art history as part of the recent developments of secondary school art education in the Canton of Bern from 1994 until today will be retraced. Methodologically, it combines an archival data analysis with oral history. Thus, the curricula of seven secondary schools from the region Bern-Mittelland have been analyzed, and ten interviews with current and former secondary school art teachers have been held. The aim of this case study is to research the as yet neglected historical evolution of secondary school art education in Switzerland by analyzing the changing position of art history within its training and practice. In addition to the structural implementation of art history in art classes, the research principally strives to reveal prevailing concepts of art mediated in Bern gymnasia.

Art history in the curricula of Bern gymnasia since 1994

In 1995 new federal regulations (Maturitäts-Anerkennungsreglement, MAR) directed the gymnasia of all Swiss cantons to generate their own curricula in accordance with the Swiss Secondary School Curriculum from 1994 (EDK 1995). In Bern, these regulations lead to the establishment of cantonal guidelines for secondary schools, which until then had been village schools. Before 1995 it fell mainly to local gymnasium teachers to decide what was taught and how in secondary schools. In the Swiss Secondary School Curriculum from 1994 the core passage referring to art history is the following:

Through the debating of art works of applied and fine arts, as well as current visual media, students gain additional insight into intellectual and cultural relations. Bildnerisches Gestalten [Arts and Crafts] poses questions to which art history can provide answers. Through a concentration on the medium of the image, its understanding is promoted. Practical and analytical work on images helps students to orient themselves among today's continuously increasing barrage of images. (EDK 1994, 124 trans. HS.)

This passage primarily refers to the foundation of a cultural context, as well as to the promotion of understanding visual media. The close interdependence of practical and analytical work is also stressed, even though their exact relationship is largely left open to interpretation.

In contrast to the Swiss Secondary School Curriculum from 1994, the corresponding curricula for, and written by individual Bern gymnasia, have been complemented and differentiated by the concrete art historical content. In most cases, they relate to traditional art historical eras, some of which appear especially often (e.g., the Renaissance, twentieth century and contemporary art), and with a focus on cultural objects from Europe, the USA and Switzerland. Next to focal points relating to art historical periods, there are also those referring to genres, of which painting, graphics, sculpture, architecture, and photography are frequently mentioned. In some of the curricula, however, there is an expanded concept of the image, including, for example, technology, advertising, and fashion (Gymnasium Köniz 1997).

On the whole, in the curricula from 1994 to 2005 a hegemonic concept of art is represented, one which relies exclusively on Western art history writing and the periods and genres relating to it. Non-European perspectives play almost no role at all; when they do, they are only in direct relation to Western art developments. Female artists and their position in the Western art system are not mentioned at all.

In the context of the development of a Secondary School Curriculum of the Canton of Bern of 2005, a group of secondary school art teachers compiled a compulsory curriculum for art classes in the canton's gymnasia (ERZ 2005, 165–181). This curriculum replaced the individual curricula of Bern gymnasia from the late 1990s and is still valid today. One out of six modules within this curriculum is dedicated exclusively to art history. A central paragraph states:

To perceive the dialogue between artworks and buildings as a conscious and creative act. To name characteristics of a piece, to investigate it and to put it into its cultural-historical context. To distinguish between objective and subjective statements. To gain insight into the development of European art and architecture as well as into non-European cultures. To acquire a broad overview of great European/Western art. (ERZ 2005, 174 trans. HS.)

In summary, the portion of art history has been considerably enhanced in the Bern curriculum of 2005 by the dedication of an entire module to it. Historically this must be understood as a consequence of the extensive educational "Bologna reforms" of the 1990s, when professionals decided to strengthen Bern secondary school art education by enhancing that part of academic training through a mandatory minor in art history (Schärer 1999). This curriculum considers art history to be a conscious examination of art and architecture both in class and off-site cultural institutions. The close interdependence of analytical and practical aspects is stressed once again. The former focus on European art has been broadened, even if the phrase "great European/Western art" still indicates a reliance on a limited concept of art. The new curriculum also demands a critical consideration of certain statements. It contains an expansion of the concept of art in its inclusion of thematic focal points, referring to "recent art history" and in its consideration of a broad scope of materials and techniques (ERZ 2005, 174 trans. AH).

Interviews with secondary school art teachers

Because curricula outline central educational objectives, their content is a crucial guideline for art teachers and their practice. But how do art teachers transfer instructions referring to art history into their teaching program? To find out about the attitude and teaching methods of art teachers regarding art history we interviewed ten secondary school art educators from the Canton of Bern (T1–10, trans. HS).

Even if art history plays a major role in secondary school art classes of Bern gymnasia, indicated by its eminent position within the 2005 curriculum, there is a broad agreement on the fact that practical work is the core content of art classes. T 6: "In the art major we decided to dedicate one out of five art lessons to art history. We asked ourselves whether to teach at the ratio of 2:3 or 1:4. We decided on the latter." Or T 10: "In my classes I do 70 per cent practical work and 30 per cent art history. But the ratio is flexible." In the context of final exams, the role of art history is a crucial theoretical part, which is tested orally or in writing.

T 6:

> From the 3rd grade on, we teach one lesson of art history a week. Those are straightforward lectures with a projector, 'dry as a bone.' I show images and talk about them; then there are tests. This prepares the students for their final exams, so they understand why it is done that way. The oral art history exam is 50% of the final grade.

This last quotation indicates that, methodologically, teachers are prone to create art history lessons similar to academic university readings accompanied by image presentations. Students who appreciate the creative work in art classes – in contrast to the scientific nature of other school subjects – often complain about this. Additionally, art teachers often struggle with the integration of theory into their program and, in the end, tend to neglect the art history portion of the class:

T 2:

> I feel that our students have so many theoretical classes, that simply painting or drawing is extremely important for them. That's the reason why art history often goes short in my classes.

From these statements it should become clear that the implementation of art history in art classes demands a great deal of reflection, work, and systematic experimentation from art teachers. Many of them write lecture notes that define the art historical content they consider relevant. The art teachers study diverse teaching materials and art history books from which they extract images and texts. Their notes serve as scripts for their lectures or as study material for their students' final exams.

Methodologically, most of the teachers aim to mediate a diachronic development of art history and at the same time treat thematic art historical sections in close interdependence with creative work. Furthermore, most teachers stress the importance of museum visits, which enable students to take part in cultural life. In regard to the ratio of theory and practice, there do not exist any fixed rules for secondary school art education. Therefore, it is mainly the art teachers' personal interests that define the art historical content:

T 2:

> The content also depends on the teacher's preferences. One of my colleagues absolutely loves Rome. He teaches a lot about Rome, the ancient world and the Renaissance. [...] I've always done both: contemporary and older art history. That is due to my opinion that contemporary art doesn't exist without ancient art.

Since the teachers' comments show many different strategies and methods for implementing an art historical content into art classes, they primarily represent another level of differentiation and an extension of that which is defined by the curricula. By analyzing the art historical topics they choose, some of the content missing from the general and individual curricula can be detected: T 10: "For me, the FEMALE artists are important. [...] In every epoch that I teach, there is at least one woman artist." And T 8: "What I love about this book (Farthing 2012) is, that there is not just art from Europe, but also non-European art, which generally is not part of my lessons."

Conclusion

While the curricula offer a very narrow concept of art history, one that is focused mainly on the Western world and traditional genres, it should be noted that the programs of secondary school art teachers demonstrate many different approaches and strategies. Furthermore, the increasing quantity of learning goals related to art history in the curricula from 1994 to today points to the political emphasis laid on art history within secondary school education by professionals. Finally, it should be pointed out that as the importance of art classes within the general curricula of gymnasia grew, so too did the portion of art history implemented in those classes. As the analysis of the role of art history within secondary school art education has proved successful for insight into the subject's overall development, what must now be debated is how the dominant narrative of Western art history can be challenged within this context. The close reading of Bern curricula raises the hope of regarding the inclusion of updated concepts of art, even if it also highlights the "conserving" function of schooling in relation to social change (Noffke 2008, 5).

REFERENCES

EDK, ed. 1995. "Verordnung des Bundesrates/Reglement der EDK über die Anerkennung von gymnasialen Maturitätsausweisen (Maturitäts-Anerkennungs-Reglement MAR) vom 16. Januar 1995." In *Systematische Sammlung des Bundesrechts* 413.11. Bern: Eidgenössische Drucksachen- und Materialzentrale.

EDK, ed. 1994. *Rahmenlehrplan für die Maturitätsschulen. Empfehlung an die Kantone gemäss Art. 3 des Schulkonkordats vom 29. Oktober.* Bern: EDK.

ERZ, ed. 2005. "Lehrplan gymnasialer Bildungsgang: 9. bis 12. Schuljahr (Bern 2005)." Accessed January 9, 2017. http://www.erz.be.ch/erz/de/index/mittelschule/mittelschule/gymnasium/lehrplan maturitaetsausbildung/lehrplan-2005.assetref/dam/documents/ERZ/MBA/de/AMS/ams_klm_gesamtdokument.pdf.

Farthing, Stephen, ed. 2012. *Kunst: Die Ganze Geschichte.* Köln: DuMont (Orig. 2010).

FHNW 2017. "Studienaufbau." Accessed January 9, 2017. http://www.fhnw.ch/hgk/iku/master-fine-arts/studienaufbau.

Gymnasium Köniz. 1997. *Lehrplan EF.* Bern. Gymnasium Köniz.

HSLU. 2015. "Art Teaching." Accessed January 9, 2017. https://www.hslu.ch/de-ch/design-kunst/studium/master/fine-arts/art-teaching/.

Noffke, Susan E. ed. 2008. "Revisiting the Professional, Personal and Political Dimensions of Action Research." In *Handbook of Educational Action Research.* London: Sage.

Preuss, Rudolf 2016. "Sinnes- und Sinnwahrnehmung. Über die Einbindung von Kunst- und Kulturgeschichte in den Kunstunterricht." In *zkmb,* Accessed January 9, 2017. http://zkmb.de/77.

Schärer, Fritz. 1999. "Bildnerisches Gestalten im Kanton Bern." In Gymnasium *Helveticum* Nr. 3. 38–41. Bern: Verein Schweizerischer Gymnasiallehrerinnen und Gymnasiallehrer (VSG).

ZHdK. 2015. "Programm." Accessed January 9, 2017. https://www.zhdk.ch/index.php?id=40749.

A TOOL FOR ART EDUCATORS
THE COMMON EUROPEAN FRAMEWORK OF REFERENCE FOR VISUAL LITERACY

Ernst WAGNER
Akademie der Bildenden Künste München, Department of Art Education, Germany

ABSTRACT

From 2013 to 2016 art educators from nine European countries organized within the European Network for Visual Literacy (ENViL), collaborated in the EU-funded project *Common European Framework of Reference for Visual Literacy*. It aimed to

- research and describe the different approaches to art education at school in Europe;
- develop a concept/framework of reference that would encompass European diversity;
- conceptualize a model of crucial competencies based on research;
- offer a set of scales with which to differentiate these competencies;
- offer instruments for applying the CEFR_VL to daily practice in schools.

Visual Literacy is understood as a field of competencies for reflecting, understanding and creating messages. These competencies gain more and more importance in the context of our contemporary world (mass media, heterogeneous backgrounds of pupils, "glocal" identities, intercultural dialogue, the "iconic turn" in the sciences, etc.). *Visual Literacy* is a premise for the critical and self-determined cultural participation of the individual, and can thus be understood as a decisive requirement for political participation.

KEYWORDS

visual literacy, competencies, curricula, assignments, assessment

Survey of national art education curricula

In order to find a common starting point for a "Common European Framework of Reference for Visual Literacy" (CEFR-VL), the network ENViL asked experts in all European countries about their respective art education curricula. This survey collected data on curriculum structures, as well as curriculum contents and contexts. The qualitative empirical analysis led to the insight that many country-specific curricula are competency-based, comprising production (making and using images) and reception (responding to images). These two main dimensions are divided into different sub-competencies. Sometimes a third main dimension, reflection, is added, and which relates to the other two dimensions. Despite differences in denominations and subcategories, the curricula show a high degree of conceptual similarity. This analysis formed the basis for modelling the competency model in the next step (see below).

Situations in which visual competencies are needed

Visual literacy becomes apparent in specific *situations* in which individuals act. Thus ENViL collected relevant situations where visual literacy is required, answering the following questions:

- In which situations will learners need visual literacy? Which activities will they need to engage in?
- What kinds of people, places, occasions will be involved? How will they communicate using visual tools? Under what conditions will they produce or respond to images/objects?
- What types of images/objects will they draw on? For what topics and tasks will they need to use them? What images/objects will they have to see and understand? How will they produce them?
- What world knowledge or knowledge of other cultures will they need?

In the context of the Framework, the overarching aim of acquiring competencies is to result in European, visually literate citizens who can lead successful lives (the personal domain), succeed in their careers (the occupational domain), and play active parts in social, public and political life (the public domain). (Figure 1.)

Action	Images, objects, genres, media	Places	Core competencies, topics
dressing with a specific visual appearance in mind	clothes, jewellery, accessories	private space (home), public space	cultural identity, intercultural awareness, creativity, lifestyle, self-confidence, active dialogue with the world, personal fulfilment
designing one's own private space	interior design, design, images, textiles, furniture, plants, lighting	home, garden	lifestyle, creativity, cultural identity, self-confidence, ability to express oneself with visual means, personal fulfilment
expressing personal memories with images and objects	photographs, memorabilia	photo album, memory board, cabinet at home, shelf, grave	integrated personality, ability to act, ability to express oneself with visual means, lifestyle, appreciation
using visual media for leisure activities	TV, digital and interactive media, video, computer games, music video	online, on a screen, TV, home	cultural identity, integrated personality, critical thinking, openness, curiosity, lifestyle
observing foreign customs and rituals and understanding their aesthetic forms	rites – all media	travel, urban space	intercultural awareness, critical thinking, openness, curiosity, empathy, appreciation, exchange, active dialogue with the world
consuming	consumer products, advertisements, presentation, staging, packaging	supermarket, shops, online, on a screen	critical thinking, reflective thinking, ability to act, lifestyle

Table 1 Example of a table of situations (personal domain)

Figure 1. Visual Literacy in its context. Source: Ernst Wagner

Figure 2. Visual Literacy in its context. Source: Ernst Wagner

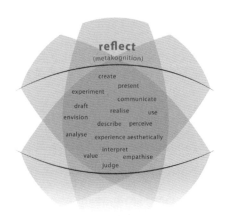

Figure 3. Differentiation of sub-competencies. Source: Ernst Wagner

Definition of Visual Literacy

The next essential step was to find common ground in the understanding of Visual Literacy: "Literacy involves a complex set of abilities to understand and use the dominant symbol systems of a culture for personal and community development" (Kickbusch 2001, 292). As it is often stated that we live in an increasingly visual culture (e.g. Elkins 2003), there is a need for citizens to be visually literate. As early as 1969 John Debes coined the term "visual literacy" (Debes 1969, 26). To define the content of the domain, ENViL decided to adhere to the definition of Brill, Kim and Branch who define Visual Literacy – independent from specific areas – as "a group of acquired sub-competencies for interpreting and composing visible messages. A visually literate person is able to: (1) discriminate, and make sense of visible objects as part of a visual acuity; (2) create static and dynamic visible objects effectively in a defined space; (3) comprehend and appreciate the visual testaments of others; and (4) conjure objects in the mind's eye." (Brill, Kim and Branch 2001 9)

Competence model

Visual Literacy is a competency. ENViL's work is based on a competency model that describes the skills, abilities, attitudes and knowledge that can be acquired in art education. The desired learning outcomes are described in the form of domain-specific competencies. The Framework uses the definition of the term "competency" formulated by the education scientist Weinert: competencies are "skills and abilities that an individual possesses or is able to learn and that are used to solve certain problems, and the associated motivational, volitional and social willingness and skills required to use the solutions successfully and responsibly in changing situations" (Weinert 1999).

Visual Literacy is required in order to deal effectively with certain situations. However, this does not yet consider the aims of applying Visual Literacy. It requires a normative statement. (Figure 1)

In order to adequately describe the processes and results of learning, certain basic elements – knowledge, skills and attitudes – must always be considered. These are necessary in order to deal with a situation or a problem. Furthermore, Visual Literacy is always embedded in a general concept of education: (Figure 2)

- Visual Literacy relates to the person and is therefore always connected to personal competencies (self-competencies).
- Visual Literacy is equally fundamentally based on expression and communication, and therefore takes place in a social context. Thus, Visual Literacy is linked with social competencies.
- Furthermore, responding and producing use specific methods. Visual Literacy therefore also always involves methodological competencies.

Level	Description
Elementary	Can select familiar motifs and topics for a preliminary work or an attempted work that are appropriate for his/her intention and use pre-set artistic means. Can apply rules and principles, as well as the results of experimentation when producing an appropriate form.
Intermediate	Can choose appropriate content, motifs and topics on the basis of suggestions and under consideration of what he/she intends to depict. Can select artistic means and strategies from among a number of options and use them appropriately. Can take into account artistic rules but break them to a certain extent in order to achieve a desired effect.
Competent	Can use a range of contents, motifs and topics and give them an adequate form under consideration of the intended effect. Can use methods and strategies purposefully and in a targeted manner or experimentally in order to enhance his/her artistic expression. Can reflect critically on rules and conventions with regard to a specific effect and consider them (follow or break them) when producing.

Table 2: Example of a scale of levels in respect to the sub-competency "Create"

Reflection or metacognition plays an important role in this context. Whatever a student is doing or learning, he or she has to use metacognition in order to understand what he or she is doing or to control the learning process.

Finally, the basic dimensions can be broken down into sub-competencies. Based on an analysis of curricula in Europe (see above) and intensive conceptual discussion, these sub-competencies have been included in the CEFR-VL. (Figure 3)

Scales of levels

Scales for competency levels are used to describe a specific performance in which the corresponding sub-competency becomes evident. The competency level achieved by an individual therefore describes their ability to deal with a specific challenge on a specific level. The aim of creating such scales is to ensure that a competency-orientated approach is productive in practice. The set of scales can be used as an instrument to assess learners' achievements, whether this assessment is carried out by the learners themselves or by a teacher.

The *levels* developed by ENViL are general ones, i.e., they are not related to, for example, specific ages, educational policy or contexts. In order to ensure that consistent differences can be recorded, three levels have been determined. The first (elementary) level describes the basic requirements for participation in society. The third (competent) level describes the characteristics of a fully visually literate European citizen (i.e., not professionals trained as designers, artists, art critics or art historians). As an example, the three levels of the sub-competency *Create* are presented in Table 2.

Forms of assessment – an example

Assessing the learning progress and results in Visual Literacy is a complex issue. The creative process and the process of visual perception are often associated with unpredictability and individuality, whereas assessment stands for predictability and comparison. However, especially in formal education, we need to state which results of learning are expected and to evaluate whether those goals are achieved. Assessment can be carried out by teachers, by students themselves or their peers. The advantage of having students assess their own performance is that the assessment itself can become a tool for learning as it stimulates self-regulation and metacognition (Nicol & MacFarlane-Dick 2006).

Taking into account the importance of this approach, ENViL constructed inter alia an instrument for self-evaluation, a rubric. (Figure 4–6) Rubrics are transparent for students and therefore enable them to assess themselves and regulate their own learning. Sluijsmans et al. (2013) say that rubrics are useful for summative and formative testing as they provide early and informative feedback.

Conclusion

The Framework, developed by the European Network for Visual Literacy (ENViL), is a reference document that can be consulted, for example, as a foundation for curricula or to develop learning materials. Its aim is to advise, not to standardize. By drawing on the knowledge and experience of international experts, it offers orientation for strengthening quality development in acquiring Visual Literacy in schools. At the same time, it is, one hopes, an instrument that can be used to observe and describe the visual competencies of learners. Through its connection to the current discourse on education policy, the Framework gives national efforts in quality development in Visual Literacy education a new, well-founded document of reference.

Figure 4. Visual rubric, example "analyse."
Source: Folkert Haanstra, Oskar Maarleveld

Figure 5. Further items from the visual rubrics.
Source: Folkert Haanstra, Oskar Maarleveld

REFERENCES

Brill, Jennifer M., Dohun Kim, and Robert Maribe Branch. 2001. "Visual Literacy Defined: The Results of a Delphi Study: Can IVLA (Operationally) Define Visual Literacy?" In *Exploring the Visual Future: Art Design, Science and Technology*, edited by R. E. Griffin, V. S. Williams, and J. Lee, 9–15. Blacksburg, VA: The International Visual Literacy Association.

Debes, John. 1969. "The Loom of Visual Literacy." In *Audiovisual Instruction*, 14 (8): 25–27.

Elkins, James. 2003. *Visual Studies. A Sceptical Introduction*. New York: Routledge.

Kickbusch, Ilona S. 2001. "Health Literacy: Addressing the Health and Education Divide." *Health Promotion International* 16(3): 239–297.

Sluijsmons, Dominique Desirée Joosten-ten Brinke, and Cees van der Vleuten. 2013. *Toetsen met leerwaarde. Een reviewstudie naar de effectieve kenmerken van formatief toetsen*. NWO-PROO rapport. Accessed January 7, 2017. https://www.nro.nl/wp-content/uploads/2014/05/PROO+Toetsen+met+leerwaarde+Dominique+Sluijsmans+ea.pdf.

Wagner, Ernst, and Diederik Schönau. 2016. *Common European Framework of Reference for Visual Literacy – Prototype*. Münster, New York: Waxmann.

Weinert, Franz E. 1999. *Concepts of Competence. Theoretical and Conceptual Foundations* (Contribution within the OECD Project Definition and Selection of Competencies (DeSeCo)). Neufchatel: DeSeCo.

Analysing	= linking form, content, and context	You hardly made any connections between form, content, function, and context of the visual products. Connections that you made were not elaborated.	You made some connections between form, content, function, and context of the visual products. The connections you made were somewhat elaborated.	You made several connections between form, content, function, and context of the visual products. The connections you made were elaborated and understandable.	You made many connections between form, content, function, and context of the visual products. The connections you made were well elaborated and understandable (explained thoroughly and/or illustrated with references to sources)
Using various perspectives	Examples of perspectives are: from the producer of the work, from the owner, political perspective, aesthetic perspective, etc.	You interpreted the visual products from a single perspective. The interpretation was not convincing/plausible.	You interpreted the visual products from a single perspective. The interpretation was convincing/plausible.	You interpreted the visual products from more than a single perspective. The interpretation was convincing/plausible.	You interpreted the visual products from more than a single perspective. The interpretations are quite convincing/plausible and surprising/original.

Figure 6. Each level is accompanied by a text, describing the respective level. Source: Folkert Haanstra, Oskar Maarleveld

PLAYFUL HANDS-ON CRAFTING FOR PERSONAL GROWTH AND COMMUNAL WELL-BEING

Ulla KIVINIEMI
University of Jyvaskyla, Department of Teacher Education, Finland

ABSTRACT

Crafts education in Finland has recently been exposed to considerable challenges, on both the theoretical and practical levels. The emphasis is shifting to personal expression and communal arts and crafts practices are being adapted to solidify social and cultural participation. Learning research shows us how inner motivation and multilevel objectives in comfortable learning environments induce stable and generalizable learning results. In addition, collaborative ways of working make data processing more open and turn learning into a shared effort. On the other hand, playful learning and dramatic methods offer productive ways of examining life situations in an active and empathetic way. When using concrete materials in functional activities, deep learning is stimulated by offering experiential forums for learning. As well, an intentionally good-humored atmosphere facilitates success. Community art projects offer a platform for participants to generate well-being through art and craft activities combining personal expression with dialogue between actors. A person's activity cycles proceed spontaneously without questions of right and wrong, and in a dialogic and inclusive manner. The storyline of this presentation is about building up communal workshops designed under the pedagogical guidelines to be described and using hands-on activities involving materials. Specific effort was put on playful ideas and easy-going pursuits. Certain piloted hands-on workshops will be exhibited as case studies.

KEYWORDS

craft education, community art, playful learning, collaborative learning

Introduction

This article concentrates on participant-based, hands-on activities in communal crafting workshops. The storyline concerns building up communal workshops designed according to certain pedagogical guidelines of participant-based activities using concrete materials. These workshops were built up with the focus on both personal and communal orientation in conjunction with playful learning. Sophisticated equipment and specific materials were not particular prerequisites, and the most important aim was not to design and make completely finished, high-quality objects; rather, it was the idea itself. The piloted hands-on workshops were carried out within a teacher education program preparing the teachers for art education projects in schools. Too, these students were offered a possibility to personally experiment with learning crafting exercises that were not based on the traditional aims and standards of craft education, which used to underline the development of manual crafting skills so as to produce useful objects by hand, including the practice of diligent working skills and meticulous handwork.

Craft education

Craft education in Finland has recently undergone considerable challenges both theoretical and practical. The new national curriculum for elementary schools was introduced in the autumn of 2016 with the new subject called "crafts." The new curriculum instructs schools to unite the former textile crafts and technical crafts and to begin a gender-free craft education. For teacher education this conceptual shift means new approaches in craft education.

Traditional reproductive and model-based making has stepped aside and the emphasis has now shifted to the entire making process. In making, the student is also seen as a designer, visualizing the look of the artifact, planning how to construct the object, and finally making it through recurring processes. The words materiality, embodiment and expression are reformatory concepts in school crafts. Craft education also highlights the importance of creativity and practical skills but with a new twist: pupil-oriented practices that allow students to take responsibility and to organize their work themselves. On the other hand, communal arts and crafts practices are seen as being practical for solidifying social and cultural participation.

Brain research (Huotilainen 2016) show us how touching and forming different materials cause good stimulation for the somatosensory areas of the brain. Stimulative pre- and sub-processing in brains even take place unconsciously. This has a large impact on learning, and at its best enables an embodied, active but peaceful flow state so that we can perform our best through crafting.

Playful learning

Playful learning and drama offer productive ways to examine real-life situations in an active and empathetic way. When using concrete materials and functional activities, deep learning is stimulated by offering experiential forums for learning. Furthermore, an intentionally good-humored atmosphere facilitates successful experiences. Playful learning also tends to focus on personal and communal growth.

Huizinga (1947) pointed out that children's play is a free activity and thus independent of any obligation or concept of mission. Free play is fun, flexible and active, and these characteristics stand out when contrasted against guided play. Indirect learning is easily built in stories that are open to various interpretations and can thus create new meanings. (Alanen et al. 2009)

Studies show us that therapeutic humor parses the chaos of mind, because laughter promotes positive emotions, coping with stress and changing the way situations are interpreted. In educational workshops irony is deliberately avoided since it violates the person and the atmosphere. Mentors should understand how humor already exists in the group and use it. However, serious attitudes must be accepted and supported in a constructive way. (Martin 2007, 269–270, 369–370).

Community art

History shows that art has been justified in its own right and was originally allowed for only the few. However, in the contemporary world, we have seen how art can serve personal well-being and even economic growth. By developing creativity, affirmative art education concentrates on the positive significance of art for the individual, the community and society. Strengthening the individual and collective are also important (Shiner 2001).

According to Bredin and Santoro-Brienza (2000), art has traditionally been a part of organized communities, adding meaning to their lives. Individuals made art because they wanted to leave something behind them. Art was the tie that bound community members together, and in particular, in connection with community rituals (also Huizinga 1947, 14).

Catterall (2011) tells us how long-term art education affects children's perceptions of their originality and the life choices they make. His massive longitudinal study shows that art enthusiasts are employed more, vote more and are more active. Intense art involvement was also found to correlate strongly with higher academic achievement. Art education invites all and everyone to participate in the creative process. Art reception and enjoyably making art cultivate and develop individuals in ways that, apparently, purely cognitive theory does not.

In community art artistic acts are made by members of a community. Sometimes professional artists collaborate with people who may not otherwise normally engage in the arts. These collaborative projects are also suitable for school communities where they can enhance interaction and dialogue. According to Kaitavuori (2015), community-based art can be defined by the active participation of community members. In the case studies presented here, the participants are seen as active and autonomous beings who work together as co-creators in workshops where their activities are inclusive, social and communal.

Workshops

Three workshops designed according to the above mentioned guidelines will be described in this chapter, along with some photos. Each workshop's structure stressed generic skills and personal learning using artistic methods. As Eisner (2002, 93–147) describes the pedagogical situation in art education, objectives are personal and the actual art-making is based on communal activities such as discussing, helping, learning by seeing, and appreciating the work of others. Materials are dealt with in a specific environment, the situation is mobile and the work is based on social activity. Also, personal expression and the ability to visualize are important. Participants also become free of the world of words and rational thought, and instead employ their emotions and feelings.

The "Meditative Wristband Workshop," inspired by Tellervo Kalleinen and Oliver Kochta-Kalleinen (*http://www.complaintschoir.org/*), was designed to combine braiding techniques with self-awareness. On the internet one can order bracelets that encourage one to make positive changes in her or his life.

The idea of the workshop was to make a bracelet for oneself and adding a statement of a personal goal to it. In this way, one practices self-examination, increases self-awareness and gains self-empowerment in an enjoyable way. The practice of braiding is itself meditative. The techniques chosen can be crocheting, braiding, knotting or twisting; and all of it is done with tempting materials and colors. If it is not inconvenient or too personal, the self-development goals can be revealed and shared in the group. Some of the wristbands made in the workshops were: "Everyday art, just notice it !"; "Use Finnish!"; "Act differently!"; "Compliment someone everyday!"; "Take a new route to work!"; "Think outside the box!"; "Disrupt your routines!"; "Stop eating candy!"; "Talk less!"; "Don´t be late!"; and "Give positive feedback!".

Figure 1. A braided wristband with the motto: "There is always another option!" Photograph: Ulla Kiviniemi

The "Miracle Machine Workshop" was for designing and building prototypes of a miracle machine that could help newly qualified teachers in their work. Recently graduated teachers in Finland experience many challenges, including the threat of unemployment, uncertainty about their own professional knowledge and skills, inexperience, stress (including the ability to cope with everyday events), self-confidence, and the ability to influence their pupils' learning (Tynjala et al. 2011). Soon-to-graduate student teachers were the participants of the workshop in an EU project. The groups were multicultural and their first task was to communicate the challenges of being newly qualified teachers in their respective countries. Then, they jointly designed and built a prototype of a "miracle machine" that could solve their problems. To enhance their imaginations some pictures were presented on the topic of the *Kalevala*, the Finnish national epic that has inspired generations of artists. (See the exhibition *The Kalevala in images: 160 years of Finnish art inspired*

Figure 2. A miracle machine: "The Classroom Creator." Photograph: Ulla Kiviniemi

by the Kalevala at the Ateneum Art Museum in 2016 (*http://www.ateneum.fi/nayttelyt-nyt/kalevala/?lang=en*). In the *Kalevala* there is the character Sampo, the Magical Artifact that brings good fortune to its holder. The equipment and materials used in the workshop were very simple and merely suggestive: tape, scissors, staplers, paperboard, markers, pens, yarns, and so on. At the end, each group introduced its machine to each other. The inventions were: the Classroom Creator; the Helmet for Peaceful Solutions; the Motivation Machine; the Magic Cloud; and the Communicative Digital Portfolio.

The idea of the "Thank You Medal Workshop," inspired by Katariina Guthwert (*http://www.katariinaguthwert.com/?page_id=65*) was to construct a medal in celebration of oneself or another person for their everyday existence and just "being there." The participants were asked to think of the person to be remembered and cherished, or praised and rewarded. A photo could be attached to a brooch that was decorated with a variety of available materials, including all kinds of bits and bobs as well as cast-off or recycled materials. Readymade badge bottoms could be used or any stiff material with safety pins. When attaching the parts, the hot glue gun proved swift and handy.

Figure 3. Thank-you-medals: Celebrating 1. Minna Canth (a Finnish writer and educator); 2. My family; 3. My Grandfather; 4. My friend who is going to get married.
Photographs: Ulla Kiviniemi

Conclusion

Playful learning offers productive ways of examining life situations in an empathetic way. Not only concrete materials, but functional and bodily activities too, serve to stimulate deep learning by offering experiential forums for learning. The workshops promoted dialogue between participants and enhanced collaborative ways of working. The atmosphere was intentionally good-humored and well-intentioned, as well as playful and artistic. Learning research shows us how inner motivation and multi-level objectives induce stable and generalizable learning results. In addition, collaborative work conducted in comfortable environments make data processing more open and turn learning into a shared effort. Community art projects offer a platform for participants to increase well-being through art and craft activities. Positive learning encourages human growth and is clearly supported by such activities.

REFERENCES

Alanen, Leena, and Kirsti Karila. 2009. *Lapsuus, lapsuuden instituutiot ja lasten toiminta.* (Childhood, Childhood Institutions and Children's Activities). Tampere: Vastapaino.

Bredin, Hugh, and Liberato Santoro-Brienza. 2000. *Philosophies of Art and Beauty: Introducing Aesthetics.* Edinburgh: Edinburgh University Press.

Catterall, James. 2011. "Art-Rich, Non-Art-Rich Education." Keynote lecture in Creative North for Children (Luova Pohjola) seminar, Nordic Institute in Finland. Helsinki, Finland, September 29.

Eisner, Elliot W. 2002. *The Arts and the Creation of Mind.* New Haven: Yale University Press. Accessed January 2, 2017. http://web.a.ebscohost.com/ehost/ebookviewer/ebook/bmxlYmtfXzE4ODA0Ml9fQU41?sid=280a175e-7f8e-481d-8224-810acc60e193@sessionmgr4009&vid=0&format=EB&rid=1.

Huizinga, Johan, and Sirkka Salomaa. 1947. *Leikkivä Ihminen* (Homo ludens). Helsinki: WSOY.

Huotilainen, Minna. 2016. "Why Our Brains Love Crafts?" Keynote lecture in Make it NOW! conference, University of Turku. Rauma, Finland, September 30.

Tynjälä, Päivi, and Hannu Heikkinen. 2011. "Beginning Teachers' Transition from Pre-service Education to Working Life. Theoretical Perspectives and Best Practices." *Erziehungswiss* 14: 11–33.

Kaitavuori, Kaija. 2015. "Nykytaiteen ilmiöitä meillä ja maailmalla. Taide ja osallisuus" (Phenomena of Contemporary Arts. Participatory Art). Lecture at Jyväskylä Art Museum, Jyväskylä, Finland, November 20.

Martin, Rod A. 2016. *The Psychology of Humor: An Integrative Approach.* Burlington, MA: Elsevier Academic Press, 2010. November 17. Accessed January 2, 2017. http://site.ebrary.com/lib/jyvaskyla/reader.action?docID=10151382.

Shiner, Larry E. 2001. *The Invention of Art: A Cultural History.* Chicago: University of Chicago Press.

TEACHING EMPATHY FOR DEMENTIA BY ARTS-BASED METHODS

Ruth MATEUS-BERR
University of Applied Arts Vienna, Department of Art Sciences and Art Education, and Department of Social Design, Arts as Urban Innovation, Austria

ABSTRACT

The research-project "D.A.S. Dementia. Arts. Society. Artistic Research on Patterns of Perception and Action in the Context of an Aging Society," funded by the National Research Funds FWF (PEEK) of Austria is based at the University of Applied Arts Vienna. It aims to apply artistic interventions to diverse target groups in order to evoke empathy towards the sensitivities of people with dementia. Young people (10-11 years old), were encouraged to participate in audio- and performance-based artistic interventions during their art lessons in school. The objective was to analyze the potential children have to empathize with people with dementia. How – verbally and via drawings – do they describe an experience that simulates the sensual perceptions of people with dementia? Analysis of their verbal and artistic descriptions of the experience provides insights into the word choices and artistic methods of young people. Interpretations of drawings have been made in different manners over time: they borrow strategies from social sciences, psychology, psychoanalysis, Gestalt psychology, the psychology of perception, art history, linguistics, art therapy, art education, and so on. The author used image-hermeneutical approaches. Especially interesting was the presentation of confusion and disorientation by youth within a short time frame.

KEYWORDS

dementia, arts education, arts-based research, transferable skills, empathy

Introduction

This project aims to facilitate empathy for people with dementia. The research group worked with diverse target-groups at schools and adult education centers in the capital of Austria, Vienna. For this paper one case study will be reviewed. The project's theme is rewarding for two reasons: first, we aim to investigate youths at a certain time in their education in regards to their empathic feelings for elderly people (especially those suffering from dementia) in art classes in schools by using arts-based research methods; and second, it is of further interest to study the spontaneous expression of feelings via art.

Ageism

New analysis by the WHO (the World Health Organisation; Smith and Härtl 2016), shows that negative attitudes towards older people are widespread and ageism is extremely common. By 2025 the number of people aged 60 and over will double, and by 2050 will reach 2 billion globally, with the vast majority of older people living in low and middle-income countries.

Dementia

Some ten million people in Europe suffer from dementia. By the year 2050 the number is expected to double. People with dementia suffer from social stigmatization. Common tasks such as shopping, making financial and travel plans can be difficult for them. To avoid rejection and embarrassment they seclude themselves from society. The principal hypothesis of the research project D.A.S. is that specifically-created art and design interventions can change society's attitude to dementia.

Empathy in education

There are at least two interpretations of empathic feelings in neuroscience: since the discovery of mirror neurons it is believed that empathizers actually undergo states that match those of the target groups, though not automatically; and they are associated with reconstructive empathy (cf. Vignemont 2008), which is similar to mindreading (Goldman 2014, 33, 37; Stueber 2006). Keith Oatley (Oatley 2011; Paul 2012) found through brain scans that the part of the brain we use to understand narratives overlaps with the part of the brain used when exercising; this is associated with the "Theory of Mind (ToM)," which constructs a map of other people's intentions, or, empathy.

At the age of four years, a child is able to reflect on awareness, that is, to grasp what is happening in the heads of others. At seven years, children develop a contextual empathy in which their own feelings are related to a biographical context (Bischof-Köhler 2012).

It has been proven that empathy is responsible for social interactions and plays a crucial role in acquiring positive behavioral patterns and attitudes, good achievements and long-standing friendships (Schonert-Reichel & Oberle 2011, 118). Empathy belongs to the so-called transferable skills, the core skills of the 21st century, described by Abott (2016) or Burow (2016, 16). Herbert Read reflects on the correlation between abstraction and empathy: " ... in art, the work of art is not an abstraction from life, but a direct imitation of its perceptual appearance" (Read, 1958, 86ff).

"The me-me-me generation" – the youth of our century – proves that the capacity of empathy has declined rapidly because of the predominance of virtual environments (Stein 2013, 28–35). Herbert Read proposed the development of a "language of feelings" (Engels 2015, 58). He believed that the aim of education is the creation of artists, "of people efficient in the various modes of expression" (Read 1958, 11), and further argued that "Art should be the basis of education" (Read 1958, 1).

Art education

The artistic task of this case study was very open. Sowa (2012, 255) believes that in this type of study, the student has two requirements: knowledge of the task's base patterns, and a repertoire of image formulas that he or she can refer to. This study applies research patterns and expressive images in a way similar to that of Franz Cizek. He taught ornamental studies at the Vienna School of Applied Arts around 1917, and experimented with the "abstraction of feelings"; his work revealed what he called "sub-conscious aspects," "nerves at work," "confusion," and "unornamental" elements. Around the same time, the expressionist artist Herwarth Walden wrote: "All verbalization is unimportant. It is important to see. It is important to feel" (Platzer 2011, 27).

Project case study

Children from schools in Vienna (Schulschiff), aged between 10-11 years were asked to participate at a perception workshop called "Feel Dementia" during their art classes. The artist Cornelia Bast and the designer Antonia Eggeling developed the workshop. It consisted of two aspects: one was to wear a kind of large felt helmet with various lenses on it; the second consisted of listening to an audio-file of selected information. Both interventions aimed to irritate the sense of orientation in terms of kinesthetic and audio experiences. The children were accompanied by an adult in order to feel safe. The experience was recorded by interview, written text and drawing.

In the end, the project was able to explain what it means to empathize by using artistic sensual interventions and dealing with these experiences via reflections and drawings.

The hermeneutic theory of "understanding" demands the interaction of mental representations of language and image and that these must be related to similar things (see Königer 2012, 264pp.). Both are interpretations of mental perception and insight, but differ in their characters. The following statements can be made regarding the effect of the artistic intervention on the children's empathy for people with dementia. Most of the children associated these situations with feelings such as: feeling lost and disorientated, shame, feeling unsafe and needing help. One of the boys felt anger; two described the situation as a "bad feeling"; two would have preferred to stay at home; one pupil trusted herself to do the right thing; one had to reconsider his/her confidence.

Figure 1 & 2. Audio File and Felt Helmet Fokung Wirkus
Photograph: D.A.S.

EXAMPLE: 16 students participating, aged 10-11 years
They were asked to answer the question: "How would you deal with this kind of situation?"

Drawings

Later the students were asked to draw the feelings they experienced within a short time (about ten minutes). They used pencils, felt-tip pens, crayons and sheets of A4 paper.

Figure 3. Experience Audio-File_I Source: N.N.

One boy (Fig. 3) drew the entire scene, with himself on the left side ("Ich wie ich mich gefühlt habe"/"Me, as I felt") listening to the audio-file; the background of a circus tent opposite the school (and that happened to be there at the time); in front of him the bridge to the school, with an indication of the Danube River. Also to the left is one of the research team members filming the scene, and on the right someone taking photographs (with a hiss-line in comic language). In the upper left, "in the sky," two pupils are seen; in their speech bubble we can read: "HA,HA,HA, was macht der"/"HA,HA,HA, what's this guy doing?"

Analysis of the images

Due to the short problem-solving time for the task – "Draw what you experienced in ten minutes" – the analysis was done by a comprehensive psychology method, which focused on the experienced feeling of space rather than an imitative, instructional or learning approach (Reiß 2003, 68–89). Though not to be claimed for all of the drawings, empathic feelings for people with dementia can be directly or indirectly discerned. Some drawings showed a feeling of a lost sense of orientation. Drawings are considered as "models of ideas" (Sowa 2012, 137), or recollections of "internal images" that refer to a tacit, implicit knowledge (Polanyi 2009).

Further research

Students who did not participate in the artistic intervention (the control group) were only told about the project D.A.S. They were asked to define disorientation on the left side of a sheet of A4 paper, and its contrary on the right side. Some children used realistic representations, some preferred doodles. Figures 4 and 5 show the disorder in the rooms of the children, which they associate with feeling comfortable. The abstract representations often show a chaotic structure on the left, and something more ornamental on the right (or even more iconic symbols such as emojis or language borrowed from comics) (Figures 6 & 7).

Figure 6 & 7. Disorientation, Chaos: Abstract representation (drawing on the top by a boy; on the bottom, a girl; test group 14 years) Source: N.N.

Figure 4 & 5. Disorientation, Chaos: Realistic representation (drawing on the top by a girl; on the bottom, a boy; test group 12 years) Source: N.N.

Conclusion

The intervention by "Feel Dementia" provoked disorientation by auditive and visual sense disturbance: The felt helmet with lenses prevented the user from finding her or his visual orientation, while the audio intervention evoked a surplus of information. Asking children to draw their experience proved that confusion was experienced. The drawings show – as a simple case study – by text and image analysis that empathy can be provoked by artistic interventions, though further and larger studies are needed. The use of this research via small emotional line drawings lead them back to their early childhood experiences when "right" and "wrong" drawings were not judged, and every line had a meaning; in respect of the research theme and project, their personal expressions received new attention. The expression of disorientation was described in different ways, as disorder for the control group, and less so for the test group. There seems to exist a difference between narrative explanation and embodied experimentation. The test group shows personal experiences with the art intervention and it represents such concrete experienced perceptions as disorientation, feeling ashamed, and others as seen in Figure 3. The control group drew very individual and personal experiences of chaos as Figure 4 shows: an untidy room represented by clothes lying about on the floor, some of which even seem to overlap with the girl's body. The contrary,

represented on the right side of the drawing, shows a reduction of elements: the girl's upper body, a heart and a book called "Warrior Cats" that she seemed to be fond of. The expression used is a form of sign language recalling mathematical formulae. The boy expressed chaos as well with the drawing of his room, where the guitar is lying on the floor, loud music seems to be playing, and books and CDs lie on the floor. In contrast, the right side shows the guitar hung upright, books in the bookshelf, and the school bag ready. Figs. 6 and 7 represent chaos and disorientation in a rather abstract representation: a chaotic ball of thread on the left side, horizontal and vertical lines in order on the right side; or, trees, question marks, signposts; destination panel, orientation map and traffic signs It was obvious that children older than 14 years (of the test group) expressed themselves by signs and in emotional language, as opposed to the younger children who engaged in representing a "real situation."

Further questions arise: Might there be similarities in representation by children in puberty and people with dementia? What kinds of ornamental patterns would be used to represent chaos and order? How do they relate to archaic forms (CG Jung, Hann)?

If it is shown that pupils are sensitively linked to their own emotions, then perhaps too they are aware of the needs of others. This insight might lead to more awareness of the importance of art classes for the important concerns of society today. Currently art classes have succumbed to a reduction of lesson hours all over the world due to a neoliberal input-output belief in efficiency. But such insights as described here show that they empower the expression of one's own feelings, which allows one to empathize with the feelings of others.

REFERENCES

Bischof-Köhler, Doris. 2012. "Wie Empathie entsteht. Von der Gefühlsansteckung zur "echten" Emotion", 2012. http://www.iscobel.de/page/?source=/iscobel/160627/index.html.

Burow, Olaf-Axel. 2016. "Creative Collaboration. Schlüsselkompetenzen für Lehrerinnen und Schülerinnen im digitalen Zeitalter", Journal für Lehrerinnenbildung. Kreativität von Lehrpersonen, 1/2016. 16. Jahrgang. Facultas Wien (2016): eds. Bühler, Häuser, Rabenstein, Rahm, Schratz, Schrittesser, Schuchart, Seel, Zutavern: 16.

Vignemont, Frédérique de. 2008. "Empathie Miroir et Empathie Reconstructive", Revue Philosophique de la France and de l'Etranger, 133(3): 337–45.

Engels, Sidonie. 2015. "Kunstbetrachtung in der Schule. Theoretische Grundlagen der Kunstpädagogik im Handbuch der Kunst- und Werkerziehung 1953–1979". Bielefeld: transcript.

Goldman, Alvin I. 2014. "Joint Ventures: Mindreading and Embodied Cognition". Oxford: Oxford University Press. 13(3).

Hann, Michael. 2013. "Symbol, Pattern & Symmetry. The Cultural Significance of Structure". London, New Delhi, New York, Sydney: Bloomsbury.

Jung, Carl Gustav. 1968. "Der Mensch und seine Symbole". Olten: Walter Verlag.

Königer, Petra. 2012. "Strukturierung und Strukturierung der Vorstellungs- und Wahrnehmungsvorgänge. Eine Untersuchung zum sprachlichen und zeichnerischen Wirklichkeitsverständnis von Migrantenkindern". In Bildung der Imagination Band 1: transzphänogologische Theorie, Praxis und Forschung im Bereich einbildender Wahrnehmung und Darstellung, edited by Hubert Sowa. Oberhausen: Athena.

Oatley, Keith. 2011. "In the minds of others", Scientific American Mind 22(6): 62–67.

Paul, Annie Murphy. 2012. "Your brain on fiction", New York Times, http://www.nytimes.com/2012/03/18/opinion/sunday/the-neuroscience-of-your-brain-on-fiction.html.

Platzer, Monika. 2011. "Der Wiener Kinetismus – eine Balance zwischen den Avantgarden." In wiener kinetismus. eine bewegte moderne, edited by Gerald Bast, Agnes Husslein-Arco, Harald Krejci and Patrick Werkner, edition angewandte, Wien, New York: Springer.

Polanyi, Michael. 2009. "The Tacit Dimension." London/Chicago: The University of Chicago Press.

Read, Herbert. 1958. Education through Art. New York: Pantheon Books Inc 1; 11; 86–89.

Reiß, Wolfgang. 2003. "Die Darstellung des Raumes bei Kindern und Jugendlichen". In Kunst+Unterricht/SB 2003 Kinder- und Jugendzeichnung. Seelze: Erhard Friedrich Verlag.

Schonert-Reichl, Kimberly A. and Eva Oberle. 2011. "Teaching Empathy to Children: Theoretical and Empirical Considerations and Implications for Practice." In The Politics of Empathy. New Interdisciplinary Perspectives on an Ancient Phenomenon, edited by Barbara Weber, Eva Marsal and Takara Dobashi. Berlin, Münster: Lit Verlag.

Smith, Phil and Gregory Hartl. 2016. "Discrimination and negative attitudes about ageing are bad for your health". http://www.who.int/mediacentre/news/releases/2016/discrimination-ageing-youth/en/

Stein, Joel. 2013. "The New Greatest Generation. Why Millennials will save us all". Time Magazine. 20. 5. 2013: 28–35.

Sowa, Hubert. 2012. ed. "Bildung der Imagination Band 1: Kunstpädagogische Theorie, Praxis und Forschung im Bereich einbildender Wahrnehmung und Darstellung". Oberhausen: Athena.

Stueber, Korsten. 2006. "Rediscovering Empathy. Agency, Folk Psychology, and the Human Sciences". Cambridge, Mass.: MIT Press.

"WHO". Accessed October 30, 2016, http://www.who.int/ageing/features/misconceptions/en/.

POTENTIAL OF AESTHETIC EXPERIENCES IN THE FIELD OF TEACHER EDUCATION

Birgit ENGEL
Academy of Fine Arts Muenster, Chair of Art Didactics, Germany

ABSTRACT

In our changing times, art and design education is confronted with the central question of the implications of an artistic education within the specific task of teacher training. Art educators are challenged with dealing productively and creatively with a double contingency in their everyday pedagogical practice when their actions are geared towards facilitating artistic experiences. Both the artistic experience and the pedagogic-didactic experience as a social event, are never completely predictable in their course and result. This text focuses on the potential of increased attentiveness, combined with sensory and bodily experiences in learning and teaching processes. Drawing on the professionalization discourse, the article clarifies the current challenge of cultivating a professional form of self-reflexive teaching that could enable teachers to promote the new. The text includes a brief presentation of an example of academic teaching as part of university didactics. The narrative and reflexive processes that develop are exemplified theoretically in a phenomenological sense as an "epoché" of lived experience. Such special reflexive attention in conjunction with theoretical insights is introduced as a meaningful practice in art teacher professionalization. Thinking ahead, an artistic form of educational practice could be further expanded to encourage an attitude of creative and sensory perception for dealing with their unavailability; this is a central part of pedagogical practice, and may provide an impetus for accelerating dynamic development even within the institutional order.

KEYWORDS

teacher education didactics, lived experience, epoché, sensible awareness, aesthetically-based reflexivity

In our changing times, art and design education is confronted with the central question of the implications of an artistic education within the specific task of teacher training. Art educators are challenged with dealing productively and creatively with a double contingency in their everyday pedagogical practice when their actions are geared towards facilitating artistic experiences. Both, the artistic experience and the pedagogic-didactic experience as a social event, are never completely predictable in their course and result. The following text developed from a brief critical analysis of the encounter between art pedagogy and the educational science discourse concerning the question of the possible potential of artistic and aesthetic experience in (art) teacher education. Taking a brief example of university didactics, a specific approach used in basic and practical research will be presented, as well as a concept that cultivates experimental aesthetic experience as a reflexive development of pedagogical aesthetic attention.

Figure 1. Opening up new constellations in time and space
Photograph: Birgit Engel

Movements between art and the educational sciences in the recent past

The relationship between independent art and education studies is not unencumbered in the art education discourse, at least in Germany. In the 1990s, the compatibility of both disciplines was questioned at the most fundamental level, raising the issue of "... whether school, yes, whether educational practice, could claim any kind of responsibility with regard to art experience at all." (Ehmer 1995, 15; Engel 2011, 39 et seq.) A highly critical attitude towards educational intentionality in artistic teaching had emerged from the field of liberal arts, too. In schools, on the other hand, art has never really managed to break free of its status as a minor subject as compared with languages and science.

Even in the face of this challenge, a number of innovative art didactic approaches have been established in recent years. Many of these provide space for the development of artistic experience (Bischkühle 2007, i.a.). Furthermore, the potential of artistic education for education as a whole has since also become increasingly important and been recognized for its didactic relevance (Eisner 2002).

These current movements and basic conceptual developments still frequently contradict everyday teaching in schools. Here, operationalized teaching methods that frequently do not even touch on the potential of aesthetic experience can still be found. In this situation, it is precisely a question of what should characterize the qualification of art teachers, because good didactic concepts alone are not yet enough to ensure that art education can support creative learning in the context of school practice. The current educational discourse invites us to consider the alleged incompatibility of art and the educational sciences in a changed manner. Furthermore, the current motto of "learning through research" encourages new associations between theory and practice (Engel and Böhme 2014).

As regards educational philosophy and professional research, there are fundamental doubts as to whether it is at all possible to arrive at a unified understanding of the teaching profession. Michael Wimmer speaks of a collapse of the general and a return of the specific. According to him, the fact that there could never be a specific bridge to practical professional action based on theoretical insights, challenges the educational scientific ethos time and again in completely new ways. (cf. Wimmer 2009, 425)

On the basis of a wide variety of qualitative empirical studies from recent decades, Werner Helsper speaks, while also making reference to the sociologist Ulrich Oevermann, of a significant need for the professionalization of the activities of teachers as such. In particular, "reference to individual cases, a process for dealing with double contingency, and the willingness to upset well-practiced routines" (Helsper 2011, 157) are lacking. From structural sociology it is said that people in every encounter or communication are always contingent, alien, unpredictable, but at the same time

willing to listen to others. But in school practice, there is an assumption of security, although the professional activity in the field is exposed to a fundamental uncertainty (Helsper 2003, 146; Engel 2015, 65).

What kind of profession-specific contribution can art education make in this context?

In light of the above, the following questions must be asked: Can we not make a meaningful, timely contribution to these challenges on the basis of our particular expertise with regard to artistic and aesthetic experience? Are we not skilled in dealing with singular practical problems and situations that challenge a specific reflexivity in an open-minded approach to unique situations? How can we incorporate these experiences as profession-related orientations? However, we cannot act on the assumption of an automatic transfer of artistic experience to the design of educational practice. On the one hand, the focus is therefore on the question of how a transfer can be supported and prepared systematically. On the other, one has to address what, and most importantly how, art educational university didactics can contribute to this process.

Figure 2. Palpable approach to the indeterminate
Photograph: Birgit Engel

Figure 3. Illuminated grasping process
Photograph: Antje Dalbkermeier

Reflexive approaches to moments of uncertainty

In view of this problem, at the Academy of Fine Arts Münster we are currently cultivating a specific approach to university didactics. The specifics of the lived experience are investigated on a phenomenological and aesthetic-hermeneutical basis in accompanying practical and fundamental research. The focus here is on the question of how a reflexive movement, which originates from aeisthesis, can be characterized and understood. The focus of the practice research lies in looking for orientations for pedagogic-didactic processes that support the development of lived experience in reflexive exchange with fundamental theories of educational philosophy.

In exercises, participants are invited to open up mimetically to the temporality of an experience with objects, the room, and the other participants as well as to consciously pursue the respective dynamic process. The following example will give a very brief insight.

> *"so I've um ... that's definitely some rubber material ... that ca ... well, you can ... it's just movable ... completely in itself ... um ... there is a shell around um a shell yes small balls that have different structures so some are smooth with, with holes ... some of these balls are also a bit rougher, but they are completely supported by this rubber"* (original German text in Engel 2015).

This description is not intended to demonstrate a lack of linguistic syntax but to be an example of how unskillful speech appears when a speaker has to struggle to describe something that is (still) foreign or unknown. With these words, recorded and later transcribed, the speaker here is trying carefully to put her experience into words synchronously to the advancing perception of her grasping hand. She does not know what the "thing" is in the small linen bag that hides it from her vision and orients her tactile experience towards properties (moveable, smooth, rough, etc.) and thus towards the presence of a sensation, a "how" of perception. In doing so, she makes reference to that which is already familiar to her but fails to give a clear conceptual definition. Again and again she interrupts her description, and the sentence does not adhere to any semantic logic.

In our research analysis, we went back and listened to the audio recording of the event. This revealed a new meaning behind the speaking process, now connected to the voice of speech and the sound of the words interwoven with ambient sounds. They embed the speech and connect it with the present of a vibrant social situation. This made it possible to perceive how the voice and the search for familiar meaning are intertwined. It is interesting to hear how rhythmically and melodically she speaks. She draws out "rubber material" as if she wants to allow us to participate in the tactile experience. The touch of the grasping hand and the verbal communication are tangibly and vividly

EXERCISES AS A SENSORY-PHYSICAL
AND MIMETICALLY SOUND
EXPERIENCE IN THE FORM OF
EXAMPLES

Figure 4. Experimental aesthetic exercises
Source: Birgit Engel and Jenna Gesse

goal of transferring the reflective level of an Epoché 1 to a biographical educational process by integrating more and more research-reflective aspects is of particular note. Therefore it is necessary to include critically distancing modes of reflection that can help students to further develop knowledge and personal experience on a critically reflective basis. In doing so, one can theoretically draw on the concept of Epoché 2. This second level of reflection must denounce the simple complicity with the experience that is described in Epoché 1, as a kind of natural Epoché. (ibid, p.381ff) Being aware of the ever-present integration into social processes, Waldenfels also wants it to be understood as a responsive Epoché (cf. Engel 2011).

intertwined and become perceivable in this communicative articulation. Had the participants immediately known what the object was, this space- and time-forming joint attention would have ended instantly and inevitably in a supposedly significant certainty.

Here we encounter a particular reflective movement, which commits itself to aisthesis and is associated with an intensified "mode of attention". (cf. Engel 2015, p. 70ff.)

Applying Bernhard Waldenfels' phenomenological philosophy, we can also speak of a primary attention, which he characterizes as Epoché 1 following the work of Edmund Husserl. This attention can be highly innovative and creative. (Waldenfels 2010, 115 ff.) It should also be distinguished from a secondary – and more everyday – attention that is largely repetitive and reproductive (ibid, 180 ff.). The responsively oriented search for new articulations of something that is initially unknown is about a simultaneously sensory and linguistic opening, also towards that which is not clearly determinable, but can perhaps be felt or suspected. This leads to a combination of sensory and mental activity, and has an important significance not only in artistic but also in educational processes.

Integration of experimental aesthetic exercises into a curriculum as a whole

In "experimental aesthetic exercises" (Figure 4) we initiate a joint communicative process that is open to new experiences and which allows us to enter a state of primary attention within a playful constellation. Furthermore, these exercises are reflected and discussed in reference to educational philosophy and practice. Figures 5 and 6 show the possible form of the connections of such exercise relationships within the field of teaching studies. They illustrate how the sequence and orientation of art didactic principal, methodological, and practical seminars are integrated. The ambitious

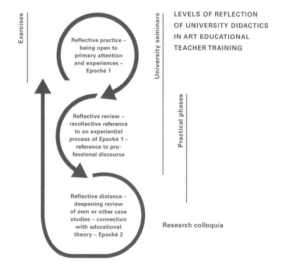

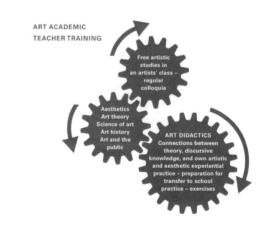

Figure 5. & 6. Structure of teacher training I and II
Source: Birgit Engel and Jenna Gesse

Outlook

The concept outlined very briefly in this text, could form part of an "aesthetic logic" that could make a profession-related contribution to teacher training that goes even beyond the specific subject of art education. The focus here would not just be on becoming aware of the fundamental entanglement of perception, knowledge, and reflection, but also on finding practical ways that make it possible for this entanglement to prove fruitful. Teaching would thus be understood as an experience whose ethos is inconceivable without the aesthetic. If it is to evolve in the context of a process that is open to further new learning, it remains dependent on an ever-regenerating Epoché that can be understood as a constantly renewed establishment of meaning that commits itself to perception. Thinking ahead, an artistic form of educational practice could be further expanded, evoking a creative and perceptive attitude for dealing with sensory unavailability, and may provide an impetus for further profession-related learning. Our current changing times are particularly challenging for art educators to cultivate an awareness of the still hidden potential of the educational space. A genuine participation – in the democratic sense – requires not only courage to embrace the new but also to take those attentive steps that can cultivate transformative processes together. But this also depends on corresponding structural conditions that provide the necessary temporal, spatial, and personal resources for such an arduous and challenging journey.

REFERENCES

Buschkühle, Carl-Peter. 2007. Die Welt als Spiel. Kunstpädagogik. Theorie und Praxis künstlerischer Bildung. Vol.2. Oberhausen: Athena.

Ehmer, Hermann K. 1995. "Betrifft: Kunsterfahrung." BDK – Mitteilungen 15.

Eisner, Elliot W. 2002. Arts and the Creation of Mind. Yale: University Press.

Engel, Birgit, and Katja Böhme. 2014. "Kunstakademische Lehrerbildung – Künstlerische und ästhetische Bildungspotenziale im Fokus der berufsbezogenen Professionalisierung. Eine Einführung." In Kunst und Didaktik in Bewegung: Kunstdidaktische Installationen als Professionalisierungsimpuls. Didaktische Logiken des Unbestimmten, vol. 1., edited by Birgit Engel and Katja Böhme, 8–31. München: Kopaed.

Engel, Birgit. 2015. "Unbestimmtheit als (kunst)didaktisches Movens in professionsbezogenen Bildungsprozessen." In Didaktische Logiken des Unbestimmten: Immanente Qualitäten in erfahrungsoffenen Bildungsprozessen. Didaktische Logiken des Unbestimmten, vol. 2., edited by Birgit Engel and Katja Böhme, 68–85. München: Kopaed.

Engel, Birgit. 2003/2011. Spürbare Bildung: Über den Sinn des Ästhetischen im Unterricht. Münster, New York, München, Berlin: Waxmann.

Helsper, Werner. 2011. "Lehrerprofessionalität: Der strukturtheoretische Professionsansatz zum Lehrerberuf." In Handbuch der Forschung zum Lehrerberuf, edited by Ewald Terhart, Hedda Bennewitz, and Martin Rothland, 149–171. Münster: Waxmann.

Helsper, Werner. 2003. "Ungewissheit im Lehrerhandeln als Aufgabe der Lehrerbildung." In Ungewissheit: Pädagogische Felder im Modernisierungsprozess, edited by Werner Helsper, Reinhard Hörster, and Jochen Kade, 142–161. Weilerswist: Velbrück.

Waldenfels, Bernhard. 2010. Sinne und Künste im Wechselspiel: Modi ästhetischer Erfahrung. Frankfurt am Main: Suhrkamp.

Wimmer, Michael. 1996. "Zerfall des Allgemeinen – Wiederkehr des Singulären: Pädagogische Professionalität und der Wert des Wissens." In Pädagogische Professionalität – Untersuchungen zum Typus pädagogischen Handelns, edited by Arno Combe, and Werner Helsper, 404–447. Frankfurt am Main: Suhrkamp.

IDENTITIES

IMPERATIVES FOR DESIGN EDUCATION IN PLACES OTHER THAN EUROPE OR NORTH AMERICA!

Lesley-Ann NOEL
University of the West Indies, St. Augustine Campus, Department of Creative and Festival Arts, Trinidad and Tobago

ABSTRACT

This paper considers the future of design education from the perspective of the designer who was not born in, will not be educated in, nor will practice in North America or Europe. What is the relevance of design education based on the curriculum of Ulm or that of the Bauhaus to the designer born today (or in the future) in an emerging economy? The importance of a "homegrown" curriculum is emphasized through reference to Usain Bolt and Jamaica's international track and field success. The developing world is not a homogenous space, and this paper focuses on the socio-economic context of three groups of vulnerable developing countries: Least Developed Countries (LDCs), Landlocked Developing Countries (LLDCs) and Small Island Developing States (SIDS). What should the curriculum of the design student include in these contexts? Should the education of designers in emerging economies be different? A model for design education in developing countries is presented in the conclusion, as well as recommendations for curricula focus at the primary, secondary and tertiary levels.

KEYWORDS

design education, developing countries, design curriculum, Usain Bolt

Introduction

I come from a middle-class family from Trinidad and Tobago where I grew up in the 1970s and 80s. Around 1990 I fell in love with design, specifically with the field of Industrial Design. At the time there was no tertiary level design education in Trinidad and Tobago, and while applying to universities in the United States, I asked myself, "how can I do Industrial Design, if we do not have the industry to support it?" In 1992, I had the opportunity to go to Brazil to study Graphic Design, but in 1993 I switched to Product Design, finally spending most of the 1990s in Brazil. My university experience was a very political and socially conscious one, and the rich socio-economic Brazilian context had a major impact on my education and future practice.

Towards the end of the 1990s, I went back to Trinidad and Tobago where I created my own jobs and cobbled together a design and academic practice which has focused mainly on training and export development projects with craftspeople in the Caribbean and East Africa. My academic practice has focused on design curricula for different audiences such as university students, craftspeople, and elementary school children.

The typical perspective from Art and Design conferences that I have attended is that of the student, academic or professional who was born in and educated in Europe or North America. As I do not come from such a background, in this paper I want to focus on the future of design education from the perspective of the student who was not born in Europe or North America, but rather, was born in, will be educated in and will practice in a developing country. What are the imperatives for design education for this person?

I struggled with the title of this paper for several months and hope that as a woman of color from a Non-European and non-North American background, I can bring a different perspective on design education and practice to the reader. The paper is divided into three parts: the first part explains my perspective as a designer and design educator; the second looks to the origins and aims of the Industrial Design curriculum via the Hochschule for Gestaltung Ulm (HfG Ulm), and the American recommendations from the National Association of Art and Design; and finally, in the third section, after examining the context of "vulnerable" developing countries, a curriculum is proposed for the non-European/non-North American design student.

Usain Bolt and the Jamaican track experience

In 2016, we watched in amazement as Jamaica, a tiny country of less than three million, dominated the Olympics track and field competitions. What explains Jamaica's global dominance in track and field? It is not genetics, according to Orlando Patterson (2016) of the *New York Times;* instead, he claims that the reason is Jamaica's school-level track and field program. Jamaica has a long history of promoting track and field at the high-school level, and this goes back to Norman Manley, one of Jamaica's founding fathers who was a track and field hero in 1911. Other factors contributing to Jamaica's track and field success are a public health campaign that promotes healthy bodies and healthy minds, and the natural confrontational and competitive character of the Jamaican people (Patterson 2016). Jamaica has been able to create its own athletics program, and produce excellent results by drawing on its own contextual factors despite its economic conditions and lack of resources. This makes me wonder: could a home-grown design curriculum in a developing country also lead to global success?

A look at two design curricula: Hochschule für Gestaltung (HfG) Ulm, and the USA

HfG Ulm

The Hochschule für Gestaltung (HfG) Ulm was founded in 1953 during a decade of rebuilding in Germany after the Second World War, and one of its aims was to "foster constructive political behavior." It closed in 1968, a year marked by global social unrest (Jacob 1988). HfG Ulm, modelled itself after the Bauhaus, which operated from 1919 to 1933; but the program at Ulm was more multi-disciplinary than the Bauhaus program and included subjects such as sociology, psychology, writing, graphic design, product design and architecture. The educational concept was to combine design with teaching and to also develop research (Jacob 1988). Collaborations with industry were also a mark of the Ulm model. The school went through three phases in the development of its pedagogy: the "foundation phase" (1953–1958), when its Bauhaus roots were more obvious, and there was a concentration on visual training of the eye and hand; the "scientification" phase (1958–1962), focused on developing methodologies for its design approach; and a third phase (1962–1968), which was marked by design practices influenced by the social sciences. By the third phase each discipline had its own foundation course. (Leopold 2013).

The HfG Ulm experiment and its curriculum provided a strong base for design education around the globe, particularly in Latin America where there was an awareness of the potential of design to impact the economy and of its importance in industrialization processes (Fernandez, 2006). The approach of the Ulm model is a good starting point for discussions of design education.

The USA's industrial design curriculum

According to the National Association of Schools of Art and Design (2016), the American industrial design curriculum should adhere to the following structural guidelines:

> *30-35% of the total program: studies in industrial design*
> *25-30%: supportive courses in design, related technologies, and the visual arts*
> *10-15%: studies in art and design history and theory*
> *25-30%: general studies*

Studies in the first three groups normally total at least 65% of the curriculum. Recommendations for general studies in the industrial design curriculum are for studies in the physical and natural sciences, the social and behavioral sciences, quantitative reasoning, and the humanities. These are all considered to be important for industrial designers. Students should be able to make connections among these disciplines and their work in industrial design.

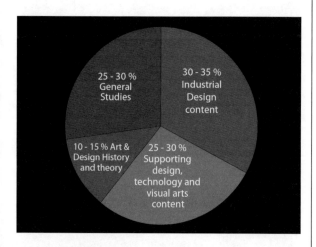

Figure 1. Recommendations for the Industrial Design Curriculum, National Association of Schools of Art and Design Source National Association of Schools of Art and Design (NASAD) Source: Lesley-Ann Noel

Developing country context

> *Since most design professions involve shaping goods and services within large industrial economies, this political-economic context is one key to the realities of design education today and tomorrow.*
> *(Ken Friedman 2012.)*

In the above statement, Ken Friedman ties the political and social contexts of design education to large industrial economies; this makes one question the validity and relevance of design education and practice outside such economies. While most design professions and design schools may operate within large economies, what should design education look like from within a small non-industrialized context? How can design and design education in these places use, like the athletics program in Jamaica, their varied cultures and contexts to create a relevant design curriculum that could serve their populations? How do we create a global view in design education that is not a hegemonic Western view, nor merely a copy of a Western curriculum?

Vulnerable developing countries

The United Nations describes the most vulnerable developing countries as Least Developed Countries, Landlocked Developing Countries, and Small Island Developing States. Let me now examine these three types of countries and the possible roles for design in each context.

The category of *Least Developed Countries* (LDCs) was established in 1971 by the United Nations General Assembly; these countries are the poorest segment of the international community and comprise approximately 12% of the world population (880 million people), but account for less than 2 per cent of the world GDP, and about 1% of global trade in goods. Their economies are primarily agrarian and are affected by low productivity and low investment. Few of these countries have been successful in diversifying into the manufacturing sector, and they produce a limited and labor-intensive product range, for example, textiles and clothing. The current list of LDCs includes 34 countries in Africa, 13 in Asia and the Pacific and one in Latin America (UN-OHRLLS 2014).

There are 31 countries classified as *Landlocked Developing Countries* (LLDCs), sixteen of which are also LDCs. The total population of LLDCs is about 429 million. Fifteen of these countries are in Africa, 10 in Asia, four in Europe, and two in Latin America. These countries lack access to the sea, which results in isolation from world markets and creates high transit costs, which impact their economic development. Most are exporters of a limited number of commodities and their sea-trade depends on transit via other countries. They are generally among the poorest of developing countries and with the weakest growth rates. In contrast to landlocked countries in Europe, in most cases the nearest neighbors of LLDCs are also developing

countries and major markets are far away, making it near-impossible to export high value-added products (UN-OHRLLS 2014).

Small Island Developing States (SIDS) are very small countries with tiny populations. The combined population of these 39 countries is 63.2 million. They are located in three geographic regions: the Caribbean, the Pacific, and the Indian Ocean and AIMS region (Atlantic and Indian Oceans and the South China Sea). SIDS are confronted by a plethora of problems including: (1) a narrow resource base and small markets that deny them economies of scale; (2) small domestic markets; (3) heavy dependence on external and remote markets; (4) high energy costs; (5) inadequate infrastructure; (6) transportation and communications challenges; (7) long distances from major export markets, and long distances from imported inputs for production; (8) low and irregular volumes of international traffic; (9) fragile natural environments and limited resilience to natural disasters such as hurricanes; (10) limited opportunities for their private sectors, and a large reliance on the public sector; (11) growing populations; and (12) volatile economic growth.

Models for design curricula in the developing world

Given these complex contexts, design education in the developing world cannot merely adopt the curricula of design schools from Europe and North America. Instead, any curriculum would need to combine key design abilities – "asking the right questions, sense-making, creating concepts, prototyping and communicating" (Morasky 2016) – and combine these with a strong base in the social sciences in areas such as:

- Social and Environmental Responsibility
- Anthropology and Ethnography
- Social Justice and Critical Theory
- Sustainability
- Culture
- Behavioral Sciences/Change Management
- Entrepreneurship

Designers will also need skills relating to advocacy, lobbying and collaborating with the public sector, since in many of these places government agencies are not yet aware of how design can support their countries' development.

Design assignments at the secondary and tertiary level in LLDCs, LDCs and SIDs can focus on specific challenges related to the particular contexts. These design assignments can have the aim of examining how to improve the basic standard of living, how to promote behavioral change, how to address logistics and transportation problems, and how to create more opportunities for the private sector.

Design education at the primary and secondary levels can play a role in building twenty-first century

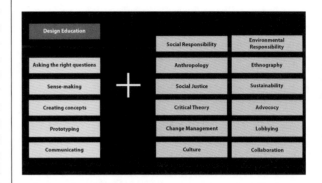

Figure 2. A model for Design Education in the Developing World that combines key design skills with the social sciences
Source: Lesley-Ann Noel

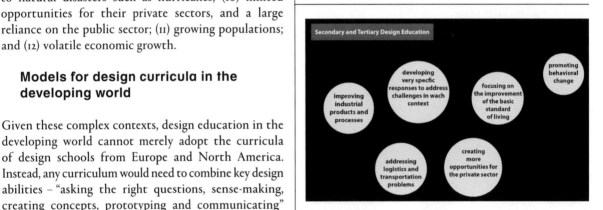

Figure 3. Key aims for secondary- and tertiary-level Design Education in the Developing World
Source: Lesley-Ann Noel

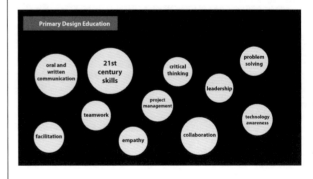

Figure 4. Key aims for primary-level Design Education in the Developing World
Source: Lesley-Ann Noel

skills among children, such as oral and written communication, critical thinking, problem solving, teamwork, empathy, facilitation, collaboration, leadership, project management and technology awareness.

In conclusion, I have re-drawn the curriculum inspired by Ulm and the needs of citizens in the developing world, and in particular from vulnerable economies such as my own. Many readers may ask how this is different from a curriculum for a designer from a more developed country. The reality is that it may not be that different, as the divisions between "first" and "third" world become more blurred. Our core skills as designers remain the same, but perhaps in the developing world, we will need to focus more on creating new opportunities, addressing sustainable development goals and contributing in general to innovation and development.

The whole world benefits when designers are more in tune with issues of development and culture. One day we may all reach a point where the world is focused on design schools and design curricula in developing countries and wondering how to mimic their success, just as during the 2016 Olympics they tried to understand the success of Jamaican athletes and how that could be replicated in their own – oftentimes "developed" – countries.

REFERENCES

UNOHRLLS. "About LDCs." Accessed November 15, 2016. http://unohrlls.org/about-ldcs/

Fernandez, Silvia. 2006. "The Origins of Design Education in Latin America: From the Hfg in Ulm to Globalization." *Design Issues* 22(1): 3–19. DOI: 10.1162/074793606775247790.

Friedman, Ken. 2012 "Models of Design: Envisioning a Future Design Education." *Visible Language* 46(1/2): 132–53.

Jacob, Heiner. 1988. "HfG Ulm: A Personal View of an Experiment in Democracy and Design Education." *Journal of Design History* 1(3/4): 221–34.

Leopold, Cornelie. 2013. "Precise Experiments: Relations between Mathematics, Philosophy and Design at Ulm School of Design." *Nexus Network Journal* 15(2): 363–80. DOI: 10.1007/s00004-013-0148-6.

Morosky, Matt. 2016 "The Art of Opportunity." Speech, Raleigh, North Carolina, September 9.

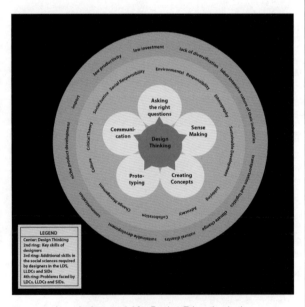

Figure 5. A curriculum model for Design Education in the Developing World, inspired by the curriculum at HfG Ulm
Source: Lesley-Ann Noel

THE DESIGN LABORATORY: A PARADIGM FOR DESIGN EDUCATION?

Gert HASENHÜTL
Academy of Fine Arts Vienna, Institute for Education in the Arts, Austria

ABSTRACT

This paper discusses design education using historical and contemporary examples. The four educational programs chosen adopted the metaphor of the laboratory to serve as a basis for their work. That they called themselves laboratories is the starting point for looking at the subject matter of their teaching. Attention is drawn to the different ways in which these educational programs included art, science and technology in their curricula. The focus of the experiments of these programs shifted from pseudo-laboratory conditions to real-world problems. The comparison shows that the experiments involved and reproduced certain conditions which enabled the emergence and discovery of artistic features. Cross-disciplinary research and/or cooperative design education increasingly included "design thinking" that was focused on intuition. The ancient Greek notion of "techne" influenced the understanding of designing; in other words, art and technology were not separated from each other. By analysing different educational concepts it becomes clear that the borders between designers and non-designers are dissolving and that design research is to a greater extent becoming influenced by Science-Technology-Society (STS) and informed by the social sciences.

KEYWORDS

design research, design education, history of science, studio studies

Four different educational programs – in the fields of architecture, industrial design, fine arts and technical sciences – applied the paradigm of laboratory sciences for purposes of education. The approaches were based on different narratives – rationalism, pragmatism, technical rationality, social constructivism – and different concepts of laboratory science: as metaphor, as method, as theme. At the "Psycho-technical Laboratory for Architecture" of 1927, the replacement of art by the use of science and technology was crucial; at the "Design Laboratory" of 1935, the focus was on art education including technology; at the "Design Research Laboratory" of 1964, the focus was on science and technology including arts research; and at the "Fabulous Laboratory" of 1998, art as a skill was reintegrated into science and technology. Currently, there are several educational programs that refer to the metaphor of the laboratory: the "AA Design Research Lab" of the Architectural Association School of Architecture, London, 1997; the "Design Research Lab" of the University of the Arts, Berlin, 2005; the "K12 Lab" of the d.school, Stanford, with its "Innovation Lab," 2007; the "Applied Design Thinking Lab Vienna," University of Applied Arts, Vienna, 2009; and the "D-Lab, Development through Discovery, Design and Dissemination," MIT, 2010.

The Psychotechnical Laboratory for Architecture, established by Nikolai Ladowski, existed only from 1927 to 1928 at the Higher Technical Artistic Workshops (WChu-temas) in Moscow. This educational program focused on a psychoanalytical method of space research (Vöhringer 2007, 59). Using instruments called "Glazometry" ("meters for visual judgement, " "Augenmeter"), objective laws of perception and the impact of architectural forms on humans were explored (Chan-Magomedow 1983, 144). These instruments were used (1) for entrance examinations for students of architecture; (2) for the training and improvement of perception skills and spatial imagination; and (3) for supporting experiments during design processes (Vöhringer 2013, 59). The curriculum included the use of "psychotechnique," created by Willam Stern and refined by Hugo Münsterberg, with the objective of reducing energy and mental effort during the perception of the spatial and functional qualities of forms (Ladowski 1992, 45). Designing by drawing was given up and replaced by designing in space (Ladowski quoted in Chan-Magomedow 1983, 544). Instead of traditional art teaching beginning with drawing, spatial models were used enhancing spatial cognition and enabling the development of construction plans (Vöhringer 2013, 50–51).

The Design Laboratory, led by Gilbert Rohde from 1935–1937, was a free art school located in New York and financed by the Works Progress Administration. Frances M. Pollak developed the original concept (Bearor 1996, 15). The curriculum was influenced by the machine-oriented second Dessau Bauhaus curriculum of László Moholy-Nagy, and by the handicraft-oriented Weimar Bauhaus curriculum and its foundation course (Bearor 1996, 19; Clark 2009, 47). Besides drawing, painting, sculpture, visual display and fine arts, industrial design constituted the core subject of the school. The basis for its curriculum was workshop training. Teaching focused on experimenting with different materials and techniques. Post-graduate training emphasised "learning-to-be-practical" (Dunne 1937, 41) by practical training, lectures, drawing exercises and field trips. Students were encouraged to work from the outset with equipment, practices and techniques from their core area of expertise. For Rohde (1936, 640) the purpose of the laboratory was to develop skills based on the integration of art, handicraft and industrial design.

The "Design Research Laboratory," founded in 1964 by Christopher Jones, was a post graduate program at the University of Manchester's Institute of Science and Technology. The objective of this program was to offer technical training enabling students to become "design technologists," working cross-disciplinarily on complex problems (Jones 1970, 355). The curriculum included methods of creativie techniques, of empirical social research and of technical product development, later published in Jones´s seminal book on design methods in 1970. The program began with teaching theory and continued with practical project work. "The course consisted of two semesters: the first (October–April) consisted of lectures and laboratory work, followed by examinations; the second was a 5-month individual dissertation, supervised primarily by Christopher Jones, assisted by the other lecturers." (Nigel Cross, e-mail message to author, 24 August 2016) The tasks in teacher-centered instruction and project work dealt with design methods rather than with real-world problems (Jones 1970: 354). Design research was regarded as more important than designing products or services. "The main emphasis, in both teaching and practice, is on the ability to deal formally and precisely with the many uncertainties that present themselves at the start of a design problem." (Jones 1970, 354)

The Fabulous Laboratory, also known as the "Lab for Fabrication," or the "Fab Lab" (Gershenfeld 2005, 11–12) was part of a university program "How to Make (almost) Anything" established by Neil Gershenfeld and his students at the MIT Media Lab, Cambridge, Massachusetts. Starting in 1998, the objective was to produce a so-called "personal fabricator" inside a laboratory setting at MIT´s "Center for Bits and Atoms" (Gershenfeld 2005, 5–6). It was centered around designing, developing and contructing technical innovations by both the students and the final users. Paradoxically, the majority of the students for the class were studying arts, architecture and engineering, not computational sciences as might be expected. Curriculum, tutorial material and teaching staff were unable to cover the requirements of such heterogeneous groups (Gershenfeld 2005, 7). "This process can be thought of as a 'just-in-time' educational model, teaching on demand, rather than the more traditional 'just-in-case' model that covers a curriculum fixed in advance in the hopes that it will include something that will later be useful." (Gershenfeld 2005, 7) Education focused on promot-

ing computer literacy and manual skills. If students acquired certain skills, e.g. programing or production techniques, they shared their knowledge with other members of the group. This exchange of ideas, skills and experiences developed momentum, boosting the students problem-solving capacity (Gershenfeld 2005, 24).

These four educational programs differed from each other with respect to experiments. Experiments at the Psychotechnical Laboratory for Architecture examined spatial phenomena, trying to find regularities in perceiving architectural forms. Ladowski dealt with spatial elements, e.g. distance, surface, volume or angles, as if they were "quasi-objects"; that is to say, he derived statements from subjective data which were verifed in his laboratory. Experiments at the Design Laboratory addressed the handling and testing of different materials and manufacturing techniques. The free art school established by Rohde and Pollak was influenced by John Dewey´s "Laboratory School." Initiative and interests were the starting points for activities to provide an understanding of the importance of handicraft work. Personal experience was later enriched by formal teaching. Experiments at the Laboratory for Design Research consisted of attempts to master complex problems by means of goal-oriented and intuitive/experimental thinking processes. Working in teams of heterogeneous stakeholders was a crucial point. Jones established the program in the spirit of the Design Methods Movement, maintaining intuitive artistic ways of thinking. Testing to what extent technical fields of knowledge could be included in a curriculum for design was also part of this program of design education. Experiments at the Fab Lab tackled problems and translated matters of interest technically. Design processes were transferred into technical innovation processes, including means of manufacturing, connecting, programing and communicating. The reintegration of manual skills into the liberal arts was a key issue of this approach.

Comparing these four programs, it is apparent that conceptual and practical work were weighted differently. Evidence can be found for lecturers turning into practitioners, colleagues and co-investigators, available for students as a resource to learn about materials and processes (Collins 1990, 5; Dougherty 2012, 12–13). The claim that "studio education is education in making things" (Schon 1985, 94) seems to have been achieved in the Fab Lab. The early laboratories imitated an approach of basic research in natural science, but not of applied research. Knowledge in design was connected with patterns of perception or a certain habitus which were criteria for deciding what "true" design was. Design ethics dealing with habitualization and subjective aspects (Findeli 2001, 13) were replaced by "design thinking" (Koh et al. 2015, 44; Mateus-Berr 2013, 74). The examples show that the engineering imperative of "design thinking" (Leifer et al. 2016, 3) spread at a similar speed as industrial design influenced by technocratic thinking, and that the metaphor of the laboratory helped to reform art and design (Farías et al. 2016, 8). A comparison of work in studios and laboratories is possible if they are regarded as instruments of, for example, democratising a society, (Alpers 1998, 415 et sequ.). Pseudo-laboratory conditions were transformed into "real-studio conditions" (Lawson 2004, 47), dissolving the borders between designers and non-designers. "Placelessness" and the relocation of research into "virtual" space are new developments of laboratories demanding interdisciplinary communication (Landbrecht et al. 2016, 40). Integrating stakeholder communities, open science, prosuming (i.e. the combination of producing and consuming), and "reskilling" practices into a framework of design education: a transformation of design science is in the making. By distancing itself from theoretical sciences a new paradigm in education seems possible (Laurillard 2012, 1). Design studio education had the potential to modernize higher education in the liberal arts because the activity of designing itself was regained as a core professional skill (Simon 1996, 111; Schon 1985, 95–97). Studio-laboratory education has the potential to enhance art production and technological research by bridging social needs and technological developmental processes (Century 1999, 9). As shown by the chosen examples, historically the integration of art, science and technology into the curricula of design education can serve as a condition to achieve a synthesis of these two claims.

REFERENCES

Alpers, Svetlana. 1998. "The Studio, the Laboratory, and the Vexations of Art." In *Picturing Science, Producing Art*, edited by Carolin A. Jones and Peter Galison, 401–417. New York: Routledge.

Bearor, Karen A., 1996. "The Design Laboratory: New Deal Experiment in Self-Conscious Vanguardism." *Southeastern College Art Conference Review*. Southeastern College Art Conference, 14–31. Washington.

Century, Michael. 1999. "Pathways to Innovation in Digital Culture." Updated 2013. Montreal: Centre for Research on Canadian Cultural Industries and Institutions.

Chan-Magomedov, Selim O. 1983. *Pioniere der sowjetischen Architektur*. Dresden: VEB.

Clark, Shannan. 2009. "When Modernism was still Radical. The Design Laboratory and the Cultural Politics of Depression-Era America." *American Studies* 50, 3/4: 35–61.

Collins, Allan. 1990. "Toward a Design Science of Education." Technical Report 1. New York: Center for Technology in Education.

Dougherty, Dale. 2011. "We are Makers." Accessed May 30, 2016. https://www.tEd.com/talks/dale_dougherty_we_are_makers?language=de#t-3849

Dunne, Liane. 1937. "Learning Design and Production. The Methods Used in the Design Laboratory of the F.A.E.C.T. School." *PM, An Intimate Journal For Art Directors, Production Managers, and their Associates*, August: 39–44.

Farias, Ignacio, and Alex Wilkie. 2016. "Studio Studies. Notes for a Research Pro-gramme." In *Studio Studies. Operations, Topologies and Displacements*, edited by Ignacio Farias and Alex Wilkie, 1–21. New York: Routledge.

Findeli, Alan. 2001. "Rethinking Design Education for the 21st Century. Theoretical, Methodological, and Ethical Discussion." *Design Issues* 17 (1), 5–17.

Gershenfeld, Neil. 2005. *Fab. The Coming Revolution on Your Desktop. From Personal Computers to Personal Fabrication*. New York: Basic Books.

Jones, Christopher John. 1970. "An Experiment in Education for Planning and Design." In *Emerging Methods in Environmental Design and Planning*, edited by Gary T. Moore, 353–357. Cambridge: MIT Press.

Kolk, Joyce Owao et al. 2015. *Design Thinking for Education. Conceptions and Applications in Teaching and Learning*. Heidelberg: Springer.

Ladowskij, Nikolai A. 1992. "Ein psychotechnisches Laboratorium der Architektur (im Sinne einer Fragestellung)." In *Der Architektenstreit nach der Revolution*, edited by Elke Pistorius, 45. Basel: Birkhäuser.

Lengwiler, Christoph, and Yeoryia Simitri. 2016. "The Laboratory as a Subject of Research." In *New Laboratories. Historical and Critical Perspectives on Contemporary Developments*, edited by Charlotte Klonk, 21–90. Berlin: De Gruyter.

Laurillard, Diana. 2012. *Teaching as a Design Science. Building Pedagogical Patterns for Learning and Technology*. New York: Routledge.

Lawson, Bryan. 2006. *What Designers Know*. Burlington: Architectural Press.

Lindberg, Tilmann, and Christoph Meinel. 2011. "Mainstream Dismissed. Designprocesses revisited." In *Design Thinking Research. Making Design Methods Workable*, edited by Hasso Plattner et al., 1–8. Cham: Springer.

Mateus-Berr, Ruth. 2013. "Applied Design Thinking LAB and the Creative Empowering of Interdisciplinary Teams." In *Springer Encyclopedia on Creativity, Invention, Innovation and Entrepreneurship (CI2E)*, edited by Elias G. Carayannis et al., 73–116. New York: Springer.

Rohde, Gilbert. 1936. "The Design Laboratory." *American Magazine of Art* 29 (10): 638–643 and 686.

Schon, Donald. 1985. *The Design Studio. An Exploration of its Traditions and Potentials*. London: Riba.

Simon, Herbert A., 1996. *The Sciences of the Artificial*. Cambridge: MIT Press.

Vöhringer, Margarete. 2007. *Avantgarde und Psychotechnik. Wissenschaft, Kunst und Technik der Wahrnehmungsexperimente in der frühen Sowjetunion*. Göttingen: Wallstein.

THE JOYS AND OBSTACLES OF A CHANGE AGENT
TEACHING IN PAKISTAN'S ONLY POSTGRADUATE ART EDUCATION PROGRAM

Razia I. SADIK
Pakistan Institute of Fashion and Design, Pakistan

ABSTRACT

The arts are a vehicle of learning, expression and human development and have a crucial role to play in the education of all citizens. Though Pakistan has a long and powerful tradition of higher education in the fine arts, to date it has had very little impact on society. The arts remain heavily underrepresented in Pakistan's schools, existing only in some independent schools, and thus leaving children in the vast majority of public schools without the transformative experiences they offer. Pakistan is a nation of vibrant and diverse citizens, with a disturbed political landscape where energies need to be re-positioned towards humanistic values. Arts education is a powerful tool for promoting such change, yet it has not been given due attention even in large-scale educational development initiatives. Given this context, it is imperative to generate discourse on the pedagogy of art both at the university level – teacher education and artist education – as well as in regards to the schooling of children and informal educational experiences for people of all ages. Six years ago Pakistan's first Master's Program in Art Education was set up at a private university to provide a serious professional development opportunity for in-service teachers from all over the country. This essay chronicles the setting up, development and ongoing challenges of running this program in an environment riddled with both societal and institutional opposition to the pedagogy of art and design.

Disclaimer: All uncited views and assessments of the author were made on the basis of academic meetings regarding curriculum, and interactions with faculty, students and administration while serving as faculty at various art and design Higher Education Institution's in Pakistan between 2000 and 2017.

KEYWORDS **higher education, teacher education, pedagogy, curriculum, Pakistan**

Preamble

This essay tells the story of Pakistan's first art teacher education program from my perspective as a founding member and instructor in the program. At the inception of the program in 2011, I was completing a doctorate in art education in the United States. Over the next two years I moved back to Pakistan to take charge of this course as program director. With this transition I came to be considered a "change agent" thanks to the expectations of my peers and mentors in the U.S. and Pakistan. I was daunted by this prospect as I was carrying back new knowledge and skills that risked professional rejection for me, by virtue of being the bearer of the new and unfamiliar.

Art Education as a formal academic discipline has only recently been introduced in Pakistan via this program. The teaching of the arts as a formal discipline dates back to the nineteenth century when four major art schools were established in British-ruled India in the cities of Calcutta, Bombay, Madras and Lahore (Tarar 2011). The identities of these schools evolved and diversified over time. In Lahore, the Mayo School of Arts, established in 1875 by John Lockwood Kipling (Choonara and Tarar 2003) was the first art school in the western part of India (present day Pakistan). Over the course of the next century other art schools emerged. By the late twentieth century a growing art scene had also associated itself with these schools in the two major cities of Lahore and Karachi.

Though the arts have existed for many centuries in Pakistan, as formal art schools developed art pedagogy became associated with independent artists who had no formal teacher training. More recently, art pedagogy seems to be deeply embedded in hubs of art production, such as artists' studios and, primarily, studio art classes at art schools (Ali 2008; Sadik 2011; Hashmi 2015). Teaching methodologies emerge from particular personalities rather than through theoretical and broader socio-cultural contexts.

At the policy level, Pakistan currently does not have teacher certification criteria in the arts, nor any officially endorsed professional councils or societies of the arts. Pakistan's rich traditions in the visual arts has little impact on everyday life and culture. In the absence of a clearly defined national policy on culture and the arts, educational policy often neglects the pedagogy of art, especially in the schooling of children. Recent large-scale educational development projects undertaken through donor support have also neglected the arts.

In this context introducing art education as a formal discipline at a Master of Arts level at a private university generated a variety of challenges. Simultaneously, it opened up a vibrant array of learning for teachers that highlights the transformative potential of the arts. I believe that this spark was particularly relevant at this crucial moment in Pakistan's history.

A context of urgency

Following 9/11 the political framework of Pakistan and its western and northern borders were destabilized due to the presence of war across the Afghan border (2001–2014). In 2008 Pakistan's major cities persistently experienced terror-related violence which brought an unprecedented loss of human life in its wake. Sixteen years on, the remnants of this instability are still visible in the civic structure of society and the visual culture of Pakistani cities.

The small close-knit arts community based mainly in the urban centers of Lahore and Karachi, became quite prolific during this time. This community is closely allied with art schools, and has been most active during times of political strife despite the censorship and suppression it faced under the military dictatorship of Zia-ul-Haq (1977–1988) (Hashmi 2015). This community's recent output has created new global networks and markets for art's consumption. The careers of some younger artists who were only recently students or mentees of senior artist-teachers have also been leveraged through these new networks and markets. Often these young artists are recruited to teaching positions soon after receiving their bachelor's degree, primarily on the basis of their art practice and its commercial success, or for reasons of academic merit (Sadik 2011). The induction of a majority of teachers on the basis of practice alone brings up ethical concerns regarding their lack of experience and preparation for teaching.

It was to address this gap that in 2010 a few art professors at a small private university, who had been educated in some of the most prestigious art education programs in European and American universities, collaboratively developed a graduate program for in-service art and design teachers from K-12 and higher education schools. Beaconhouse National University (BNU) is a young liberal arts institution in Lahore where its flagship School of Visual Arts and Design (SVAD) offers an undergraduate studio program concerned primarily with contemporary discourses in art and culture. Its emphasis on studio art was pivotal in the development of an arts teacher education program. The initiative was further grounded through the inception of a Centre for Art and Design Education and Research (2013) founded at SVAD to pursue national research, curriculum development and teacher education in the arts (BNU 2015).

A curricular vision

SVAD's MA Art Education Program is a low-residence, intensive summer program for in-service arts teachers from all over Pakistan (MA Art Education website 2017). It is composed of 36 (US) credits of coursework, including six credits of field-based thesis research. In Pakistan, higher education policy is governed by the Higher Education Commission (HEC), a public body for accreditation and funding of post-secondary education, which stipulates the delivery of a minimum

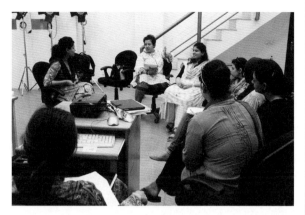

Figure 1. Live writing workshop: Students share and respond to in-process writing. Photograph: Asif Khan

Figure 2. Place-based learning: Silent walkabout, observation and planting activity on campus grounds. Photograph: Asif Khan

Figure 3. Sonic relationality: A studio exercise in which students use their voices as instruments to gauge a space and enhance their observation of ambient sounds. Photograph: Asif Khan

of 48 contact hours for theory courses and 96 for studio courses over a 16–18 week semester. In the Summer MA Art Education Program, however, the curriculum is delivered over eight weeks each summer over three summer semesters.

Each summer semester students take two theory courses and one studio. Theory and studio classes are held twice a week for three hours and six hours each, respectively. During the fall and spring in between the three summers, students conduct a fieldwork practicum on teaching in classrooms or in another educational context. Its purpose is to analyze and develop best practices of pedagogy and/or curriculum-making based on their core content knowledge. Students also conduct a research project in the last year of the program, on which their MA degree is awarded.

The coursework consists of a variety of content organized and delivered to facilitate the development of a practice-based approach to art education. The content is divided into five types of courses, namely: (1) educational foundations (history and philosophy; artistic development through one's lifespan; curriculum design and assessment; critical pedagogy; technology in education); (2) studio art (material exploration; archival and documentary processes; place and space-related studies); (3) research methods (qualitative and arts based methods; thesis research writing); (4) fieldwork in teaching; and (5) fieldwork in research.

The philosophy of the program is based on the following points:

1. Arts facilitate holistic learning.
2. Community building through education and the arts.
3. Arts are essential for civic well-being, and a responsive and engaged citizenry.
4. Arts facilitate reflective and transformative learning over one's lifetime.
5. Theory and practice must be connected.
6. Pedagogy and curriculum are interconnected and iterative.
7. Experiential learning is crucial to meaningful and lasting learning.
8. Mentoring and stewardship are powerful approaches to teaching.
9. Field-based educational research is crucial.

Both the program structure and content are significantly influenced by the Art and Art Education Program at Teachers College, Columbia University, New York, where I undertook my doctorate.

Glimpses into a pedagogy of hope and joy

The program philosophy is implemented through a project-based approach that emphasizes "learning by doing" and integrates theory and practice. A major need in teaching educational research to arts teachers in Pakistan is the facilitation of guided reading and writing strategies. In my experience the K-16 educational system in Pakistan rarely prepares students from the professions for academic writing. In this program the core faculty and I have been using group reading and writing exercises to address this situation; live teacher and peer feedback is used to edit student work on a projected screen (Figure 1).

These exercises are also supported with ideation, written and verbal feedback and free-writing exercises. We have observed that this method is supportive of student confidence and skill building for academic writing.

Another element that we have found particularly useful to students is the activation of informal spaces as places of learning. In my experience teachers across institutions often become limited by the confines of classrooms and time. In order to facilitate a creative disruption of these limits, we engage students in various place-based learning exercises in city centers, gardens, fields etc. (Figure 2).

We also extend the space-body and kinetic-relational sense gleaned from such exercises through holistic learning approaches that engage multiple senses (Figure 3).

Integration of theory and practice is also manifested in student journals and self-reflective notebooks. The artistic development course works closely with the material exploration course in which students investigate the structure and possibilities of different art and non-art materials (Figures 4 and 5).

Often, when these student journals bring together content knowledge from various courses, some of the most rewarding learning outcomes emerge. In Figure 5 we see the juxtaposition of the ideas of the local and western forefathers of art education, Rabindranath Tagore and John Lockwood Kipling. Such a juxtaposition brings to light critical understanding of the need for cultural contextualization in art education, especially as its precedents are mainly western. These can currently be found in both the scholarly literature available today, as well as in the post-colonial traces of history on the practice of art pedagogy in South Asia since the early twentieth century (Tarar 2008).

We have found that such methods of learning and reflection open up the meta-cognitive processes crucial to high quality teaching practice. Very often we find that students with a studio art background are better able to express themselves in a visual-verbal manner that facilitates this reflexivity. This reiterates the crucial role of studio art in the education of art teachers (Figure 6).

Figure 4. Reflective journaling: Free associative dialogue and observation notes in material exploration studio course. Photograph: Komal Khan, 2016

Figure 5. Reflective journaling: Juxtaposition of Western and South Asian art education histories. Photograph: Komal Khan, 2016

Figure 6. Reflective journaling: Development of a visual teaching philosophy. Photograph: Komal Khan, 2016

The perils of change

Having had a peek into the promising possibilities for learning that the MA Art Education program offers, it would be sadly ironic to consider that this richness has thus far proved quite vulnerable. Various challenges stemming from the complex contextual background described above hold sway over the delivery and maturation of such a program. Among these factors, foremost, is the culturally hegemonic notion that artists are better contributors to society than art teachers; this resistance to art pedagogy can be seen at many art schools, including SVAD. Academic leadership at such institutions often closes any discussion of the subject by pushing forward the primary purpose of art schools as being primarily for "creating" artists.

Furthermore, factors such as the HEC's focus on assessment and evaluation criteria from the pure or social sciences for Quality Assurance of art and design degree programs is counter-productive to the growth of the arts. The need for the subject of art education as a serious discipline of research and scholarly contribution is still not grasped by academia or public bodies. Neither are there any forums to create advocacy for it. Ultimately, greater awareness about the field is imperative at the policy level. In my experience, institutional support of the field and degree programs within it, is currently the only way to ensure that its practice is maintained. Only when such practice is supported can there be any furthering of research, which in turn can become the basis for policy building.

In 2016 following a change in leadership at SVAD the Centre for Art and Design Education and Research was discontinued due to the School's financial streamlining drive. This resulted in a re-prioritization of teaching over research at BNU. While the program continues to run, it lacks both faculty strength and institutional backing to its discipline. This imposes tragic limits on an important field that ought to be given the chance to expand in a part of the world where there is an urgent need for learning opportunities that remind us of the human dimensions of teaching, learning and the arts.

REFERENCES

Ali, Atteqa. 2008. "Impassioned Play: Social Commentary and Formal Experimentation in Contemporary Pakistani Art." Ph.D. dissertation. The University of Texas at Austin.

Beaconhouse National University (BNU). 2015. Mariam Dawood School of Visual Arts and Design Student Handbook 2015. Lahore: Printing Professionals.

Beaconhouse National University (BNU). MA Art Education Program. Accessed January 4, 2017. http://www.bnu.edu.pk/bnu/SVAD/ProgramsofStudy/GraduatePrograms/MAARTED.aspx.

Choonara, Samina, and Nadeem Omar Tarar. 2003. "Official" Chronicle of Mayo School of Art: Formative Years under J L. Kipling, 1874–94. Lahore: National College of Arts.

Hashmi, Salima. 2014. "The Urge to Spin." In The Eye Still Seeks: Pakistani Contemporary Art, edited by Salima Hashmi, 149–156. Gurgaon: Penguin Studio.

Higher Education Commission (HEC). Accessed January 11, 2017. http://www.hec.gov.pk/english/aboutus/pages/aboutus.aspx.

Higher Education Commission (HEC). (c.2000's). "Implementation of Semester System in Higher Education Institutions of Pakistan: Draft Policy Guidelines (Revised) Approved by the Higher Education Commission." (Public document circulated at HEIs).

Sadik, Razia Iram. 2011. "The Art Institution as a Site for Cultural Production in Pakistan: A Performative Reflexive Analysis of the Practices of Three Contemporary Artist-Teachers." Ed.D. diss., Teachers College, Columbia University.

Tarar, Nadeem Omar. 2011. "From 'Primitive' Artisans to 'Modern' Craftsmen: Colonialism, Culture, and Art Education in the Late Nineteenth-Century Punjab." South Asian Studies. 27(2): 199–219. DOI: 10.1080/02666030.2011.614427.

Tarar, Nadeem Omar. 2008. "Aesthetic Modernism in the Post-Colony: The Making of a National College of Art in Pakistan (1950–1960s)." International Journal of Art & Design Education. 27(3): 332–345. DOI: 10.1111/j.1476-8070.2008.00587.x.

MESTIZA PEDAGOGIES: SUBVERSIVE CARTOGRAPHY APPLIED TO ARTS AND CRAFTS MAKING

Verónica SAHAGÚN SÁNCHEZ
Universidad de Monterrey, México

ABSTRACT

This article brings forward my recently concluded doctoral research: a self-study focused on my cultural identity. My project was shaped as the result of moving from Central México to Montréal, Canada, in order join the Art Education Department of Concordia University. In my inquiry, I departed from my creative practice and asked: In what ways may the aesthetics of Mexican vernacular textile traditions influence my art making and my teaching as a visual artist trained within Western educational contexts? In the studio, I reflected on the implications of merging practices of the handmade (weaving) with digital media (digital imaging and printing). The (self) knowledge gained when fusing these two ways of working supported the design of a crafts-oriented pedagogy that promotes egalitarian relations/interactions within culturally heterogenious educational landscapes. Within this pedagogy, I proposed the strategy of "subversive cartography," which is meant to provide a space for underrepresented cultural groups to engage in inquiries on cultural identity and its relationship to place.

KEYWORDS **cultural identity, place, art/craft, mapping**

My Mestiza pedagogies are the result of an autobiographical studio-based inquiry centered on Mexican vernacular textile traditions as part of my doctoral research in Canada. On the conceptual level, my research was grounded on postcolonial theory and material culture applied to contemporary art/craft practice (Jefferies 2007, 283; Helland, Lemire and Buis 2014, 1). Within this framework, the notion of handicraft as a cultural object was key. Seen from a material culture perspective, vernacular (or local) craft is an "artifact production that embodies the historic and symbolic relevance of a community or region's occupations, social relations, and environmental interaction" (Chiappara 1997, 399). Following this idea, in my research, vernacular textiles acted as gateways for me to revisit my own relationship to the people and culture of Central México. Being an outsider to the communities of Indigenous artisans who produce the vernacular textiles used, weaving allowed me to develop a deeper understanding of the world-view embeded within them. Engaging with this craft practice provided me with the ability to translate aspects of the Mexican vernacular into my own art work and teaching. With this experience taking place outside of México, I achieved a more ample understanding of the term cultural identity, and the role that it might play in art education.

The "term *cultural identities* refers to the way that individuals or groups define themselves" in relation to a set of "beliefs, traditions, rituals, knowledge, morals, customs, and value systems" (Nieto 2010, 166). In other words, cultural identities are constructed through exposure to an environment and through the socio-political interactions taking place within it. From this perspective, the building of a cultural identity is not a once-in-a-lifetime experience. Cultural identity is instead recreated when we insert ourselves into new cultural/geographical environments. Applied to my Mestiza pedagogies, I propose to approach cultural identity as a fluid or relational concept that allows individuals to reflect and voice out their experiences of belonging and not-belonging (Rogoff 2000, 5), or, becoming part of specific communities and locations.

In this article, I share insights into the conceptualization and execution of autobiographical maps that combine digital printing and hand weaving. I focus on the learning experience provided by this creative project as the grounding for the pedagogical strategy of "subversive cartography." Envisioned as an ample framework that may be adapted to the needs of learners, subversive cartography invites individuals to voice out their experience of place.

The *Petate* as a means to map out my personal history

A dry leaf woven mat known as a "petate" and produced by the Nahúas – an Indigenous group that resides in Central México – was my entry point to review my childhood years in the historical center of Coyoacán in México City. The photograph in Figure 1 depicts myself and my brother sitting in our family´s backyard. My father used to acquire domestic handicraft items, such as metal/wooden kitchen utensils, clay pottery and basketry items, in the traditional local markets because he preferred us to be exposed to vernacular handicrafts' aesthetic qualities rather than industrially made items. Among our houshold handicrafts, the petate has held a special significance for me due to the close physical contact I had with the mat's woven surface when sitting, playing, and interacting with my brother. It was indeed my father who introduced the habit of laying a petate on the floor rather than a blanket for my brother and I to sit and play upon.

Historical research showed me that my early experiences with the petate and the uses conferred on this item in pre-Hispanic traditions were not entirely different.These functions included sitting and listening to the teachings of elders, eating, sleeping, making love, giving birth, and even making houses (Garduño 1997, 79). That is, the petate framed daily personal, intimate, and educational/communal experiences.

For my studio work, I kept this view of the petate in mind and interpreted it through the concept of "intercorporeality" (Springgay 2004, 56). On the one hand, intercorporeality enabled me to construct the metaphor of the petate being a sort of second skin. Intercorporeality stands for paying attention to our experiences of space and to our interactions with other people; this awakened state of being is largely ignited by our experiences of touch (Springgay 2004, 66). In my childhood, the petate played the role of mediator/stimulator of intercorporeal relations and experiences, symbolically marking a safety zone provided by my father, where my brother and I could play under the watchful eye of our extended family. On the other hand, I began to associate the petate with the Coyoacán neighborhood.

During the Winter of 2011, I visited Coyoacán in order to re-enact my childhood memories. Walking in Coyoacán made me aware of the process through which I learned to be at ease when going beyond the physical boundaries set by the petate itself. At that time, going beyond those boundaries mostly stood for going into Coyoacán's colonial center with various members of my family. Consequently, the petate metaphorically represents my family history and known territory. I created a series of hand-woven maps in which I traced such personal connections. Develping my woven maps also sparked reflections on the ways in which craft practice and digital technologies could be combined for the creation of hybrid art/craft projects focused on an individual's relationship to place.

Figure 1. Daniel and Verónica in the family house of the Coyoacán neighbourhood (1980).
Photograph: Concepción Sánchez Quintanar

Figure 2. *Memory Circuits*: Mother (2012).
Photograph: Verónica Sahagún Sánchez

Memory Circuits: Grandparents (2012).
Photograph: Verónica Sahagún Sánchez

The meaning of fusing the digital with the handmade

The series *Memory Circuits* was developed in Montréal, using Google Maps as a way of tracing my childhood walks, and to further reflect on memories of place. Beyond being mere representations of space, my maps evoke the memory of activities conducted with my mother (Figure 2) and my grandparents during my early childhood (Figure 3). These paper-woven maps became the third space in which visual representations of Coyoacán's colonial center (my Western side) and tactile memories of the petate (my Indigenous side) are set in dialogue, not as a binary, but as a hybrid state, where my identity is fluid, shifting, and always becoming.

I used weaving as a way of producing a (post)colonial critique of mapping that acknowledges and (re)evaluates the presence of Indigenous peoples in Mexican public sites. On a personal level, Coyoacán represents a family safety net. Yet going back to Coyoacán as a visitor allowed me to see this location with a more critical mind. From a romantic perspective, I consider how historical sites are spaces that allow us to travel back in time, which may give us the possibility of preserving traditions, sensing belonging, and articulating hybrid identities. The downside to this romanticized perspective is that, in the case of México, the preservation of colonial buildings is also symptomatic of the preservation of an unfair social system in which Indigenous peoples are kept within the margins. It is common to see Indigenous artisans walking around Coyoacán's main plaza or selling their crafts – including petates – outside the market and the parish, whereas Mestizo(a)s and tourists treat these spaces as sites of recreation. Weaving is my way of metaphorically questioning what I regard to be an unfair social system. My work does not speak for Indigenous peoples, as I cannot pretend to understand their experience in Coyoacán. However, my mappings are reflective of my in-between location as a socially conscious Mestiza, or as someone who has been disturbed by the unfairness of the situation. By tearing my digitally rendered maps into strips of paper only to weave them back together in the form of unreadble maps, I metaphorically rupture the power-based relations (Indigenous-Spanish) stemming from my cultural legacy as a contemporary Mexican Mestiza.

Engaging with digital media as well as with weaving also gave me the possibility to observe and to contrast the differences between working directly with materials and working with digital media. Digital technologies characterize contemporary forms of comunication that demand intense visualization, whereas a craft requires more bodily participation, particularly touch. Memories of touch ignited by weaving stimulated memories of the petate's strands, which, in turn, awakened memories of playing with my sibling in Coyoacan's plazas in the company of my mother and grandparents. The digital, in contrast, allowed me to visualize places in Central Mexico and to re-evaluate their cultural legacies while living in (and assimilating the culture

of) Montréal. In other words, the digital allowed me to bring my past life experiences in Mexico City closer to the reality lived in Montréal. In this way, my *Memory Maps* are reflective of my emerging, hybrid (Mexican-Montréaler) aesthetic sensibility characterized by my constant need to metaphorically (and literally) define my location within old and new territories.

Focusing on the pedagogical dimension of mapping

The pedagogical strategy of subversive cartography stems from my bodily experiences of place as suggested by feminist postcolonial geographies (Blunt and Rose 1994, 1). When creating *Memory Circuits*, I came to the realization that the "politics of (my) location" (Rogoff 2000, 6) as a middle-class white (in appearance) Mestiza also affects my spatial experience (Blunt and Rose 1996, 8). In México, I belong to the priviledged classes, whereas in Montreal I can be considered part of a minority group. A practice of subversive cartography became the third space in which I worked through such opposing experiences. Coming to a subversive cartographic practice also meant becoming conscious of what those emotions told me about both locations. That is, I drew on my bodily (or emotional) responses to them rather than patriarchal social/institutional versions of what a place represents (Nelson and Seagar 2005, 1).

In a Western colonial (or imperialist) mindset, mapping is about claiming ownership and setting clear territorial boundaries (Ackerman 2009, 1), which in turn contribute to the creation of hierarchical (class/ethnic-based) social systems. Seen from a global perspective, immigrants from developing countries are usually not considered desirable within Europe and North America. Within the internal geographies of these countries, the urban spaces clearly mark the working-class and immigrant ghetto areas, and in the case of North America (including México), leave Indigenous peoples relegated to far away places in the countryside. Subversive cartography is meant to question and to rupture such kinds of social boundaries as well as preconceived ideas of what is a relevant learning experience.

From my perspective, the dichotomy of formal-informal education is another way of establishing the superiority of Western ways of producing knowledge in relation to vernacular ways. Formal education stands for serious or rigorous ways of producing knowledge, whereas informal education represents more intuitive learning processes. By moving between both realms, a practice of subversive cartography seeks to bring forward traditional or vernacular knowledges in order to recuperate aspects of identity that might have been neglected by or denied to underrepresented populations.

Subversive cartography may provide an opening for voicing out experiences of cultural displacement. Displacement may refer to Indigenous peoples being racialized within Western public spaces and/or institutions. It may also refer to immigrant popu-

lations being stereotyped. A practice of subversive cartography proposes to adopt a relational ethical attitude of abandoning pre-established ideas of what is "right" and what is "wrong," or who is the Other (Springgay 2008, 9; La Jevic and Springgay, 2008, 70). Instead, subversive cartography seeks collaborative approaches so that learners may lead the way to an aesthetic inquiry that is valuable to them, and to find ways to express their experience of place that are coherent with their cultural backgrounds.

REFERENCES

Ackerman, James, editor 2009. "Introduction." *The Imperial Map: Cartography and the Mastery of Europe*. Chicago, University of Chicago Press.

Anzaldúa, Gloria. 2013. "The New Mestiza Nation: A Multicultural Movement." In *Feminist Theory Reader: Local and Global Perspectives*, edited by Carole McCann and Seung-Kyung Kim, 277–284. New York: Routledge. (Originally published 1992)

Blunt, Alison and Rose, Gillian.1994. *Writing Women and Space: Colonial and Postcolonial Geographies*. New York: Guilford Press.

Chiarappa, Michael.1997. "Affirmed Objects in Affirmed Places: History, Geographic Sentiment and a Region's Crafts." *Journal of Design History*, 10(4): 399–415.

Garduño, Blanca.1997. "Vital rhythms: Petatearse is something Grand." Artes de México, 38: 79–80.

Helland, Janice Beverly Lemire, and Alena Bui. 2014. *Craft, Community and the Material Culture of Place and Politics, 19th–20th Century*. Farham: Ashgate Publishing.

Jefferies, Janice. 2007. "Laboured Cloth: Translations of Hybridity in Contemporary Art." In *The Object of Labor: Art, Cloth, and Cultural Production* edited by Livingston, Joan and Ploof, John, 283–294. Chicago: School of the Art Institute of Chicago Press: MIT Press.

La Jevic, Lisa, and Stephanie Springgay. 2008. "A/r/tography as an Ethics of Embodiment: Visual Journals in Preservice Education." *Qualitative Inquiry*, 14(1): 67–89. DOI:10.1177/1077800407304509.

Nelson, Lise and Seager, Joni. 2005. *A Companion to Feminist Geography*. Malden: Blackwell Publishing.

Nieto, Sonia. 2010. "Cultural Identities." In *The Encyclopedia of Curriculum Studies*, edited by Craig Kridel, 1:165–167. Oaks: Sage.

Rogoff, Irit. 2000. *Terra infirma: Geography's Visual Culture*. London: Routledge.

Springgay, Stephanie. 2004. "Inside the Visible: Youth Understandings of Body Knowledge through Touch." PhD diss. University of British Columbia, Vancouver.

WAR ON CASH

Mila MOSCHIK and Virginia LUI
University of Applied Arts Vienna, Austria

ABSTRACT

It is rumored that cash will be abolished in the coming years; we have already witnessed a dwindling of cash in circulation, and increasing worldwide disputes about the "War on Cash" and the "Death of the Banknote." Advocacy for the demise of cash goes along with the crackdown on crime, tax avoidance, terrorism, human trafficking and money laundering. Against this background, understanding of the social, cultural and aesthetic dimensions of cash is important in order to grasp the reality of its demise. Although cash is dealt with on a daily basis, there is a significant lack of public knowledge of the "sensory literacy of cash" – its visual and haptic qualities. With this in mind, artistic approaches have been developed in order to tackle this topic from a critical and informative standpoint. Students of the University of Applied Arts Vienna from the fields of Art, Design, and Social Design have developed a multitude of participatory and performative reactions to the topic. These include the collection of historical artifacts and documents concerning cash, as well as participatory tasks assigned to the public. Almost no medium is as emotionally charged and present in society as banknotes. Cash money was the first reliable, visual and tangible mass medium of industrial society. Given its significance in history and its social and cultural importance, a re-examination of cash needs to take place in order to comprehend the meaning behind its abolishment and its relevance for our future.

KEYWORDS

war on cash, money design, actuality vs. virtual reality, physical money, culture

Community Art and Service Learning

The issue of actual versus virtual reality is happening today on a global scale and encompasses many realms, with cash money being one of the larger elements in this discourse. Cash, as a product that combines aesthetic and technical precision, has a long design history. Its elaborate design is represented by its safety requirements, recognition, consistency, appeal and functionality. All of these qualities are directed to a single goal: to signal the amplification of worth, continuity, and the possible future. For these reasons, banknotes have no real intrinsic value, only the value ascribed to them. Over the course of two hundred years a diversity of strategies have been tested and undergone changes in their aesthetic standards. Until now, the cultural sciences have only had limited engagement with iconographic analysis. In the battle for attention and acceptance, the business card of nations – banknotes – have become significant instruments of power. Governments, municipalities and banks visualize their power and address the pride of their citizens. Throughout their time banknotes have borne memorable images meant to strengthen a sense of community. While the iconography of money is always in flux, security aesthetics remain consistent with international standards. The corporations appointed with the printing rights to banknotes are reluctant to analyze their own design products. Banknote design is just one example that shows how much research still has to be done.

Figure 1 Avarice, Anonymous photographer, silver gelatin print ca. 1930. Photograph: Mila Moschik

Given the apparent dwindling amount of cash in circulation, it is of particular interest to closely examine the effects of the (still) tangible flux of cash. Students of the University of Applied Arts, Vienna have developed reactions to the demise of cash, many aimed at filtering out the stylistic features and the perceptual and psychological foundations of the banknote. Perspectives from the fields of ethnology, history, art history and cultural studies on the research topic of the "bill" are also considered.

The projects deal with the social, cultural and aesthetic dimensions of this medium and stem from the belief that art serves as a tool to sharpen one's sight on critical issues and provides a platform for opening up new perspectives. Some questions that are dealt with in these projects include:

> What are the reasons for and against cash?
> What might a cash-free society look like?
> Which histories, rituals and manners of use are connected with cash?
> How do advertisements depict cash?
> How do artists or protest movements use the aesthetics of cash?
> What kind of artistic work could symbolize the present plan?

Figure 2. Loan note, approx. 1914, restored with stamp border
Source: Mila Moschik

Mila Moschik, one of the initiators of the project, is writing her PhD about the significance of synesthetic reception and the material semantics of photography; this work became the starting point of her interest in banknotes. Framed photographs and banknotes are both meant for multi-sensory perception and can evoke emotions by addressing one's memory. For her artistic research, Moschik collects historical artifacts and documents in connection to cash within a time-frame of 1800 to the present. Through archival work and visual recombination she tries to understand the origins and functions of the appearance and materiality of cash. By handling and re-contextualizing objects, she assesses their sensual and psychological dimensions, using her own experiences as a starting point for more general questions concerning human behavior connected to cash. Using the methods of cultural anthropology, she takes into account the rituals, narratives and symbolic dimensions of the objects. An "Image Atlas" will document her work, and in it all the visual records and her own visual formulas will be gathered together. Money and art-related objects will comment on and question each other, offering insight into anthropological constants and some unknown aspects of both media. The goal is to visualize these alienated and forgotten parts of our culture of money. The Atlas will be published in the form of an artistic magazine, the "Cash-Atlas." For further information visit the homepage: https://mammon-world.com.

Figure 3. Memorial bracelet in silver with engraved coins, Vienna c. 1885. Source: Mila Moschik

For Virginia Lui, a re-examination of the experience of banknotes in their sensory, cultural and aesthetic qualities was crucial as a starting point to grasp the medium of cash and the consequences of its demise. In a climate where polarizing discussions on whether or not cash should or should not be abolished, many are overwhelmed by the sheer amount of information and arguments available as governments and private corporations continue to dispute the matter. Her project attempts to shift the focus away from legislative or governmental arguments, and instead initiate a process of thought that reexamines the individual person's own experience with cash as a haptic and sensory medium. A participatory art project – www.waroncash.net – was designed to invite the public to engage with the topic through taking part in certain tasks. Referencing similar participatory projects such as *Learning to Love You More* by Miranda July and others, and *PostSecret* by Frank Warren, the project aims to unveil the many facets of an individual's relationship with cash; to recollect moments of life, people and events that evoke a sense of memory, pain, sorrow or joy. The project deals with the inner workings of the mind, its fetishes, taboos and its inner turmoils. Sixteen tasks were formulated, each focusing on a specific quality of cash; the artist invites the audience to perform existing or forgotten cash rituals, address their cash knowledge and memory, delve into the different functions of cash as well as confront one's own taboos concerning cash. Such tasks include:

Figure 4. Submission for Task 4 by Jasmin Duregger, October 11, 2016 Photograph: Virginia Lui

Task 4. Use magazines, newspapers or any mass print medium to look for images of/relating to/concerning cash. It could be a photograph, illustration or text. When you are done, carefully cut out these images and glue them onto a piece of paper.

Task 5. Sometimes we do strange things with our cash, only later – days, months or years after the event – realizing how unusual it actually was. You probably told a friend or colleague about what you had done, and then realized through his or her reaction how strange that activity was, or perhaps you met someone who had also done what you had done. Write down your uttermost taboo experience with money on a piece of paper. Send it to us anonymously and burn or destroy it so that no one you know will ever set his or her eyes on it.

Task 10. Take a photo of where you normally store your secret cash stash.

Task 13. Try to draw as accurately as possible a five-euro note without looking at one.

A multitude of tasks were submitted, many presenting very personal accounts, narratives and associations with cash.

Figure 5. Submission for Task 10 by Cash Hider, August 28, 2016 Photograph: Virginia Lui

Conclusion

The move from the tangible, visible mass medium of the banknote to its virtual, non-material rendering is no doubt a highly contested topic. Further examination of the effects of virtual money on the interpersonal, social, economic, historical, cultural and societal levels needs to take place. Art and artistic research can serve to explore this subject.

Figure 6. Submission for Task 5 by Anonymous, January 8, 2017
Photograph: Virginia Lui

REFERENCES

Moschik, Mia. 2015. „Materialillusion auf Wertpapieren." In Der schöne Schein: Symbolik und Ästhetik von Banknoten, edited by Stefan Hartmann and Christian Thiel, 221–240. Regenstauf: Gietl Verlag 2015.

Frisby, Dominic. 2016. "Why We should Fear a Cashless World." Accessed March 27, 2016. http://www.theguardian.com/money/commentisfree/2016/mar/21/fear-cashless-world-contactless.

N.N. 2016. "The Political War on Cash." Accessed February 28, 2016. http://www.wsj.com/articles/the-political-war-on-cash-1455754850.

Warren, Frank. 2005. PostSecret: Extraordinary Confessions from Ordinary Lives. New York: ReganBooks.

Fletcher, Harrell, Miranda July, Julia Bryan-Wilson, Laura Lark, and Jacinda Russell. 2007. Learning to Love You More. Munich: Prestel.

HYPER-LISTENING: PRAXIS

Budhaditya CHATTOPADHYAY
The Academy of Creative and Performing Arts, Leiden University, The Netherlands

ABSTRACT

Hyper-listening: Praxis is a series of workshops that operates as a set of exercises and collaborative experiments involving the methodology of hyper-listening. As a conceptual framework hyper-listening means to explore the mindful and transcendental aspects of listening and engaged learning about one's surrounding environment through community art practice. Participants are asked to locate certain sites that trigger a multitude of associative thoughts, imaginings or personal memories. They are guided to utilize these auditory associations embedded in everyday navigation, thereby helping themselves to engage inclusively with their environments. This paper theorizes the intent and method of the workshop series.

KEYWORDS

sound art, listening, environment, community art practice, mindfulness

We live in an era of constant and perpetual dislocation, one that finds perception constantly shifting across places and thus forming unsettled geographies. These shifts often produce meanings that are questionably independent from their sited source. In this essay the rapidly emerging discourse on migration, mobility and nomadism (Braidotti 2012; Deleuze and Guattari 1986) is addressed within the practice of sound art, arguing that sonic mobility renders thought processes that transcend epistemic constraints of a sound's source identity and towards an involved subjectivity, triggering a poetic or contemplative mood for the itinerant and nomadic listener (Chattopadhyay 2013).

As increasingly migratory beings, these errant listeners may interact with various sites during their everyday navigation, considering and/or perceiving them as spatially-temporally evolving but gradually disorienting "auditory situations" (Barwise and Perry 1999; Wollscheid 1996; Chattopadhyay 2013, 2015) following sonic memory, imagination, and previous experience of other sites. The listener may relate to these situations by thought processes generated by means of cognitive associations in the context of a psychogeographic (Coverley 2010) interaction with the situated sonic phenomena. Essentially subject-oriented and contemplative, the itinerant sonic interaction between listeners and these constantly emerging situations as cognitive processes of hyper-listening may arguably transcend the ontological and epistemological constraints of sound toward including the contemplative states and mindfulness of the listener. In his seminal work *Listening*, Jean-Luc Nancy has argued that a philosopher is one who hears but cannot listen, "or who, more precisely, neutralizes listening within himself, so that he can philosophize" (Nancy 2007, 1). His argumentation challenges the currents of epistemic discourse in sound art that equates "listening" with "understanding," "audibility" with "intelligibility," or the "sonic" with the "logical" (Nancy 2007, 3). Apparently, by keeping the epistemological the lone framework to study sound, this equation seems one-dimensional. Rather, it would be a worthy project to explore the contemplative potential of sonic phenomenon at the listener's end. Taking as my point of departure the phenomenological premises of sound (Ihde 2007), subjective and personal experiences are made the basis of my workshop series, one that frames spatial and "unsitely" sound events into their entirety, including the transcendental potential of the situation of the itinerant listener. The contemplations activated by sonic phenomena arguably transcend the epistemic comprehension of the source identity of sound and move toward an outlining of the auditory situation into a context that delineates the sound events beyond immediately accessible meanings and expands the existing knowledge-structure in sound art practice.

Bearing this theoretical context in mind, *Hyper-listening: Praxis* develops as a series of exploratory workshops that employ the concepts and methodologies of mindful listening whereby seemingly mundane auditory situations are studied by means of their spatio-temporal and narrative developments, and (con)textualized by chronicling the myriad of thoughts triggered within the psychogeographic evocation of a listener's sited mobility in the listening experience. The series of workshops operates as a set of exercises and collaborative experiments involving the methodology of community art practice with an interest in engaged and "expanded" modes of listening (LaBelle 2006, 4) that intends to explore a mindful aspect of interaction with everyday sounds. Participants are asked to locate certain sites that trigger a multitude of associative thoughts, imaginings and/or personal memories. The participants are guided to utilize these auditory associations embedded in everyday navigation, helping to engage inclusively with their environments, producing subjectivities marked by an elevated and emancipated selfhood. The outcomes are presented as readings and performances in a collective setting at the end of the workshop.

The contemporary world is strained with intensified conflicts between nations, and within various sects and segments of people. Future human societies need to learn how to resolve conflicts of interest, values and beliefs. Needless to say, it is essential now to nurture a sense of plurality, enriched by a philosophically-oriented approach of acceptance and tolerance in our collective listening faculty – as suggested by Nancy – in order to navigate the challenging times ahead, which will be marked by a scarcity of natural resources and an unprecedented human-made decay of the environment, leading to possible Anthropocenic calamities (Morton 2013). It is my assumption that the root of all these many conflicts is essentially embedded in the lack of an ability to listen carefully to the other. As philosopher Gemma Corradi Fiumara suggests (Fiumara 1990, 73), a propensity to listen to others, without making immediate judgments, may potentially lead to bridging the troubled water of difference. My proposal for the workshop series *Hyper-listening: Praxis* is to employ an inclusive and contemplative listening practice as a way of approaching conflict resolution. The idea revolves around listening as a creative act so as to engage with one's surrounding environment, and the various bodies that inhabit that environment, more compassionately. Departing from the idea of a functional mode of listening as immediate meaning-making for the purpose of everyday cognition and navigation, I suggest the practice I term "hyper-listening," which intends to explore the aesthetic and mindful aspects of the listening act as framed in the term. This act indicates a need to transcend the epistemological constraints of the immediate meaning deducted from the mere objecthood and materiality of sound, towards embracing the aesthetic and poetic contemplation triggered by attentive listening to the ineffable and ephemeral phenomenon of sound. Through my artistic research and practice-oriented approach in the field of sound art and community art activities I have come to realize, as mentioned earlier, that sonic phenomena often trigger

poetic contemplation if we open our ears both to the environment and to others with an inclusive and empathetic approach, and that this is a methodology for engaging more compassionately and to accommodate others' views and perspectives. I have been involved in conducting this series of workshops in various art and humanities organizations and institutions across Europe and Asia in order to mobilize the idea realized as a community art practice. I intend to promote the practice of engaged listening as a methodology appropriate to spreading an awareness of inclusion and a contemplative acceptance of the other. I hope that the sharing of this idea will help us recognize the potential of listening to others in our environment not as bodies of conflict, but as extension of ourselves as a part of a larger, human common.

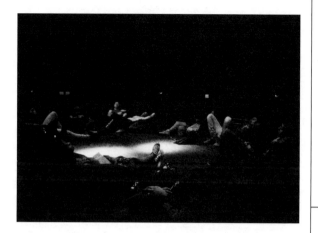

Figure 1. Installation view of "A Day in the Life of a Listener" by Budhaditya Chattopadhyay. Photograph: Miguel Isaza

Figure 2. Listening session of the work by Budhaditya Chattopadhyay. Photograph: Helicotrema Festival

Figure 3. Listening session of the work by Budhaditya Chattopadhyay. Photograph: Helen Frosi

REFERENCES

Barwise, Jon, and John Perry. 1999. *Situations and Attitudes*. Center for the Study of Language and Information. Chicago: The University of Chicago Press.

Braidotti, Rosi. 2012. *Nomadic Theory: The Portable Rosi Braidotti*. New York: Columbia University Press.

Chattopadhyay, Budhaditya. 2013. "Auditory Situations: Notes from Nowhere." *Journal of Sonic Studies* 4 (1). Accessed December 27, 2016. http://journal.sonicstudies.org/vol04/nr01/a06.

Chattopadhyay, Budhaditya. 2015. "Auditory (Con)texts: Writing on Sound." *Ear | Wave | Event* 2. Accessed December 27, 2016. http://earwaveevent.org/article/auditory-contexts-writing-on-sound/.

Cobussen, Marcel. 2002. "Deconstruction in Music." Doctoral dissertation. Rotterdam. Erasmus University Rotterdam.

Coverley, Merlin. 2010. *Psychogeography*. Harpenden: Pocket Essentials.

Deleuze, Gilles, and Felix Guattari. 1986. *Nomadology: The War Machine*, translated by Brian Massumi. Cambridge: MIT Press.

Fiumara, Gemma Corradi. 1990. *The Other Side of Language: A Philosophy of Listening*. London: Routledge.

Ihde, Don. 2007. *Listening and Voice: Phenomenologies of Sound*. New York: The SUNY Press.

LaBelle, Brandon. 2006. *Background Noise: Perspectives on Sound Art*. New York: Bloomsbury Academic.

Morton, Timothy. 2013. *Hyperobjects: Philosophy and Ecology after the End of the World*. Minneapolis: University Of Minnesota Press.

Nancy, Jean-Luc. 2007. *Listening*, translated by Charlotte Mandell. New York: Fordham University Press.

Wollscheid, Achim. 1996. *The Terrorized Term*. Frankfurt: SELEKTION.

InSEA
REGIONAL
CONFERENCE
Vienna

22—24 SEPTEMBER 2016

ART &
DESIGN
EDUCATION
IN TIMES
OF
CHANGE

INTERNATIONAL SPEAKERS

Austria 20%
Australia 1%
Belgium 1%
Brasil 2%
Canada 1%
Carribean 0,5%
Chile 1%
Croatia 1%
Cyprus 0,5%
Czech Republic 3%
Egypt 2%
Finland 14%
France 2%
Germany 10%
Great Britain 7%
Hungary 7%
India 1%
Iran 1%
Israel 1%
Japan 2%
Latvia 1%
Macedonia 0,5%
Mexico 0,5%
Netherlands 12%
Oman 0,5%
Pakistan 0,5%
Poland 2%
Portugal 3%
Serbia 1%
Singapore 0,5%
Slovenia 0,5%

PROGRAM

5 KEYNOTES
95 LECTURES
20 WORKSHOPS,
SCHOOL, MUSEUM
AND URBAN
EXCURSIONS

AIL Angewandte Innovation Lab

D'Art

Registration

Booking workshops

Registration

Welcome address from the Organizing Committee,
Luise Reitstätter, Ruth Mateus-Berr

Former President of InSEA: Charlotte Strobele

Keynote lecture Pascal Gielen

Welcome address from the InSEA Committee,
Left to right: Rita Irwin, technician Gerhard Rösner, Teresa
Torres de Eça, Glen Coutts, Carl-Peter Buschkühle

Parallel lecture session

Parallel lecture session

Lunch break

ART &
DESIGN
EDUCATION
IN TIMES
OF
CHANGE

Opening address: Ruth Mateus-Berr,
Angewandte President Gerald Bast

Keynote lecture Jocelyn Dodd

were issued with shoes and stockings—importa
respectability. When they left the Hospital to ta

Imperatives!

contextual critical collaborative

glocal confidence-building

future-focussed participatory

 facilitating

inclusive

visionary reflective

Keynote lecture Lesley-Ann Noel

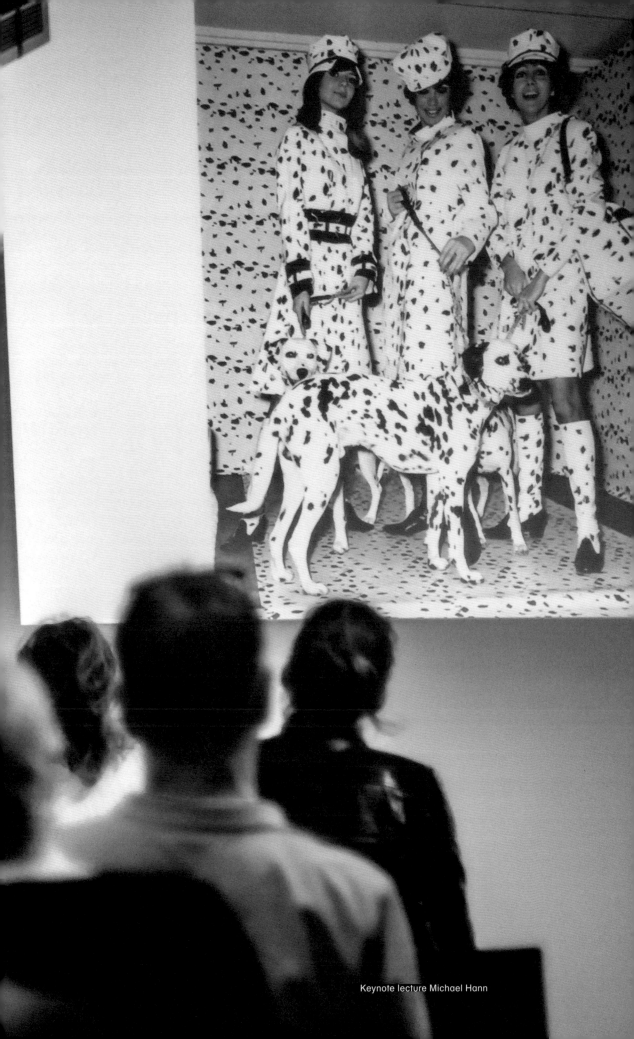

Keynote lecture Michael Hann

Organizing Committee
Left to right: Luise Reitstätter, Ruth Mateus-Berr, Klelija Zivkovik

Budhaditya Chattopadhyay

is an Indian-born artist and researcher involved with sound and new media. His work questions the materiality, site-specificity and object-hood of sound, and addresses aspects of contingency, contemplation, mindfulness and transcendence inherent in listening. Chattopadhyay graduated from the Satyajit Ray Film and Television Institute in India specializing in sound, completed a Master of Arts degree in new media/sound art from Aarhus University, Denmark, and recently obtained a PhD in sound studies involving artistic research from Leiden University, The Netherlands.

http://budhaditya.org/

Glen Coutts

is a Professor of Applied Visual Arts at the University of Lapland. He was a Reader in Art and Design Education at the University of Strathclyde in Glasgow until 2010. He is the former President of the National Society of Education in Art and Design (UK), and Vice-President of the International Society for Education through Art. He is the Leader of the Applied Arts and Visual Culture special interest group of the Arctic Sustainable Arts and Design Network, and Principal Editor of the *International Journal of Education through Art*. He writes regularly about issues in art, community and education.

Dipti Desai

is Associate Professor and Director of the graduate Art + Education programs at New York University. Her work addresses the intersection between art, activism, and critical pedagogy. She is co-editor of *Social Justice and the Arts* (Routledge, 2014), and her co-authored book *History as Art, Art as History: Contemporary Art and Social Studies Education* (Routledge, 2009) received honorable mention by AERA. She has received the Ziegfeld Service Award and the Specialist Fulbright Award.

Jocelyn Dodd

is Director of the Research Centre for Museums and Galleries, School of Museum Studies, University of Leicester. RCMG aims to inform and enrich creative museum thinking, policy and practice, and to support museums to become more dynamic, socially purposeful institutions. She has project-managed and directed a number of large research projects with multiple partners, most recently *Exceptional & Extraordinary: Unruly Bodies and Minds in the Medical Museum*.

Birgit Engel

holds the Chair of Art Didactics, Academy of Fine Arts Muenster. She has taught and researched in schools and in the field of (inter) cultural and educational research at the University of Bielefeld. In her book *Spürbare Bildung* she develops an approach, based on a background of phenomenology, to working with images of remembering. Her current teaching and qualitative phenomenological research is motivated by the goal to make the artistic experience useful and transferable to (art) teaching, and to promote professional awareness and sensitivity. Her expertise lies in the specific combination of research and teaching on an aesthetic basis.

http://www.kunstakademie-muenster.de/lehre/kunstbezogene-wissenschaften/kunstdidaktik-prof-dr-engel/

Pascal Gielen

is full Professor of the Sociology of Art and Politics at the Antwerp Research Institute for the Arts (Antwerp University, Belgium), and at the Research Center for Arts in Society (Groningen University, the Netherlands). He is editor in-chief of the international book series *Arts in Society* (Valiz, Amsterdam). In 2016 Gielen became laureate of the prestigious Odysseus grant for excellent scientific research of the Fund for Scientific Research Flanders in Belgium. His research focuses on creative labor, the institutional context of the arts and on cultural politics. Gielen has published many books which have been translated into English, Korean, Polish, Portuguese, Russian, Spanish and Turkish.

Peter Gregory

is currently Principal Lecturer in Education (Creative Arts) and trains students to teach art. He is a World Councillor for the International Society for Education through Art (InSEA), and President of the National Society for Education in Art and Design (NSEAD). In the UK, Peter also chairs the Expert Subject Advisory Group (ESAG), which was originally set up by the Department for Education to advise schools on the implementation of the national curriculum in art.

Jessica Hamlin

is Assistant Clinical Professor in the graduate Art + Education programs at New York University. Her interests include contemporary art as a site for transdisciplinary exchange and inquiry, and the connections between artistic practices and educational theory. She previously worked with the non-profit cultural organizations ART21 and Art In General plus the Boston Public Schools and Office of Cultural Affairs. She co-authored the book *Art as History, History as Art: Contemporary Art in the History Classroom* (Routledge, 2009).

Michael Hann

(BA, MPhil, PhD) holds the Chair of Design Theory (2002–present) at the University of Leeds. He is also Director (2003–present) of ULITA, an Archive of International Textiles. He has published across a wide range of subject areas, has made numerous keynote addresses at international conferences, and is an international authority on the geometry of design.

Gert Hasenhütl

holds several teaching positions at the Academy of Fine Arts Vienna and at the University of Applied Arts Vienna. From 2010 to 2011 he was a research fellow at the International Research Institute for Cultural Technologies and Media Philosophy, Weimar (IKKM). After completing his doctorate in 2008, he was given a position as assistant professor at the Institute of Architectural Theory, Art History and Cultural Studies at the University of Technology, Graz. He is publishing in the fields of Design Studies, Drawing Research and Cultural Technique Research.

Susannah Haslam

is a doctoral researcher currently based at the Royal College of Art in London. She co-organizes JOURNEY/SCHOOL and AOTCS Press, a conversation and publishing program, in addition to a series of happenings that consider the conditions and relations of friendship to leisure/work. Susannah's doctoral research is supported by the AHRC's Creative Exchange program and explores knowledge and art, alternative educational forms and organizations through written, organizational and dialogic practices.

susannahehaslam.com

Annika Hossain

is Head of the Research Field Art Education at Bern University of the Arts (HKB). The Research Field focuses on scholastic and extracurricular art education. Currently, Hossain is working on a project regarding the role of art history in Swiss secondary school art education. Prior to her employment at HKB, she worked for documenta 12 and as a gallery assistant in Karlsruhe. Hossain did her PhD at the Swiss Institute for Art Research (SIK-ISEA) in Zurich on the U.S. contributions to the Venice Biennale.

https://www.hkb.bfh.ch/de/hkb/ueber-uns/dozierende-und-mitarbeitende/?tx_feuserlisting_pi1%5BshowUid%5D=3062

Lisa Jacques

is the Learning Officer, Arts and Museums, Leicester. With eleven years of gallery and museum education coupled with twelve years of further and higher education experience, Lisa is committed to developing learning programs that are research-based and participatory in practice. Lisa's preferences for her practice are to engage in a co-production method of development, to work closely with curatorial teams, and to employ a co-construction method of delivery.

https://www.leicester.gov.uk/leisure-and-culture/museums-and-galleries/our-venues/new-walk-museum-and-art-gallery

Jana Jiroutová

completed her Master's degree studies at Trinity College Dublin in the field of literary translation. Currently, she is a PhD student in the Department of Art Education, Palacký University Olomouc, CZ, specialising in the history and development of museum education in the works of Anglo-American authors. She has recently finished the translation of a monograph she co-authored titled *Useful Symbiosis Reloaded* (2016), on the intersections of art and science.

Timo Jokela

is Professor of Art Education and Dean of the Faculty of Art and Design, University of Lapland. He is also the leader of the University of the Arctic's thematic network on Arctic Sustainable Art and Design, and has been responsible for several international and regional action research projects in the field of art education. Furthermore, Jokela works actively as an environmental artist, often using natural materials and the local cultural heritage as a starting point for his works. He has realized several exhibitions of environmental art and community art projects in Finland and abroad.

Ulla Kiviniemi

works as a lecturer in teacher education at the University of Jyvaskyla, Finland. Her major teaching area is textile crafts education; she is currently focused on cross-cutting materiality in crafts. She is interested in connecting craft education with art education, both theoretically and practically. She also sees benefits in combining informal learning with formal learning and eagerly takes part in international collaborations.

Jolana Lažová

holds a Master's degree from the Department of Art Education, Palacký University Olomouc, CZ, where she is currently in the PhD program. Her thesis focuses on digital technologies and their application in museum and gallery education. Apart from teaching at art schools, she also specializes in photography and ceramics in her own art practice.

Christine Liao

is an Assistant Professor at the University of North Carolina Wilmington, USA, where she teaches arts integration to undergraduate and graduate students. Her research focuses on theorizing the virtual body and identity, exploring interactions between the virtual and the real, and the curriculum of new media technologies in art education. She has presented her work at national and international conferences including NAEA, AERA, and InSEA. She is also the Managing Editor of the *International Journal of Education and the Arts*.

Virginia Lui

is a multidisciplinary designer and artist. She studied architecture at the University of Sydney, and practiced in a range of architectural firms before studying Social Design at the University of Applied Arts Vienna. She has worked on projects dealing with a wide range of topics including urban design and rights to public space, affordable housing, migration and right-wing populism. She is currently based in Vienna.

waroncash.net

Ruth Mateus-Berr

is Professor of Art and Design Education at the University of Applied Arts Vienna, artist, researcher, and social designer, is professor. In her PhD thesis (2002), she investigated the design of carnival parades in Vienna in 1939. She has published several articles and books contributing to the fields of art and design, arts/design-based research, inter-/transdisciplinarity, as well as education. She has delivered numerous lectures and held workshops and exhibited her artworks all over the world.

ruth-mateus.at

Mila Moschik

is a paper/photo conservator, curator and artist based in Vienna. Currently she is writing her PhD at the University of Applied Arts Vienna about material semantics and the synesthetic reception of frames in photography, 1840–1940. The book *Naturselbstdrucke* (Wien 2014) led her to the history of security printing. Since then she has been collecting stories, information and objects related to the culture of money. She is creating her own work and field of research inspired by this material.

metahaptik.wordpress.com

Jonny Mundey

is co-founder of The *IF* Project, a "free university." *IF* runs free, university-level arts and humanities short courses that are taught by a network of academics who volunteer their time and expertise. *IF* is a community where knowledge is shared, taught, and discussed at no cost to students. He studied history at the University of Manchester and has worked for the British Council and the Creative Society.

ifproject.co.uk

Lesley-Ann Noel

is a Lecturer of the Department of Creative and Festival Arts and the Arthur Lok Jack Graduate School of Business, both at the University of the West Indies, St. Augustine Campus. She has worked as a consultant with development agencies such as the Export Promotion Council of Kenya, Caribbean Export, the International Trade Centre and the Commonwealth Secretariat, focusing on product design. She has also consulted on export product development and entrepreneurship training for micro and small entrepreneurs in Africa and the Caribbean. She has exhibited work at design exhibitions in Trinidad & Tobago, Jamaica, Brazil, Germany, France and the USA; and has presented peer-reviewed papers at design conferences in the Caribbean, the USA, the UK and India.

Hannah Pillai and Gina Mollett / Untitled Play

Young artists Hannah Pillai and Gina Mollett have created *Untitled Play* as a participatory research project with the aim of delivering innovative projects that provide alternative and accessible pathways into arts engagement. Using lo-fi materials and playful approaches, their passion lies in transforming public and gallery spaces into contemporary art installations that continually evolve through participation. *Untitled Play* invites audiences to collaborate and be the driving force behind their own work.

http://untitledplay.tumblr.com/manifesto

Jo Plimmer

is the coordinator for *Generation ART*. A freelance arts project manager and engagement curator, she has previously devised and delivered arts and heritage programs in gallery and non-gallery settings across the south of England, including cultural, educational and public art settings. Recent projects include *Future Perfect,* Bristol City Council's first public art program with governance extended to the local community.

www.generationART.gallery

Pia Razenberger

is an art historian and art educator with expertise in Islamic Art. Currently she is in charge of the project *Tabādul* in cooperation with Ceurabics, Dom Museum, mumok, Technisches Museum, Volkskundemuseum and the Department of Art History at the University of Vienna. In her projects she aims to bring together people from Europe and the Near East through art objects.

https://tabadulblog.wordpress.com/

Luise Reitstätter

is a cultural scientist based at the University of Applied Arts Vienna with vast work experience in the international art field (e.g. documenta 12, the Austrian Pavilion – La Biennale di Venezia). She holds a doctorate in sociology and cultural studies. Her main research interests are art and social issues, museology and exhibition studies, as well as qualitative methods. Recent projects include the transdisciplinary Autumn School *Approaching the 3S. The Spatial, the Social and the Sensorium,* the research and development project *personal.curator* on mobile technology in museums, and the study *Say it Simple. Say it Loud.* on inclusive museum strategies that use plain language.

Martina Riedler

is Professor of Art Education at Çanakkale University (Turkey) and a visiting professor at Hamburg University (2014–2017). Before earning a Fulbright Fellowship to pursue her doctorate at the University of Illinois (USA), she worked with the education programs at the Guggenheim Museum (NY) and at ZKM/Center for Art and New Media Karlsruhe (Germany). Drawing upon critical theory and progressive education, her research emphasizes museum education and democratic participation, memory institutions and collective national identities, the hidden curriculum of informal learning sites, and critical theory in teacher education.

Razia I. Sadik

is a Professor of Art and Design Education at a public institution in Lahore, Pakistan. She received her doctorate in Art Education from Teachers College, Columbia University, New York, and her MA from CSM, London. She teaches graduate level courses in pedagogy, curriculum, human development, philosophy and qualitative research. Her research interests include art-based research, critical pedagogy, curricula in urban and community settings, the education of artists and designers, and critical curatorial practice.

Verónica Sahagún Sánchez

is a visual artist/educator/scholar who specializes in textile arts. At present, Dr. Sahagún Sánchez is a full-time Professor in the Textile and Fashion Design program of the Universidad de Monterrey, where she teaches textile printing. One of her main professional goals is to contribute to the sustainability of vernacular crafts through collaborative projects with craftsmen and women in the Americas.

Helena Schmidt

is a research assistant in the field of Art Education at Bern University of the Arts (HKB), where she graduated in Art Education (MA) in 2015. Recently, she has been working with Annika Hossain on a project regarding the role of art history in Swiss secondary school art education. Prior to this she studied Information Design at FH Joanneum Graz, and has worked as a designer on various projects (ETH Zurich, Designmonat Graz, and *Falter* Vienna). She also works as an art and design teacher in Switzerland.

http://www.hkb-gk.ch/de/personen_0/helena-schmidt-154.html

Jane Sillis

has been Director of *Engage,* the lead advocacy and training network for gallery education in the UK and internationally since 2005. She holds a master's degree in Cultural Theory from the University of Birmingham. Previous roles have included Education Officer, Ikon Gallery, Head of Education, Whitechapel Gallery and arts consultant (1999–2005). Formerly Vice Chair of *Engage's* board, she is currently a trustee of the Institute of International Visual Arts.

www.engage.org

Petra Šobánová

is an Associate Professor at the Department of Art Education, Palacký University Olomouc, CZ, where she teaches art education didactics. Besides realising many research projects, she has contributed substantially to the field of museum teaching and museum presentation, publishing a number of academic articles and monographs. Her principal works include *The Educational Potential of Museums* (2012), and *The Museum Exhibition as an Educational Medium* (2014).

Teresa Torres de Eça

PhD, researcher at the Institute of Art, Design and Society, University of Porto, Portugal; President of the International Society for Education Through Art – InSEA.

Ernst Wagner

studied art at the Academy of Fine Arts in Munich. After teaching art at school he was responsible for art, film and drama education (curriculum development, central assessments) at the Institute for School Quality Munich 2006–2014. He graduated with a PhD in art history, and is working at the Academy of Fine Arts in Munich, and at the UNESCO-Chair in Arts and Culture in Education at the University of Erlangen-Nuremberg.

ACKNOWLEDGEMENTS

Our heartfelt thanks go out
to our loved ones for their
understanding and support
throughout this project;
to the International Society
for Education through Art
(InSEA) and its president
Teresa Torres de Eça
for their great collaboration
at the conference and in this
proceeding publication;
to the president of the
University of Applied Arts
Vienna Gerald Bast, and
our project manager Anja
Seipenbusch-Hufschmied,
for making this book pos-
sible; to our reviewers for
making difficult but fair
decisions in the double blind
peer review; to all of the
authors for their precious
contributions and their efforts
on a tight schedule; to our
editor Arturo Silva for his
exemplary work and endur-
ance; to our publishers and
especially to Angela Fössl
for her trust in this project;
and last but not least to our
graphic designer Pia Scharler
for her outstanding coopera-
tion and design.

Ruth Mateus-Berr
Luise Reitstätter
Editors

D'Art
Austrian Center for Didactics
of Art, Textile & Design
Institute of Art Science and
Art Education
University of Applied Arts
Vienna
didactic-art.org

Library of Congress Catalo-
ging-in-Publication data
A CIP catalog record for this
book has been applied for at
the Library of Congress.

Bibliographic information
published by the German
National Library. The Ger-
man National Library lists
this publication in the
Deutsche Nationalbiblio-
grafie; detailed bibliographic
data are available on the
Internet at http://dnb.dnb.de.

This publication is also
available as an e-book
(ISBN PDF 978-3-11-052832-9)

© 2017 Walter de Gruyter
GmbH, Berlin/Boston

Copy Editing: Arturo Silva

Design → GET USED TO IT
Pia Scharler & Gerhard Jordan

Printing: Holzhausen Druck
GmbH, Wolkersdorf, Austria
Printed on acid-free paper
produced from chlorine-free
pulp. TCF

Paper: Munken Lynx Rough
Cover: Amber Graphic
Fonts: Portrait by Berton
Hasebe & Helvetica Textbook
by Max Miedinger/Linotype

Printed in Austria

ISSN 1866-248X
ISBN 978-3-11-052512-0

www.degruyter.com